LEGACY OF THE WEST

This catalogue has been partially funded
by a generous contribution from

THE INTERNORTH FOUNDATION

Published by Center for Western Studies, Joslyn Art Museum
and distributed by University of Nebraska Press,
Lincoln, Nebraska and London, England

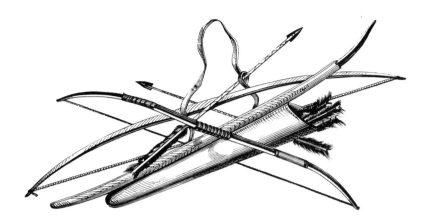

LEGACY
OF THE
WEST

· BY DAVID C. HUNT

WITH A CONTRIBUTION BY

MARSHA V. GALLAGHER

Cover:
W. R. Leigh
A Double Crosser
Oil on canvas
Joslyn Art Museum

Illustrations not otherwise credited have been taken
from a folio of Bodmer wood engravings and watercolor
studies in the collection of The InterNorth Art
Foundation/Joslyn Art Museum.

First Edition
©1982, Joslyn Art Museum.

Published by
Center for Western Studies, Joslyn Art Museum
Omaha, Nebraska

Distributed by University of Nebraska Press
901 North 17th Street
Lincoln, Nebraska 68588-0520
and London, England

Copy Editors: Janice J. Braden, Theodore W. James,
Audrey S. Kauders
Research/Typing: Joy Poole, Marilyn L. Shanewise
Designers: Lou and Julie Toffaletti
Photography: Lorran Meares
Composition: Trump Medieval by Compos-it, Inc.
Production and lithography: The Arts Publisher, Inc.,
New York. Paper stock is Champion 100 lb.
Wedgewood Gloss.

Library of Congress Cataloging in Publication Data

3. Art—Nebraska—Omaha—Catalogs. 4. Indians of
North America—Art—Catalogs. 5. Artists—Biography.
6. Joslyn Art Museum—Catalogs. I. Hunt, David C.,
1935- . II. Gallagher, Marsha V. III. Title.
N8214.5.U6J67 1982 704.9′49978′00740182254
ISBN 0-936364-11-4 82-10109
ISBN 0-936364-08-4 (pbk.)

TABLE OF CONTENTS

UNC Press 6/4/84

FOREWORD

This book is especially important as it presents for the first time the core of the Joslyn Art Museum's Western American paintings and works of art on paper collections. It also offers a tantalizing glimpse into the Museum's ethnographic collection which will gradually gain more significance within the Museum's programs. We are pleased to share this legacy during our fiftieth anniversary year, and hope this publication offers a strong and lasting fascination for what has become one of the most important interests in the Museum. Together with the previously published book, *The West As Romantic Horizon* which serves as an introduction to The InterNorth Art Foundation's collections permanently loaned to the Joslyn, these combined publications give a comprehensive overview of the magnitude of these collections.

David C. Hunt, Curator of Western American Art/Center for Western Studies, has written an illuminating and insightful essay, "The Artists' Legacy of the West." He has, as well, selected the works illustrated in this publication with careful attention. Mr. Hunt's fifteen year study of the paintings of the American West gives his observations special significance. Marsha V. Gallagher, Curator of Material Culture/Center for Western Studies, has selected representative works from our ethnographic collections which will be substantially enhanced by her astute attention.

Our interest in the *Legacy of the West,* this publication and related collections, cannot be separated from the rich, historical tradition of the Midwest itself. We understand it and cherish it. With never-ceasing interest, enthusiasm, and zest, it is perhaps our greatest artistic indulgence.

Henry Flood Robert, Jr.
Director

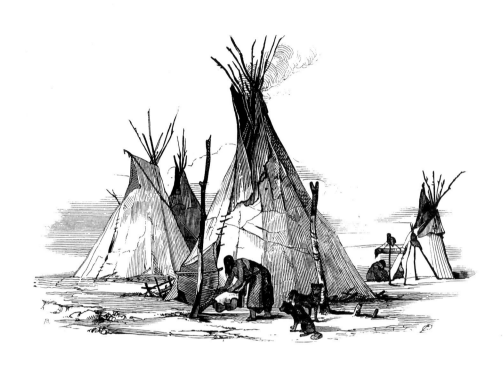

THE ARTISTS' LEGACY OF THE WEST

BY DAVID C. HUNT

The wilderness of North America represented different things at different times to different people, and many differing motives prompted individuals and groups to explore its frontiers. In contributing pictures to published reports of discovery in the western hemisphere, the artist early occupied a place in American frontier history. A more scientific approach to frontier reportage had to await the nineteenth century. Even then visual accounts were generally rendered with an eye to the picturesque.

The territory west of the Mississippi was a wild and dangerous region to travel at the beginning of the nineteenth century. Much of it was imagined to be a land of deserts and impenetrable mountain ranges unfit for civilized habitation. Of the artists who visited the frontier at this time, the majority were engaged as draftsmen or topographers in surveys for the U.S. War Department or the Department of the Interior. Others traveled westward on their own, including several students of natural history, ethnology, and landscape painting in search of new subjects and experiences to describe.

Whether European or native born, artists working in America in the nineteenth century were familiar with the philosophies and techniques taught in Europe's art schools where many of them had received their formal training. That some desired to venture beyond the bounds of civilization to observe life in the wild was itself expressive of the intellectual and essentially European interest in global exploration that typified the times. The tendency to idealize images of the frontier reflected European artistic and literary trends. In his book *Fatal Impact*, Alan Moorehead speaks of this predilection among the artists who portrayed native life in the South Pacific in the eighteenth century:

> It was not merely that no photographs were available . . . but a question of whether or not the artists could paint what they actually saw. The temptation to paint the idea rather than the reality was very strong, and it was an idea often interpreted in the European manner.[1]

In his *Pursuit of the Horizon*, Loyd Haberly says much the same when he states that to the artist on the American frontier in the nineteenth century, the thing that occupied his attention was not "the thing in itself, but the meaning and significance of the thing."[2]

Then, as now, success for the artist was seldom assured. Those who were employed in the West by the government may have been satisfied that their work would be utilized. Without such sponsorship, artists returning from the far frontier faced the problem of what to do with the sketches that filled their portfolios. Some managed to promote exhibitions of their work in various eastern cities or in Europe. Others found publishers willing to reproduce their pictures in book or folio form enabling them to reach a wider audience and realize a profit in sales. Many found it necessary to publish on their own if they expected to receive any reward for their efforts. Many were never able to generate appreciable interest in the results of months or years of labor in the wilderness.

English born Samuel Seymour, who made his living for a time as a scenic designer in New York City, was one of the first artists of any training to venture west of the Mississippi when he accompanied Major Stephen Long's expedition to the Rocky Mountains in 1819-20. Sent to explore the western parts of the Missouri Territory and to establish amicable relations with the Indian tribes along the way, Long's party met with chiefs of several tribes near present-day Omaha, Nebraska, where Seymour made portraits of several of the participants.

Seymour produced approximately 150 landscape views during his travels in the West. Sixty of these were finished following his return to Philadelphia. His *View of the Rocky Mountains on the Platte*, now considered the earliest of its kind made from firsthand observation, was one of eight sketches reproduced in the report of this expedition compiled by botanist Edwin James in 1823.[3] This same year Seymour again accompanied Long on an excursion to the headwaters of the Mississippi and regions surrounding the Lake of the Woods and Lake Winnipeg in Canada. An account of this experience was published in London in 1825 featuring five more of Seymour's pictures.

Also with Long's first expedition as its official naturalist-illustrator was Titian Ramsay Peale, son of portraitist Charles Willson Peale. Returning from his travels with Long to assist in the management of his father's museum in Philadelphia, Peale again explored uncharted regions with Charles Wilkes's expedition to the Pacific in 1838-41 and was one of the first American artists to record the topography of the Hawaiian Islands.[4] Peale contributed to several important scientific publications of the period and in his later years resided in Washington where he worked in the U.S. Patent Office. Original examples of his work are few and scattered today. Among them are some of the earliest depictions by a white artist of Plains Indian subjects.

The Indian on the frontier long occupied the attention of the nation. Portraits of Indians were obtained very early, varying in excellence according to the abilities of respective artists. Charles Balthazar Julien Fevret de Saint-Memin, a French miniaturist active in America from about 1804 to 1809, made a few such portraits mostly in profile. Better known today is Charles Bird King, a native Rhode Islander, who captured the likenesses of numerous Indian visitors to the nation's capitol in the 1820s. Most of King's portraits were done at the request of Thomas L. McKenney who, from 1816 to 1830, served variously as Superintendent of Indian Trade and head of what later became the Bureau of Indian Affairs under the War Department.

By far the greatest number of Indian pictures produced during the first quarter of the nineteenth century were the work of artists commissioned by the government. James Otto Lewis was thus employed on the frontier over a period of nearly fifteen years during which he attended treaty-making councils in Indiana, Michigan, and Wisconsin. A collection of pictures resulting from these experiences was reproduced in his *Aboriginal Port-folio*, issued in a series of ten parts in Philadelphia in 1835-36.[5] Now acknowledged as the first

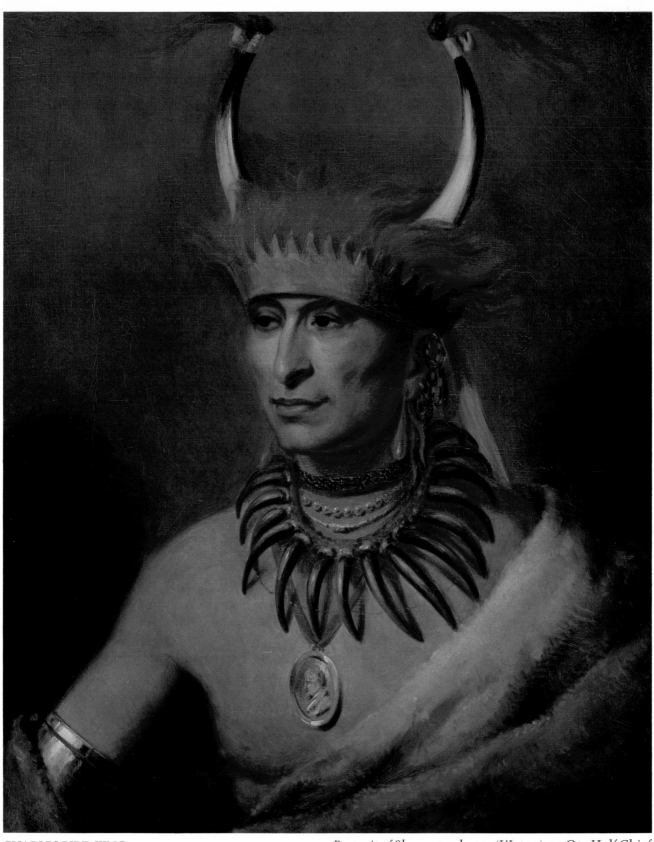

CHARLES BIRD KING · *Portrait of Shaumonekusse (L'Ietan), an Oto Half Chief*

of its kind ever published, this work was largely forgotten following t.
ance of the three-volume *History of the Indian Tribes of North An.*
Thomas L. McKenney and James Hall in 1836-44.[6] This featured fu
lithographic reproductions from Charles Bird King's American Indian (
in Washington as well as copies of several portraits by Lewis which had e
appeared in his *Port-folio.*

In his book *Portrait of the Old West,* author Harold McCracken makes the
comment that "An examination of the available works of these early Western
artists is disappointing—both from the standpoint of art and of historical doc-
umentation. There is but little evidence of the amazing material so profusely
thrust upon them."[7]

This opinion does not take into account the varying purposes of those who
were engaged in frontier reportage at this time, or the conditions under which
the artist on the frontier was forced to work, roaming the wild prairies far
removed from the sources of material supply. James Otto Lewis makes these
conditions abundantly clear in the foreword to the first installment of his *Port-
folio* when he explains to his readers:

> The great and constantly recurring disadvantages to which the artist is neces-
> sarily subject, while travelling through a wilderness, far removed from the abodes
> of civilization, and in 'pencilling by the way' with the rude materials he may be
> able to pick up in the course of his progress, will he hopes, secure for him the
> approbation, not only of the critic, but of the connoisseur.
>
> And when it is recollected, that the time for holding Indian treaties is generally
> very limited, that the deepfelt anxieties of the artist to possess a large collection
> must be no small impediment in the way of his bestowing any considerable share
> of his time or attention on any one production, together with the rapidity with
> which he is obliged to labour—he confidently believes, as they are issued in their
> original state, that whatever imperfections may be discoverable, will be kindly
> ascribed to the proper and inevitable cause.[8]

McKenney and Hall also state their views regarding the accomplishments of
the artist on the frontier in the introduction to the first volume of their *History.*
Crediting the frontispiece illustrating one of the war dances of the Winnebago
to Peter Rindisbacher, described as "a young Swiss artist who resided for some
years on the frontier and attained a happy facility in sketching both the Indians
and wild animals of that region," they sum up the importance of such docu-
mentation with the observation:

> This drawing is considered to be one of his best efforts, and is valued not so
> much as a specimen of art . . . as an account of the correct impression it conveys
> of the scene intended to be represented.[9]

Other reports of the period refer to the value of the artist as pictoriographer,
including such accounts as that compiled by an adventuring German prince,

Maximilian of Wied, who in the course of his travels across North America, set out from St. Louis in 1833 with a party of traders of the American Fur Company to explore the unsettled reaches of the upper Missouri River. A respected naturalist and experienced world traveler, Maximilian published on his return to Europe an informative account of travel west of the Mississippi. In his preface to the 1843 English edition of *Travels in the Interior of North America*, as translated by H. Evans Lloyd, Maximilian remarks that vast tracts of the trans-Mississippi West are in general but little known, and that "a faithful and vivid picture of those countries and their original inhabitants can never be placed before the eye without the aid of a fine portfolio of plates by the hand of a skillful artist. . . ."[10]

Referring to the picture atlas of eighty-one hand-colored engravings after original illustrations by Karl Bodmer, which was published as a supplement to his lengthy travelogue, Maximilian further declares:

> In my description of the voyage up the Missouri, I have endeavored to avail myself of the assistance of an able draughtsman, the want of which I so sensibly felt in my former travels in South America. On the present occasion I was accompanied by Mr. Bodmer, who has represented the Indian nations with great truth and correct delineation of their characteristic features. His drawings will prove an important addition to our knowledge of this race of men to whom so little attention has hitherto been paid.[11]

The frontier played host to several famous artists such as Bodmer, George Catlin, and John James Audubon, whose works were widely acclaimed in Europe, as well as lesser-known illustrators such as Rindisbacher, whose acquaintance with frontier life was relatively brief and his pictures correspondingly few. Alfred Jacob Miller and Paul Kane also had limited experiences in the West, although they managed to produce important collections of pictures on the subject. Miller in particular executed a surprisingly large volume of western paintings in his later years as the result of an excursion to the northern Rockies with a Scottish nobleman in the summer of 1837.

Alfred Sully, son of portraitist Thomas Sully, produced a number of views of U.S. Army life on the western frontier of the 1840s and 50s. West Point graduate Seth Eastman, who served with distinction as an officer at military outposts from Minnesota to Texas, achieved greater renown as one of the nation's foremost painters of American Indian life during the first half of the nineteenth century.[12] Also familiar with the western wilderness at this time were Charles Deas, Carl Wimar, and John Woodhouse Audubon, son of the celebrated John James Audubon.

Trained by his father in the delineation of bird and animal subjects and later active in preparing American editions of Audubon's *The Birds of America*,[13] J. W. Audubon made excursions to Texas and to California in 1845 and 1849 to gather material for the subsequent *Viviparous Quadrupeds of North America*.[14]

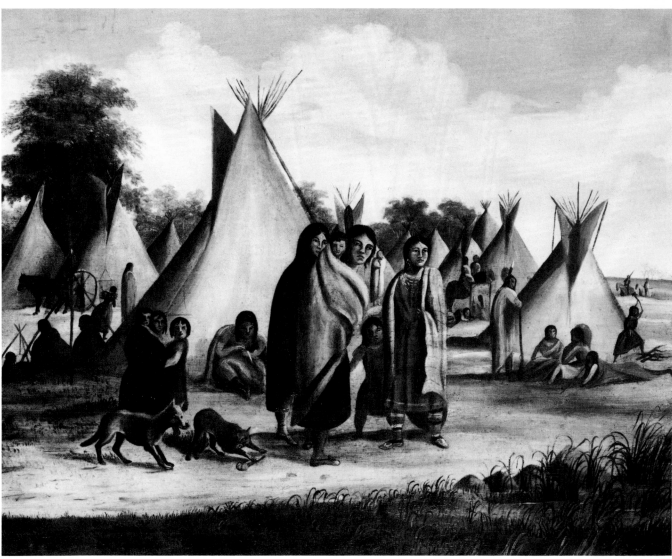

ALFRED SULLY

Dacota Sioux Indian Encampment

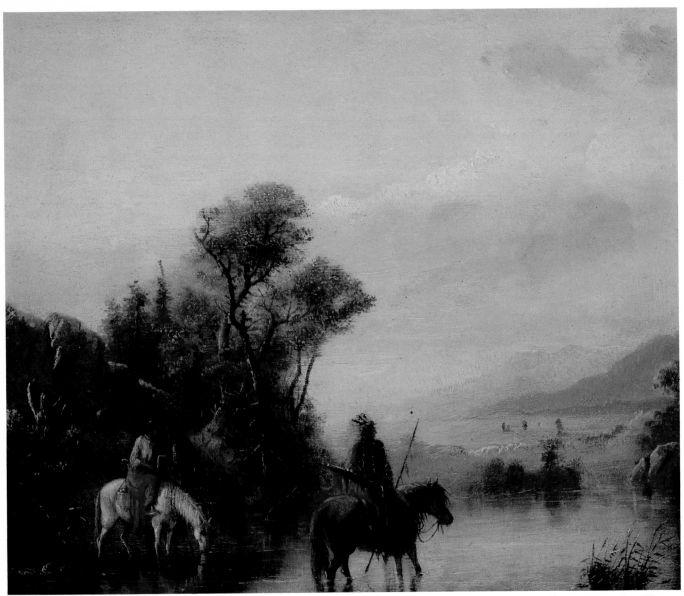

ALFRED JACOB MILLER

Indians Watering Horses

Although he failed to achieve the recognition as an artist that his father enjoyed, he contributed nearly half of the animal figures to the *Quadrupeds* folio and continued to issue editions of both famous Audubon publications throughout the remainder of his life. He is now counted among the better known artists of this period who explored the vast country beyond the then untamed frontiers of the United States.

Today we recognize that those who documented life in the early-day West produced a unique and now valuable commentary on the people and conditions of that time. Yet in attempting to evaluate such reports, one must keep in mind that the artist on the frontier was not a disinterested observer of the scenes he witnessed, nor in describing his experiences always careful to supply all of the details with which he might represent them most faithfully. There is little evidence to suggest that the artist of the day felt obliged to copy nature exactly. The viewpoint of the age, with its avowed sense of significance, did not regard all details of nature or of life as being "art-worthy."

Belief in the superior qualities of untamed nature over society's demoralizing artifices was ascribed to by many artists and writers of the time who saw in the distant Pacific islander or the American Indian the virtual embodiment of Rousseau's concept of the *Noble Savage*. This attitude is clearly expressed in one of Miller's comments preserved today in a manuscript at the Gilcrease Institute in Tulsa, Oklahoma. Remarking upon the excellence of the native American as a perfect model for the painter or sculptor, Miller says of the Western Sioux:

> Among this tribe we found some as fine specimens of Indians as any that we met. They reminded us strongly of antique figures in Bronze, and presented a wide and ample field for the sculptor; nothing in Greek art can surpass the reality here....
>
> Sculptors travel thousands of miles to study Greek statues at the Vatican; but here at the foot of the Rocky mountains are as fine forms stalking about with a natural grace (never taught by a dancing master) as ever the Greeks dreamed of in their happiest conceptions.[15]

The artist's view of aboriginal man was not shared by the majority of the nation at this time. The government sustained only a modest official patronage of Indian studies as such, concentrating its attention on scientific investigations and related surveys. Interestingly enough, the only collection of art owned by the government during this period was the gallery of Indian portraits earlier commissioned by Thomas L. McKenney, who had been vitally concerned with promoting the establishment of a center for the preservation of American Indian culture and history. With his retirement from office in 1830, his aims were never realized. After gracing the corridors of the War Department for several years, his collection was removed to the Smithsonian Institution for safekeeping and displayed along with various items of Indian manufacture secured by Congress in the course of its treaty-making activities.

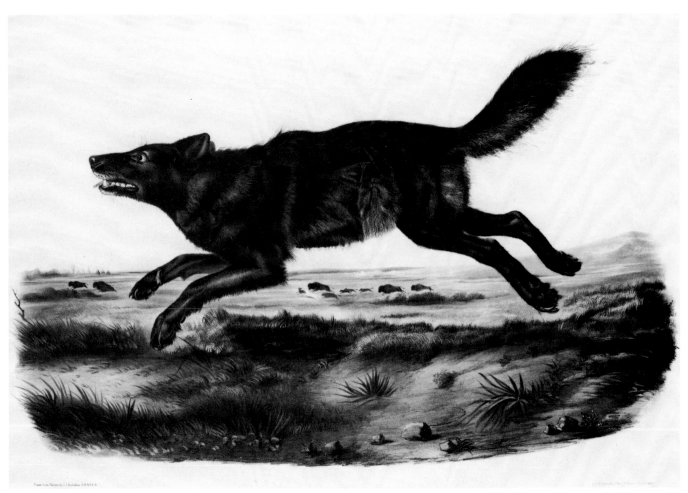

JOHN JAMES AUDUBON

Canis Lupis - Black American Wolf (lithograph)

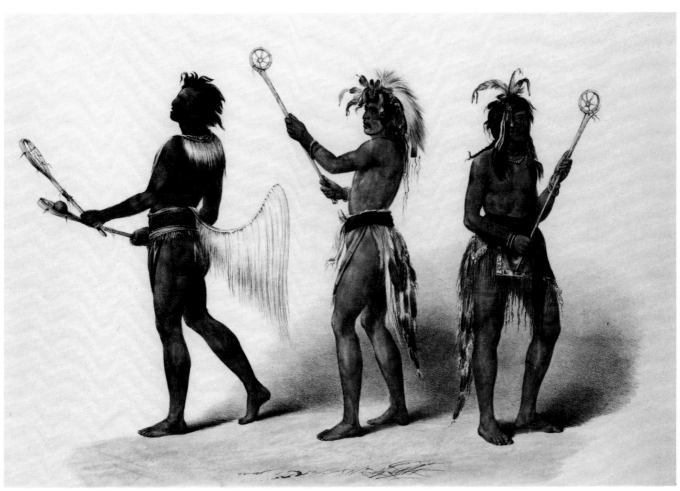

GEORGE CATLIN

Ball Players (lithograph)

George Catlin next endeavored to interest Congress in his own North American Indian Gallery which he took to Europe in 1839 and eventually lost abroad to creditors. All of his efforts to persuade the government to purchase his collection for the nation repeatedly failed, and it was not until after his death that the Smithsonian finally acquired the pictures over which he had labored so long.

Catlin was regarded as a controversial figure, criticized socially for his open admiration of the Indian and his advocacy of Indian causes, and deplored among ethnological circles as an indifferent draftsman and historiographer. Notwithstanding such opinions, his pictures are in several instances the only evidence we have to indicate the native habits and appearances of many of the indigenous tribes of the West as they lived before the effects of contact with European civilization finally overcame them. Even at the time Catlin moved among the native settlements with his brush and sketchbook, many of the groups he painted already were dwindling away as the result of the ravages of war, displacement, and disease.

The fate of the Mandan nation of the Upper Missouri is a striking case in point, described again by Prince Maximilian in the preface to his *Travels* when he says that:

> Authentic and impartial accounts of the Indians of the Upper Missouri are now especially valuable, if the information we have since received is well founded: namely, that to the many evils introduced by the whites among those tribes, a most destructive epidemic—small-pox—has been added, and a great part of them exterminated.[16]

H. Evans Lloyd also mentions this disaster in his own preface to the English translation of Maximilian's work, referring to a letter received from one observer from New Orleans dated June 6, 1838, which describes the suffering that the Indians of the northern plains were experiencing as a result of their exposure to the infection. "We have, from the trading posts of the western frontier of the Missouri," mourns Lloyd, "the most frightful accounts of the ravages of small-pox among the Indians. The destroying angel has visited these unfortunate sons of the wilderness with terrors never before known, and has converted the extensive hunting grounds, as well as the peaceful settlements of these tribes, into desolate and boundless cemeteries."[17]

The letter writer reports that the disease may have been communicated by someone on board a steamer bound for Fort Union with presents from the government to the tribes in that vicinity, and that it first broke out in June of 1837 among the Mandans, sweeping away the entire nation in one season with the exception of about thirty individuals. "Very few of those who were attacked recovered their health," he continues, "but when they saw all their relations buried and the pestilence still raging . . . life became a burden to them, and they put an end to their wretched existence, either with their knives and muskets, or by precipitating themselves from the summit of the rock near their settle-

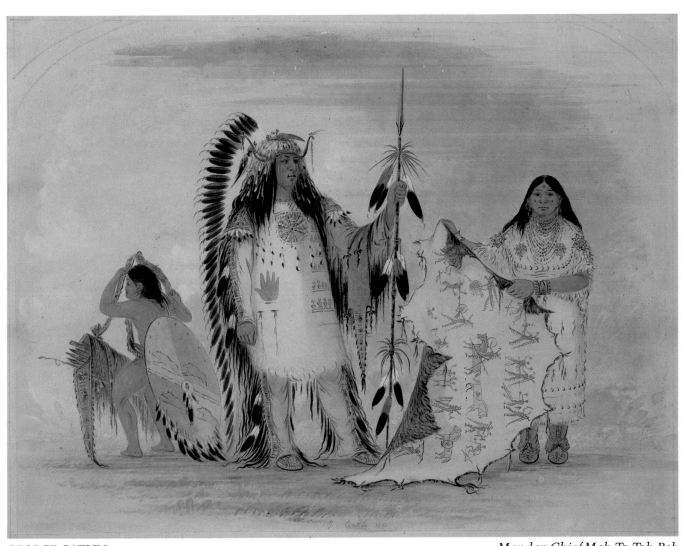

GEORGE CATLIN

Mandan Chief Mah-To-Toh-Pah

ment. The prairie all around is a vast field of death, covered with unburied corpses, and spreading for miles around, pestilence and infection."[18]

Most of the artists in the West at this time were aware that they witnessed a swiftly passing scene. Catlin in particular was distressed by evidence indicating that the Indian nations were threatened with extinction. In his paintings of the western fur trade, Miller also painted a brief and waning phase of western life. By the late 1830s, the decline in the price of beaver pelts already had begun to render the trapper's efforts unprofitable. In the 1840s the buffalo hide trade slumped for a time, and many of the commercial outposts along the overland trails were subsequently abandoned or used for other purposes.

During the first half of the nineteenth century, the United States developed rapidly as a nation. As wealth and leisure increased, so did an interest in the arts, especially pictures portraying American life or the rural American scene. Quiet country landscapes and familiar views of everyday existence were popular subjects of this period. It is now difficult to measure the effect of Catlin's scenes of life on the western prairies or Miller's views of the Rockies on the eastern public of that day. It may be supposed, however, that some of the pictures and reports of those who returned from the wilderness helped to open eastern eyes to the wonders of the Far West.

The arts continued to share with scholarship an all-absorbing interest in nature. A whole movement in painting had earlier evolved out of an appreciation of the American landscape, now called for the sake of convenience the Hudson River School after the area in which it first became apparent. Early and lesser-known artists such as Alvan Fisher and Robert Havell, Jr. typified this trend as did the better-known Thomas Cole, Asher B. Durand, and others whose works portray lovely wilderness scenes and dramatic panoramas of wooded hills and waterfalls. Carried forward by a love of the inspiring, the morally significant, and the beautiful, this romantic tradition expanded into the West in time with the efforts of such artists as Miller, Albert Bierstadt, and Thomas Moran, who attempted to capture on canvas the awesome grandeur of the Rocky Mountains and the distant Sierras.

Miller, who had been especially enthusiastic in his descriptions of the Far West, declared it to be a wonderland which one day would rival even the famous sites of Italy and ancient Egypt as an attraction for wealthy travelers. "A wide field for exploration," he had written with reference to the mountain lakes and lofty peaks of the Rockies, "and the time is rapidly approaching when villas and hotels will rise on the shores of these charming sheets of water—and when railways are carried through the South Pass, will inevitably become not only the 'grand tour' but the Grand Highway of this celestial empire."[19]

In his grandiose scenes of the Rockies and the High Sierras, Albert Bierstadt echoes much the same sentiments. A native of the German Rhineland, Bierstadt had spent his childhood and youth in Massachusetts, returning in the 1850s to Europe to study painting at the then famous Dusseldorf Academy

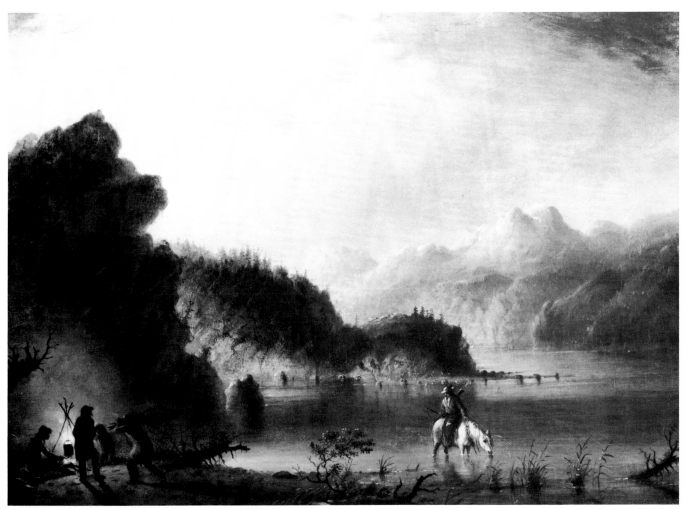

ALFRED JACOB MILLER

In the Rocky Mountains

24

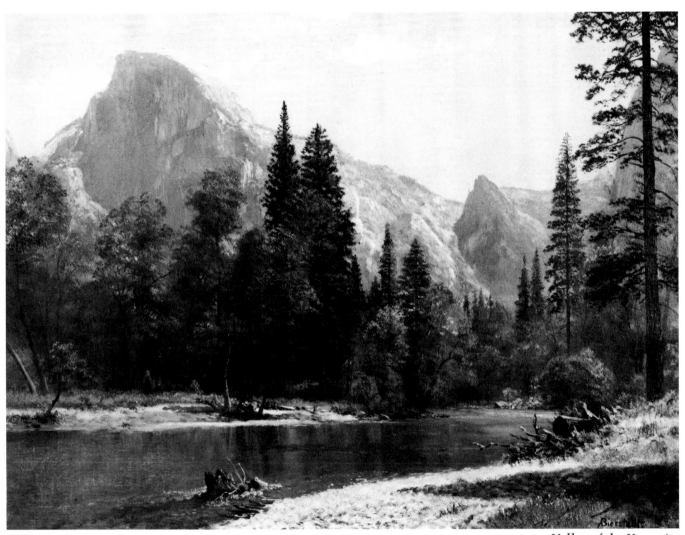

ALBERT BIERSTADT *Valley of the Yosemite*

where so many of his contemporaries received their formal instruction. Back again in the United States in 1858, he joined a military expedition on its way to lay out an overland wagon route from Fort Laramie, Wyoming to the Pacific Coast. Spending the next two summers sketching in country which Miller had viewed some twenty years earlier, Bierstadt produced a series of spectacular works which received considerable acclaim when first exhibited at the National Academy of Design in 1860.

Bierstadt produced his pictures on a grand scale, emphasizing the ruggedness of the western landscape and achieving at times unprecedented dramatic effects with his liberal use of light and shade, cloud and storm. Less concerned with reproducing the smaller details of nature, he concentrated instead on the overall impression of the view at hand, and with what was regarded as remarkable technical facility, rendered for his patrons a soul-stirring interpretation of the splendor of the unspoiled wilderness. Here indeed was a conception of the Far West which in its day did much to contradict the popular notion of the trans-Mississippi region as a harsh and alien wasteland.

Meanwhile, in 1853 Congress appropriated the sum of $150,000 to finance a series of surveys for a railroad to the Pacific. Six surveys actually were made between 1853-54 along the four proposed routes then under consideration, and extensive investigations of the interior of the country were undertaken. Each of the several teams involved in this effort was composed of a variety of technical and scientific personnel that included surveyors, civil engineers, geologists, botanists, zoologists, astronomers, and meteorologists as well as landscapists, topographers, and numerous other civilian and military specialists. Preliminary reports were released from time to time and the final results of all surveys were published in twelve illustrated volumes under the title *Reports of Explorations and Surveys to Ascertain the Most Practicable and Economic Route for a Railroad from the Mississippi River to the Pacific Ocean* (Washington, 1855-60).

While not settling the question as to which route to take in constructing the proposed transcontinental railway, these combined reports created a great deal of interest at the time of publication. The accompanying illustrations elicited an enthusiastic response from those who viewed them. Reproduced for the most part as full page, two- and three-color lithographs, these represented the work of eleven contributing artists among whom were J. C. Tidball, Albert Campbell, Richard Kern, James C. Cooper, John Young, Gustav Sohon, Heinrich Möllhausen, W. P. Blake, Charles Koppell, F. W. von Egloffstein, and John Mix Stanley. Yet another artist, Solomon Nunez Carvalho, was attached to an independent survey undertaken by John C. Fremont, who was then anxious to prove the feasibility of a central route. Fremont's reports were never published, but information concerning his expedition was included in Carvalho's *Incidents of Travel and Adventure in the Far West*, published in New York in 1859.

Tidball, Campbell, and Möllhausen, who had toured the West with Duke

Paul of Württemberg in 1851, accompanied Lt. Henry Whipple's survey along the 35th Parallel from Fort Smith, Arkansas through Indian Territory, New Mexico, and Arizona. Koppell and Blake were with Lt. R. S. Williamson on the southern or California route and John Young with Williamson's California-Oregon branch survey. Richard Kern, von Egloffstein, and others went with a Captain Gunnison to explore a central route out of Council Bluffs, Iowa, or with associated parties later headed by Beckwith, Pope, and Parke, whose western California-Rio Grande reports were prepared for publication by A. H. Campbell.[20] Kern, who had earlier accompanied his brothers Benjamin and Edward Kern on Fremont's fourth expedition to the Rockies in 1848-49, lost his life in an Indian attack in Utah while involved in the Gunnison survey. His sketches were salvaged and later prepared for publication by Stanley.

Governor Isaac Stevens of Washington Territory was appointed to head the entire project and placed in charge of surveying the proposed northern route from St. Paul to Seattle. Artists Stanley, Sohon, and Cooper accompanied this expedition with Stanley and Sohon being assigned to the preparation of the reports following the party's return to the East in 1854. In 1858-62, Sohon again ventured westward as an interpreter and guide for a military road-building operation, returning to Washington to assist in the preparation of reports of this latter expedition. Sohon is now considered one of the more important of the artists who contributed to the railroad surveys along with Möllhausen, whose drawings appeared in Whipple's *Report Upon the Indian Tribes* (1855) and again in Joseph C. Ives' *Report Upon the Colorado River of the West* (1861).

Represented by more plates in the published reports than any of the above mentioned artists, Stanley deserves special acknowledgment with respect to the railroad surveys. With the possible exception of Kern and Möllhausen, Stanley had at the time of his association with the surveys more actual experience in the West than any of the others, having spent several years on his own in Indian Territory, New Mexico, California, and the Pacific Northwest. Like Catlin before him, Stanley produced a large body of pictures which documented western Indian life. A significant portion of this record was destroyed along with the government's collection of Indian portraits by King and Lewis in a fire which swept through a wing of the Smithsonian in January, 1865. Subsequent fires in New York City and again at his studio in Detroit, where Stanley died in 1872, consumed nearly everything that this artist had ever done relative to his earlier western adventures.

During the latter half of the 1860s and throughout the 1870s, Congress authorized successive explorations of the western half of the continent. In 1870 an official investigation of Wyoming's Yellowstone country was announced by the government. In 1872 an act was approved authorizing a survey to be made to determine the boundary between the United States and British possessions in Canada. Expeditionary field work for the latter survey occupied the better part of two years. Although the boundary team did not employ an

artist during the whole of this time, New York illustrator William Cary joined it on its return down the Missouri River to Bismarck in 1874.[21]

The Yellowstone had been known to the Indians of that region for hundreds of years before the first European ever visited it. John Colter was the first white man on record to view a part of it when he passed through in 1807 after leaving the Lewis and Clark expedition on its return eastward from the Pacific coast. Hunters and trappers such as Jim Bridger ventured occasionally into the upper reaches of the Yellowstone before the Civil War. Their stories of hot springs, geysers, bubbling mud pots, and fantastic rock formations in that area were generally received as another of the tall tales characterizing so many reports of the West during this period.

Following the discovery of gold in western Montana in the 1860s, adventurous white men again roamed the headwaters of the Yellowstone River and the neighboring Teton range to the south. In their haste to lay claim to hidden treasure, few expressed any interest in the bizarre beauty of that place. Curious about the reports being circulated of unusual geological activity in the area, a group of Montanans under David E. Folsom and Charles W. Cook braved the dangers of an Indian uprising to travel into the Yellowstone region in 1869. The following summer another party under Henry D. Washburn, Surveyor-General of Public Lands in Montana, and a Lt. G. C. Doane undertook a detailed and extensive exploration of the area. The survey convinced them that the government should take immediate steps to protect the Yellowstone from future commercial exploitation.

Scribner's Monthly carried its share of frontier reportage at this time and early in 1871 planned to publish a manuscript by Nathaniel P. Langford on "The Wonders of Yellowstone" in its May and June issues. Langford had visited Yellowstone with Washburn and Doane the previous summer and had included in his manuscript a few sketches of the country made by one of the soldiers in the party. *Scribner's* suggested that staff artist Thomas Moran work these up into suitable illustrations to accompany Langford's article. Langford planned another trip to Yellowstone that summer with geologist Ferdinand V. Hayden, who had been appointed to head the government's official exploration of the region. Moran also wished to accompany this expedition and succeeded in obtaining the approval of his editor and additional funding from Jay Cooke of the Northern Pacific Railroad to undertake this venture.

Since 1867 Hayden had been active in geological surveys of the western territories exploring large areas of Nebraska, Colorado, and Wyoming. He was aware of the importance of taking artists along on such expeditions, having been accompanied to Colorado in 1870 by Sanford R. Gifford and pioneer western photographer William H. Jackson, who also went with him to the Yellowstone. Hayden welcomed the addition of Moran to his Yellowstone party and the two became lifelong friends as a result of their experiences together in the West.[22]

While Hayden surveyed the Yellowstone, lobbyists in Washington contin-

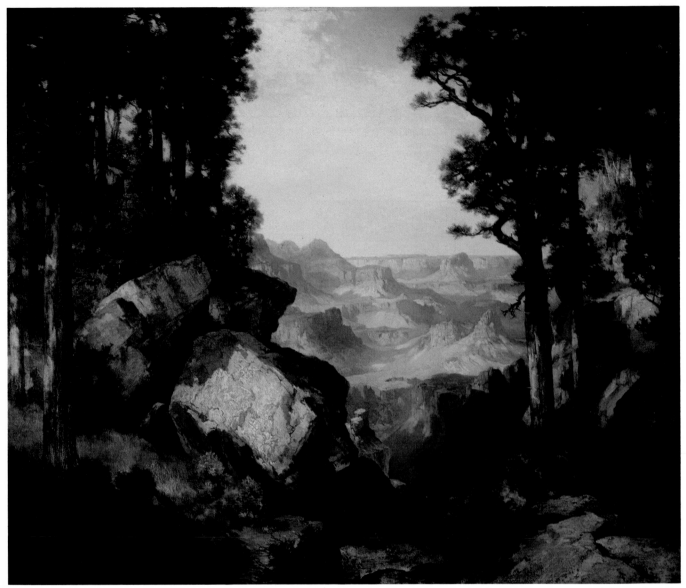

THOMAS MORAN

The Grand Canyon of the Colorado

ued to promote the idea of setting this region aside as a national park to be preserved forever in its natural state. When Hayden returned to Washington, he was called to assist in determining the boundaries of the proposed park and to help secure passage of the bill authorizing its establishment. Strong opposition was voiced by some senators and representatives to the bill's prohibition of private ownership of land in the area. Advocates of the bill stressed the importance of protecting the natural beauty and unique geological features of Yellowstone, of which the sketches by Moran and the photographs by Jackson furnished indisputable proof. Their pictures publicized the region to the nation, and Congress subsequently acted to preserve it in large part because of the visual documentation these men provided.

Moran continued from the time of his first trip to the Yellowstone until his death in 1926 to travel widely throughout the United States and its western territories, visiting more primitive and unspoiled areas of the North American continent than any other artist of his generation. He was represented in numerous publications. With exhibitions in New York and Washington of his monumental *Grand Canyon of the Yellowstone*, later purchased by Congress, his pictures began commanding higher prices than any of that time with the possible exception of paintings by Bierstadt. A prolific artist, he spent nearly half a century at the task of portraying the nation's principal wilderness areas to an increasingly admiring public. Widely publicized through the distribution of copies of his works, many of his favorite sketching sites in the West were set aside as national parks or monuments during his lifetime.

George Catlin had been one of the first Americans in his day to envision the creation of a wilderness reserve in the heart of the continent for the preservation of nature and the Indians' way of life. He died in 1872, the same year in which the Yellowstone Bill passed Congress creating the first national park in North America. In succeeding decades, the cry for conservation was heard with increasing frequency as more and more areas of the West came under the ax and plow. For some this awakening concern for the land and its resources came too late. With the end of the Civil War, the nation's last great era of westward expansion had begun in earnest.

By 1869 the Union Pacific Railroad crossed the continent. Uniting the country east and west, the railroad split the continent north and south insofar as many of the Indians in the West were concerned. Having been pushed ever westward by the relentless advance of Anglo-American settlement throughout the first half of the century, these same tribes again found themselves confined to smaller and less desirable areas of occupation as civilization followed swiftly along the iron trail to California.

Even before the fury of the plains wars of the 1870s scattered and defeated them, most of the tribes in the western territories underwent severe changes in their material cultures and customs. Some declined or perished with the destruction of their hunting lands and food supplies as hide hunters swept the

prairies of the buffalo, leaving in their wake uncountable numbers of skinned carcasses to putrify in the sun. As a result of intermarriage and tribal decimation, many of the lesser nations disappeared altogether as a people or distinct group.

By 1880 a government-enforced peace was established in nearly all of the western states and territories and the free roaming life of the Plains Indian was at an end. The once vast herds of buffalo and other wildlife disappeared from nearly all of their former range, and farmers in Kansas and Nebraska gathered their bones off the grasslands and shipped them East by rail to be sold as fertilizer.

Homesteads and townsites spread across the West as herds of longhorn cattle, driven up from Texas, found their way to the railheads and stockyards of Abilene and Kansas City. The now celebrated activities of the rancher, cowboy, lawman, and businessman soon displaced the once flourishing and independent occupations of the trapper, trader, and Indian scout of the earlier days.

For more than two hundred years, the frontier represented a vital part of the American experience, beckoning to multitudes of hardy and enterprising individuals who pushed ever westward from the Atlantic seaboard in search of land, wealth, and opportunity. By the last quarter of the nineteenth century it was at an end, but not entirely forgotten by either Easterners or Westerners who still identified with the West of recent memory. Writers and artists continued to exploit the rich store of adventure left by those who had explored and settled the western wilderness. Thus the idea of the frontier and its attendant concepts of individualism, free enterprise, and self-reliance survived long after the geographical reality had disappeared forever.

The importance of the artist as a reporter greatly expanded during this latter period, especially before the photographer began taking over as visual documentarian from the draftsman and portraitist. Along with an increase in the number of books and magazines published, knowledge in general increased as men and women in all walks of life found the source of their current information in the illustrated journal. The practical or expedient aspects of magazine illustration tended to relegate the commercial picture-maker to an inferior artistic category in the opinion of the academicians of the day. Nevertheless, the artist in the West performed a necessary service in relation to developments on the fading frontier, assuming a role not unlike that of the modern newscaster on location in one of the trouble spots around the world.

Eastern illustrators such as William Cary and Arthur F. Tait kept the idea of the frontier alive in their newspaper designs and commercial art reproductions. With an increasing sense of nostalgia, Frederic Remington maintained to the last a tradition of western reportage obtained on the spot in the closing decades of the century. George de Forest Brush, Edwin Deming, Joseph Henry Sharp, and Henry Farny continued to paint Indian subjects long after the wild, free life of the Indian in the West was a thing of the past. Other painters and storytellers such as C. M. Russell, Ed Borein, Harvey Dunn, and Frank Tenney Johnson largely reminisced about the good old days in their depictions of

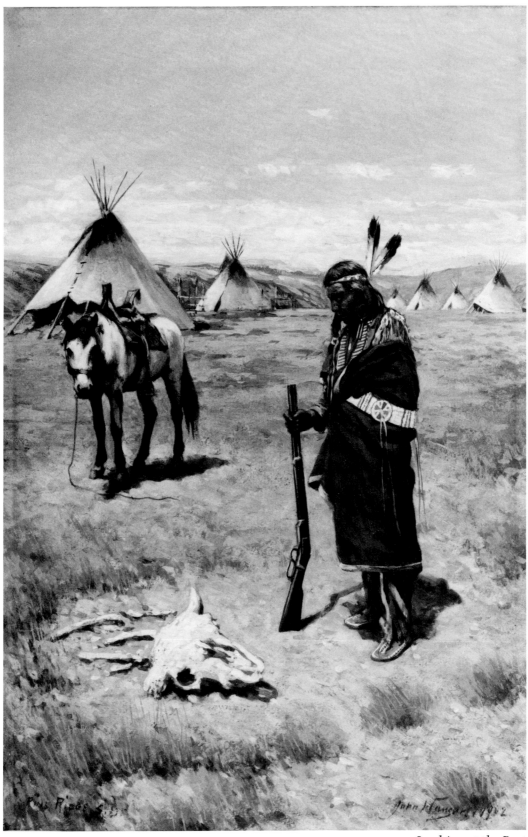

JOHN HAUSER

Looking at the Past

32

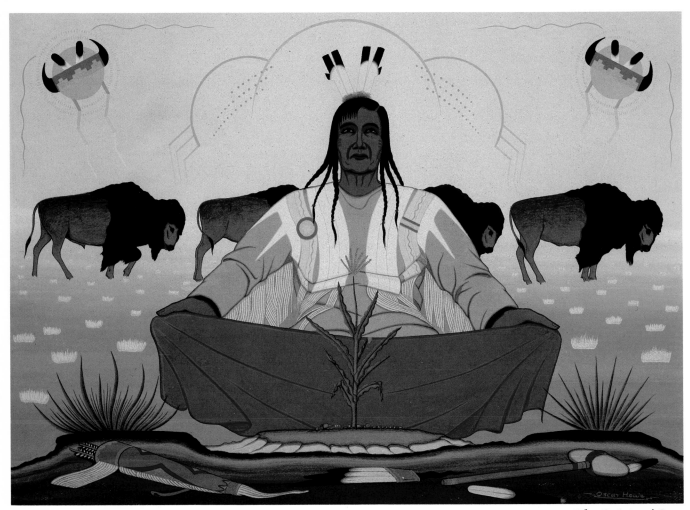

OSCAR HOWE

The Origin of Corn

mountain men, Indians, settlers, and the cowboy on the open range.

The tendency today to regard these artists almost solely in the light of their local or regional importance has caused many scholars to forego a more relevant examination of their reports as works of art. Only lately have they been treated seriously in academic circles. It might also be said that perhaps too much attention has been paid to a relatively few illustrators of the western scene despite the fact that many capable painters made significant contributions to our knowledge of the West, its people, and the drama of their lives.[23]

To the artist in the West, of whatever period, originality of concept was of less importance to his purpose than an observation of nature. Creativity was understood chiefly in terms of productivity. And while the artistic conventions of the time interfered with observation, the ability to represent the subject or view at hand as accurately as possible was the primary quality that distinguished the successful portraitist or draftsman in the field from the less able or successful one. The portfolio of the western artist was appreciated and judged by such standards. His reputation as an artist often rose or fell according to such judgments, however qualified.

Admittedly, no artist is or ever was an unequivocal realist. Art and nature are not the same. For all the attempts to render an accurate view or produce a believable report, the majority of the artists on the western frontier envisioned and perpetuated what we think of today as a romance: one that may well have been, in a personal sense, real enough to most of them.

In *Aesthetic Aspects of Ancient Art*, Robert Scranton has suggested that history represents the sum of many human observations and experiences, a vision of the past compiled from many different sources. He comments upon these varied sources and their importance as references when he states that for us, "Reality must include an awareness of the reality known to our ancestors."[24] Indicating that the ideas and ideals of former times are a part of that reality, he insists that it is therefore important for us to know what we can of the world as it has been perceived by people of other times and places. He identifies the arts as one of the channels through which such knowledge has come down to us when he concludes:

> To recapture the experiences of these visions of the past, there are perhaps various ways; but one, certainly, is through the arts in their various styles. For what do they mean when they speak of different styles, unless they mean different visions of the world?[25]

The American West of the nineteenth century is now beyond the range of our immediate experience. If we would see or picture or imagine it today, we must do so largely through the eyes of the artists who experienced it. Reporting this experience was itself a part of the experience, and the artist's perception of and preconceptions about the West greatly affected what each finally had to say about it.

FOOTNOTES

[1]Alan Moorehead, *Fatal Impact* (New York: Harper and Row, 1966), p. 48.

[2]Loyd Haberly, *Pursuit of the Horizon* (New York: The Macmillan Company, 1948), p. 61.

[3]Edwin James, *An Account of An Expedition from Pittsburgh to the Rocky Mountains*, 2 vols. (Philadelphia: Carey and Lea, 1823).

[4]Also with Peale on the Wilkes's expedition were fellow artists Alfred T. Agate and Joseph Drayton. Agate was working as an illustrator in New York City before joining Wilkes. After his return to the United States in 1842 he lived in Washington, D.C., where he prepared numerous sketches for publication in Wilkes's reports (1844-47). Drayton was employed as an engraver in Philadelphia when hired by Wilkes as an artist with the Pacific exploratory expedition. He also returned to Washington in 1842 to work with Agate on the preparation of illustrations for Wilkes's reports. Little else is known of his subsequent career.

[5]James Otto Lewis, *Aboriginal Port-folio*, in 10 parts (Philadelphia: Lehman and Duval, lithographer-publishers, 1835-36). This series was issued between May 1835 and February 1836. A complete set today includes three pages of advertisements and the ten original paper covers in which each folio was first published, with a total of eighty hand-colored lithographic plates reproducing Lewis's Indian portraits and related scenes.

[6]Thomas L. McKenney and James Hall, *History of the Indian Tribes of North America*, 3 vols. (Philadelphia: Edward C. Biddle, 1836-44). This featured 120 hand-colored lithographic reproductions of portraits of the principal chiefs and other members of tribes represented by biographies in the text. The majority of these illustrations were derived from originals by Charles Bird King. Peter Rindisbacher is represented by frontispiece illustrations in Volume One and Volume Two. Several other plates are after James Otto Lewis, who was also represented by pictures earlier appearing in McKenney's *Sketches of a Tour to the Lakes. . . and of Incidents Connected with the Treaty of Fond du Lac* (Baltimore, 1827). Original works by both Lewis and Rindisbacher are preserved at the Joslyn Art Museum on permanent loan from The InterNorth Art Foundation. Copies of King's portraits by Henry Inman, used in preparing the lithographic plates for McKenney and Hall's *History*, are found today at the Peabody Museum. An original oil by King, *Portrait of Shaumonekusse*, is included in the permanent collection of the Joslyn Art Museum.

[7]Harold McCracken, *Portrait of the Old West* (New York: McGraw-Hill Book Company, 1962), p. 46.

[8]James Otto Lewis, op. cit., p. ii.

[9]Thomas L. McKenney and James Hall, op. cit., Vol. One, p. iv. An original watercolor by Rindisbacher, *War Dance of the Winnebagoes*, is included in The InterNorth Art Foundation collection on permanent loan to the Joslyn Art Museum. It is similar to the illustration featured as the frontispiece to Vol. One referenced here.

[10]Maximilian Prince of Wied, *Travels in the Interior of North America*, trans. H. Evans Lloyd (London: Ackermann and Company, 1843), Author's Preface, p. vi. The first or German language edition of Maximilian's journal was issued at Coblenz under the title *Reise in das Innere Nord-Amerika in den Jahren 1832 bis 1834.* Its publication date is given as 1839-41, but final delivery was not made until 1843. A French edition appeared in the meantime. German and French editions were sold by subscription in a continuing series of twenty parts. The English edition was issued as a single volume. The picture atlas (bild-atlas) of eighty-one hand-colored aquatint engravings after Bodmer included thirty-three vignettes and forty-eight larger plates on Imperial Atlas folio paper. Respective titles on all plates were rendered in German, French, and English. First editions of the text and atlas, the original Maximilian journals, related manuscript material, and nearly 400 sketches and watercolors by Bodmer were discovered at Maximilian's ancestral estate near Coblenz at the end of World War II. In 1962 the bulk of this material was purchased by the then Northern Natural Gas Company of Omaha and deposited with the Joslyn Art Museum on permanent loan now from The InterNorth Art Foundation.

[11]Ibid.

[12]With explorer-artist Edward Kern, Eastman furnished most of the illustrations for Henry R. Schoolcraft's lengthy report, *Statistical Information Respecting the History, Condition and Prospects of the Indian Tribes of the United States* (Washington, 1851-60). Eastman also illustrated several books on the subject of American Indian life written by his wife, Mary Henderson Eastman.

[13]John James Audubon, *The Birds of America*, 7 vols., Royal 8vo (New York and Philadelphia: Audubon and Chevalier, 1840-44). The first edition of this famous work, issued in London in four double-elephant folio volumes between the years 1827-38, featured 435 hand-colored copperplate engravings after J. J. Audubon by Robert Havel and Son. A separate *Ornithological Biography* in five volumes was

issued at Edinburgh between 1831-39. In the above mentioned American edition, the number of plates was increased to 500 and issued together with the revised text of *Ornithological Biography.* The original plates were reduced in size by means of a Camera Lucida by John Woodhouse Audubon and lithographed by J. T. Bowen of Philadelphia.

[14]John James Audubon, *The Viviparous Quadrupeds of North America,* 2 vols. (New York: John James Audubon, 1845-48). Issued to subscribers in thirty parts of five plates each and without text, this series featured seventy-six plates after J. J. Audubon and seventy-four after J. W. Audubon, with assistance from Victor Gifford Audubon. It was lithographed, printed, and colored by J. T. Bowen of Philadelphia. A text was issued in three volumes, Royal 8vo, in New York by J. J. Audubon, J. W. Audubon, and the Reverend John Bachman between the years 1846-54. Both plates and text again were published together in three volumes by V. G. Audubon in 1854. This was the first complete edition of the text and plates reduced to Octavo size.

[15]Alfred Jacob Miller, "Rough Draughts for Notes to Indian Sketches," Sketch 37. This is an undated manuscript of 288 pages describing persons, scenes, and episodes of frontier life based upon the author's journey to the Rocky Mountains with Sir William Drummond Stewart in 1837. Internal evidence suggests that the manuscript was prepared after 1859. A similar manuscript with the sketches described is preserved in the collection of the Walters Art Gallery in Baltimore, Maryland. It was reproduced in large part in *The West of Alfred Jacob Miller* by Marvin C. Ross (Norman: University of Oklahoma Press, 1951; 2nd ed., 1968).

[16]Maximilian, Prince of Wied, op. cit., p. vii.

[17]Ibid., Translator's Preface, p. x-xi.

[18]Ibid., p. xi.

[19]Alfred Jacob Miller, op. cit., Sketch 39.

[20]Albert Campbell was with Lieutenant John Parke's survey of a connecting route between Los Angeles and San Francisco and also illustrated Parke's Fort Yuma-Rio Grande reports. Another artist, Carl Schuchard, joined an independent survey along the thirty-second parallel under the command of A. B. Gray. Thirty-two of his sketches illustrated Gray's published reports in 1856. Von Egloffstein, who also had been with Fremont's expedition in the fall of 1853, later accompanied E. G. Beckwith's survey out of Salt Lake City. Egloffstein's views of that part of the country appeared in Beckwith's reports as well as in those relating to Joseph C. Ives's survey of the Colorado River in 1858.

[21]The government did not employ artists in its exploration of the U.S.-Canadian border in 1872-75, although a military draftsman by the name of Downing produced some field sketches during this period. It was at the invitation of Major J. W. Twining, chief astronomer for the U.S. Northern Boundary Survey Commission, that New York illustrator William Cary joined the survey team on its return to Bismarck, North Dakota in 1874. Another artist active in the government's initial border surveys was Arthur Schott. Trained as an engineer, physician, and draftsman, Schott served as first assistant surveyor with William H. Emory's United States-Mexican Boundary Survey between 1849-55. He prepared some 226 drawings for publicaton in Emory's reports. Schott later resided in Washington and frequently contributed to the Smithsonian Institution's reports on the Rio Grande country of Texas between 1856-66. He is best known today for his bird prints and Indian portraits. Other artists who contributed to Emory's survey include John E. Weyss, who served for many years with western surveys under the War Department, and A. de Vaudricourt, who served as head of the party traveling from Indianola to El Paso, Texas. The first volume of Emory's reports, prepared under the direction of the Secretary of the Interior, featured illustrations by Schott, Weyss, and Vaudricourt, including a colored lithograph of "The Plaza and Church of El Paso," believed to be the earliest published view of this subject.

[22]Henry W. Elliott, who had accompanied Hayden on other western expeditions, was also a member of the 1871 Yellowstone survey along with two other photographers, J. Crissman of Bozeman, Montana and T. J. Hine of Chicago. Sanford R. Gifford, noted American landscape and portrait painter, also accompanied this survey, but his contribution here is uncertain. Surveys of the upper Columbia River system in 1881 and the Harriman Alaska expedition of 1899 employed several photographers, notably Edward S. Curtis, but no artists. The illustrations published in the subsequent reports of these expeditions were not considered as important as those associated with the earlier surveys of this type. Again John E. Weyss, who had contributed to the Emory reports, remained a government survey-artist until his death. He prepared for publication the *Report Upon United States Geographic Surveys West of the 100th Meridian* for George M. Wheeler of the U.S. Army Corps of Engineers (Washington, 1889).

[23]Historians have not always considered pictorial material in the same light as written references. One of the first to give his attention to the study of western art was David I. Bushnell, Jr., of the Smithsonian Institution's Bureau of American Ethnology, who as early as 1925 published the first of several

monographs for the Smithsonian's *Annual Report* on artists who portrayed Indian life in the West—in this instance, John Mix Stanley. The late Robert Taft of the University of Kansas, whose *Artists and Illustrators of the Old West, 1850-1900* first appeared in 1953, incorporated information on the pictorial history of the frontier previously featured in the *Kansas Historical Quarterly*. In the years since, the number of books on the subject of the artist in the West has greatly increased.

[24]Robert Scranton, *Aesthetic Aspects of Ancient Art* (Chicago: University of Chicago Press, 1964), p. 2.

[25]Ibid.

ARTISTS'
BIOGRAPHIES
& CATALOGUE
ENTRIES

BY DAVID C. HUNT

The following catalogue presents a selection of works from the permanent collection of the Joslyn Art Museum that can be readily identified as American western art. Brief biographical essays provide additional information about the artists associated with these works. Within such a category, specific inclusions and exclusions are sometimes difficult to make, and the cataloguer must ascertain in the process not only the origin or provenance of the works to be featured, but also the appropriate range of subjects depicted and the associated concepts expressed or implied.

Western art as an accepted category of American art generally lacks a formal definition based upon considerations of philosophy, style, or technique. In terms of theme or subject, it refers to or describes the American West. This reference or description may pertain to the West geographically, historically, or both. It can also encompass special interests such as ethnology or natural history insofar as these studies relate to the West.

Deciding who is or is not to be properly classified as a western artist, however, is often a matter for debate. Much of this centers upon the question of what is really meant by the West itself. The western frontier in North America was never a fixed place. Advancing steadily from the Atlantic seaboard to the Pacific coast, it continually changed in scope and character during the course of nearly four centuries of exploration and settlement. This fact presents difficulties for those who would like to be sure of their terms.

Identifying artists who were active in the trans-Mississippi West of the nineteenth century requires relatively little expertise, but one encounters problems of criteria in deciding to include in the western category some of those who earlier painted on the frontiers of New York or in the Ohio wilderness. Questions of exact classification also arise when considering the works of some of the more recent western regionalist painters and illustrators, although specific subject matter or an obvious historical connotation can serve as determining factors in examples where a western designation is in doubt.

The place of the American Indian artist within the traditional context of western experience remains to be clarified, as well as that of the modern landscape painter and wildlife artist. Not every landscape or wildlife painter today specializes in strictly western subjects, but the long standing association of untamed nature with the frontier West persists. Westerners in particular tend to accept any artist who describes wilderness scenes or animal subjects as a western artist, whether or not all representations of this kind are necessarily consistent with established western types.

In the present instance, all artists and works in the Joslyn's permanent inventory that can be identified with the frontier West of the nineteenth century have been included in this catalogue. Some but not all of the regionalist works at the Joslyn also have been listed. The Joslyn Art Museum owns more than sixty American regionalist works by some twenty-two painters. This group

constitutes an important body of work of interest for its own sake and deserves separate treatment. Regionalist works included here represent artists or works most clearly or closely associated with traditional western themes.

Overlooked by most observers in the nineteenth century, the American Indian artist has lately won a wider recognition among western scholars. Following centuries-old formal traditions familiar to ethnologists, the native artist in the West worked relatively unnoticed by his white counterpart, who characteristically painted Indian life from other than an Indian point of view. American Indian art developed fresh vitality in the twentieth century in adapting its imagery to a variety of modern media and techniques, and has achieved a distinction of its own within the larger category of contemporary American art. The Joslyn owns a significant collection of American Indian paintings. These have been incorporated into this catalogue with corresponding biographical sketches of the artists.

The depiction of traditional western scenes and subjects continues to the present time. In the opinion of its advocates, it is a legitimate activity expressing the character of western life drawn from both past and present experience. A strict student of western art might argue that modern representations of established themes cannot be accepted as original and are apt to be less than authentic. More liberal critics, nonetheless, will allow that the West was always as much a concept as an immediate reality, and that anything interpreting this concept is admissable under the broadest of definitions.

Portrayals of the wilderness and its native inhabitants occupied the earliest artist-adventurers on the Anglo-American frontier. Scenes of hunting in the West, pioneer life, and similar activities gained in popularity throughout the nineteenth century. They are still popular today. The bison or buffalo, the grizzly bear, and the western pony remain as enduring symbols of the American West, along with the Plains Indian, the mountain man, and the cowboy, providing seemingly inexhaustible inspiration for the painter, sculptor, writer, and filmmaker. Several contemporary or near contemporary artists of the Old West are represented in this list.

Not all works relating in theme or subject to the American West are important to history. Most of them serve well enough as examples of developments in American art. In revealing a world in time and place now lost to contemporary view, they reflect varied aspects of an earlier cultural heritage. As such they have more to convey to us than simply the particulars of the subject or event that they depict.

Yet it is the subject matter in western art that predominates. It is its regional association, not the period of its production, that defines it. The West was and still is what western art is all about; and regardless of background, training, or ability, very few of those who painted the West at any time endeavored to transcend the limits of its description.

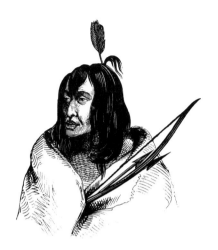

CATALOGUE ENTRY EXPLANATION

In citing dimensions, height precedes width.

Location of inscriptions is indicated
by the following abbreviations:
upper left	u.l.
upper center	u.c.
upper right	u.r.
lower left	l.l.
lower center	l.c.
lower right	l.r.

All works that are signed or inscribed are so noted.

KENNETH M. ADAMS

Dona Ascencione in Wicker Chair
Oil on canvas, 1927
30 x 30 in. (76.2 x 76.2 cm.)
Signed l.r.: Kenneth M. Adams
Gift of Mrs. Bertha Mengedoht-Hatz, 1947
1956.169

Provenance:
Kenneth M. Adams, Albuquerque, New
Mexico.
Mrs. Bertha Mengedoht-Hatz, Omaha,
Nebraska.

Literature:
The University Art Gallery, University of
New Mexico, *ADAMS/Kenneth M. Adams: A
Retrospective Exhibition*, 1964, no. 8, p. 17.

KENNETH M. ADAMS

Portrait of Mrs. Mengedoht
Oil on canvas
40 x 32 in. (101.6 x 81.3 cm.)
Signed l.l.: Kenneth M. Adams (in red paint)
Bequest of Mrs. Bertha Mengedoht-Hatz, 1963
1963.469

Provenance:
Kenneth M. Adams, Albuquerque, New
Mexico.
Mrs. Bertha Mengedoht-Hatz, Omaha,
Nebraska.

KENNETH M. ADAMS
1897-1966

Active as a teacher and professor of art at the University of New Mexico in Albuquerque for nearly twenty-five years, Kenneth Adams is represented today by works in museums throughout the United States and by mural commissions in a number of public buildings.

A native of Topeka, Kansas, Adams attended the Art Institute of Chicago following his service in the U.S. Army during World War I. He later studied at the Art Students League in New York City where he worked under Kenneth Hayes Miller, Maurice Sterne, and Andrew Dasburg.

After a period of study in Italy and France, Adams visited Taos, New Mexico in 1924 and became the last and youngest member of the Taos Society of Artists before its dissolution in 1927. He moved to Albuquerque in 1938, the same year that he was elected to associate membership in the National Academy of Design. He became a full member of the Academy in 1961.

Under the earlier influence of Dasburg, who had encouraged him to visit New Mexico, Adams experimented with cubism in an effort to formalize the basic realism he strove to achieve in the presentation of subject matter. Over the years he developed a distinctive style that is characterized by its simplicity of composition.

Paintings and lithographs by Kenneth Adams are included in many public and private collections, notably, the Los Angeles County Museum of Art, Dallas Museum of Fine Arts, The Whitney Museum of American Art, The Corcoran Gallery, and National Academy of Design. His mural paintings are found in federal buildings in Goodland, Kansas and Deming, New Mexico; the Colorado Springs Fine Arts Center; and the University of New Mexico Library.

Two portraits by Adams are included in the permanent collection of the Joslyn Art Museum.

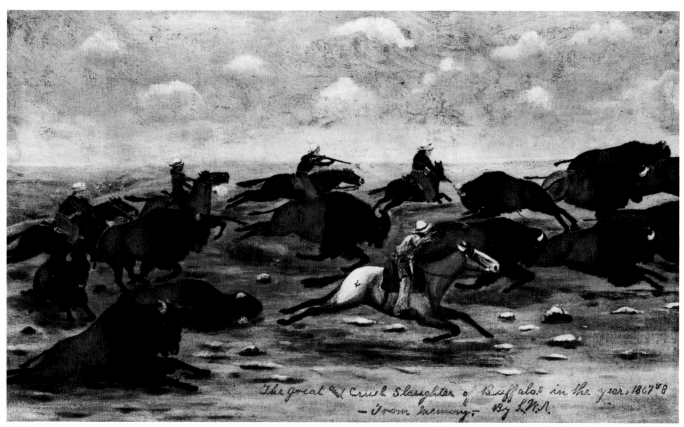

L. W. ALDRICH

The Great and Cruel Slaughter of Buffaloes

L. W. ALDRICH

The Great and Cruel Slaughter of Buffaloes
Oil on canvas
16 x 26 in. (40.6 x 66.0 cm.)
Inscribed l.r.: The Great and Cruel Slaughter of
Buffaloes in the Years 1867 & 8—From memory
—By L. W. A.
Permanent Loan, Omaha Public Library, 1948
794.3.1949

Literature:
William Rockhill Nelson Gallery of Art and
the Mary Atkins Museum of Fine Arts, *The Last
Frontier: An Exhibition of the Art of the Old
West*, 1957, no. 3, p. 25; Joslyn, *Life on the
Prairie: A Permanent Exhibit*, 1966 & 1969,
p. 15; *Pacific Northwest Quarterly*, "The
People Paint the Plains," April 1970, Vol. 61,
no. 2, p. 96; Amon Carter Museum of Western
Art, *The Bison in Art: A Graphic Chronicle of
the American Bison*, 1977, p. 117.

L. W. ALDRICH
n.d.

A Nebraska artist, probably self-taught, L. W. Aldrich
is known to have been living in Omaha as late as 1923.
Little else is known of his life or career, although something of his earlier history and experience in the West
may be deduced from the subject matter of his few
paintings that survive to the present time. He is represented in the Joslyn collection by a single oil painted,
according to its inscription, "from memory."

RALPH BARTON

Pony Express and First Mail Train
Oil on canvas panel, ca. 1920s
27 x 35¼ in. (68.6 x 89.5 cm.)
Signed l.l.: BARTON
Gift of the Chicago, Burlington & Quincy
Railroad, 1967
1967.332

Provenance:
Chicago, Burlington & Quincy Railroad,
Chicago, Illinois.

RALPH BARTON

Locomotives in the Night, ca. 1920s
Oil on canvas panel
27 x 46½ in. (68.6 x 118.1 cm.)
Gift of the Chicago, Burlington & Quincy
Railroad, 1967
1967.333

Provenance:
Chicago, Burlington & Quincy Railroad,
Chicago, Illinois.

RALPH BARTON
b. 1891

A native of Kansas City, Missouri, Ralph Barton pursued a successful career in commercial art in New
York City and Chicago during the 1920s and 30s and
illustrated for numerous magazines throughout this
period. With his contemporary, Frank Hoffman, who
is also represented in the Joslyn collection, Barton produced a number of pictures for the J. Walter Thompson Advertising Agency for promotional campaigns
of the Chicago, Burlington & Quincy Railroad. Two
such examples are included in the Joslyn inventory.
The American Art Annual from 1925 lists Barton as a
"painter, illustrator, and writer," and mentions that
he was a member of the Society of Illustrators in New
York City and the Guild of Free-Lance Artists.

ALBERT BIERSTADT
1830-1902

ALBERT BIERSTADT
Dawn at Donner Lake, California
Oil on canvas
21¼ x 29 in. (54.0 x 73.7 cm.)
Signed l.l.: ABierstadt
Gift of Mrs. C. N. Dietz, 1934
1934.13

Provenance:
Mrs. C. N. Dietz, Omaha, Nebraska.

Literature:
Goetzmann, *Exploration and Empire*, 1966,
p. 225; Joslyn, *Life on the Prairie: A Permanent
Exhibit*, 1966 & 1969, p. 34; Friends of the
Earth, Inc., *A Sense of Place: The Artist and the
American Land*, 1973, Vol. II, no. 308, p. 40;
Hendricks, *Albert Bierstadt: Painter of the
American West*, 1975, no. CL-142; Joslyn, *The
Growing Spectrum of American Art*, 1975, no.
10, p. 25; Joslyn, *Artists of the Western Frontier*,
1976, no. 7, p. 9.

ALBERT BIERSTADT
Valley of the Yosemite
Oil on canvas
14 x 19 in. (35.6 x 48.3 cm.)
Signed l.r.: ABierstadt
Gift of Mrs. C. N. Dietz, 1934
1934.14

Provenance:
Mrs. C. N. Dietz, Omaha, Nebraska.

Literature:
Hendricks, *Albert Bierstadt: Painter of the
American West*, 1975, fig. 105, p. 148; Joslyn,
Artists of the Western Frontier, 1976, no. 8,
p. 17.

ALBERT BIERSTADT
The Trappers, Lake Tahoe
Oil on canvas
19½ x 27¾ in. (49.5 x 70.5 cm.)
Signed l.r.: A. Bierstadt
Gift of Mrs. Harold Gifford, 1961
1961.430

Provenance:
Mrs. Harold Gifford, Omaha, Nebraska.

Literature:
The Mobile Art Gallery and The Birmingham
Museum of Art, *Art of the Old West*, 1974;
Hendricks, *Albert Bierstadt: Painter of the
American West*, 1975, no. CL-144; Joslyn,
Artists of the Western Frontier, 1976, no. 9, p. 9.

Born at Solingen, Westphalia, in the German Rhineland, Albert Bierstadt immigrated with his parents to New Bedford, Massachusetts in 1832. Determining at an early age to become a painter, he returned to Europe in 1853 to study art at the academy in Dusseldorf where he worked under Emanuel Leutze and acquired a taste for the grandiose style so characteristic of his later work.

After nearly four years abroad, Bierstadt returned to the United States and in 1858 accepted an invitation to accompany a western expedition under the command of Frederick West Lander to survey an overland wagon route from Fort Laramie, Wyoming to the Pacific Coast. Bierstadt spent much of 1858-59 in the Far West and in 1860 exhibited his first Rocky Mountain landscapes at the National Academy of Design in New York City. Recognition was immediate with his election to membership in the National Academy that same year.

Encouraged by his first success, he again ventured westward in 1863 and visited California. His subsequent views of the western wilderness became enormously popular and brought record prices. In 1866 he married and began construction of a palatial home and studio on the Hudson River near Irvington, New York. In 1872-73 he was again in California painting a notable series of large-scale views of the Sierras and Pacific coastal environs.

Until 1878 Bierstadt continued to travel extensively in the United States and in Europe where he received numerous decorations and awards. During this period he also produced pictures for the Capitol in Washington. Although spectacular, his popularity was relatively short-lived. In 1882 his studio on the Hudson burned and he opened another in New York City. It was about this time that gallery dealers, who preferred the work of French painters then coming into vogue, began handling fewer of Bierstadt's large landscapes.

In 1884 Bierstadt made one last trip to the Pacific coast. He began a series of paintings of the wild animals of North America in 1885. In 1889 a committee of New York artists, regarding Bierstadt's work as out of keeping with current artistic trends, refused to include his canvas, *The Last of the Buffalo*, in the forthcoming American Exhibit in Paris.

His wife Rosalie died in 1893. Bierstadt remarried

the following year and continued to paint his romantic western landscapes, which sold at much reduced prices until his death in New York City in 1902.

Today, there is an increasing interest in Bierstadt's work, numerous examples of which are widely scattered in collections throughout the United States and Europe. The permanent collection of the Joslyn Art Museum includes four paintings by Bierstadt, three of which depict western subjects or views. Twelve additional examples are on permanent loan to the Museum from The InterNorth Art Foundation.

EMIL J. BISTTRAM
b. 1895

Born in Hungary, Emil Bisttram immigrated as a child with his parents to New York City at the beginning of the present century. An interest in art manifested itself early, and Bisttram investigated every theory, school, technique, and teaching method available to him as a young man.

Attending the National Academy of Design, Cooper Union, and the New York School of Fine and Applied Art, he studied under such instructors as Ivan Olimsky, Leon Kroll, William Dodge, and Howard Giles. An interest in the theory of dynamic symmetry was acquired during this period from Jay Hambidge. A Guggenheim fellowship later enabled him to pursue mural painting under Diego Rivera in Mexico City.

Bisttram taught briefly at the School of Fine and Applied Art and at the Master Institute of United Artists, Inc. In 1930, while on a vacation, he visited Taos, New Mexico where he elected to remain and establish his reputation as a painter of local scenes and subjects.

Emil Bisttram is represented today in numerous collections throughout the United States. An early watercolor by this artist is included in the permanent collection of the Joslyn Art Museum.

EMIL J. BISTTRAM
Taos
Watercolor on paper, 1933
17 x 22½ in. (43.2 x 57.2 cm.)
Signed l.r.: Bisttram 33
Gift of George Barker, 1963
1963.626

Provenance:
George Barker, Pacific Palisades, California.

Literature:
Joslyn, *Artists of the Western Frontier*, 1976, no. 25, p. 37.

JOHN GUTZON de la MOTHE BORGLUM
Model for Proposed Pioneer Monument
Plaster
25 x 21 x 41½ in. (63.5 x 53.3 x 105.4 cm.)
Gift of Mrs. Robert Troyer, 1944
1944.80

Provenance:
Mrs. Robert Troyer, Omaha, Nebraska.

Literature:
Joslyn, *Artists of the Western Frontier*, 1976,
no. 124, p. 38.

JOHN GUTZON de la MOTHE BORGLUM
Staging in California
Oil on canvas, 1889
60 x 108 in. (152.4 x 274.3 cm.)
Signed and dated l.l.: 1889 J. G. Borglum
Gift of J. L. Brandeis & Sons, 1952
1952.93

Provenance:
Lininger Galleries, Omaha, Nebraska.
J. L. Brandeis & Sons, Omaha, Nebraska.

Literature:
Price, *Gutzon Borglum: Artist and Patriot*,
1961, p. 27; *Pictorial California and the Pacific*,
Winter 1965, Vol. XXXX, No. 1, p. 11; Johnson,
Sierra Album, 1971, pp. 66-67; Joslyn, *Artists of
the Western Frontier*, 1976, no. 33, p. 33.

JOHN GUTZON de la MOTHE BORGLUM
1867-1941

Born of Danish immigrant parents at a settlement on the Utah-Idaho border, John Gutzon Borglum grew up in Fremont, Nebraska, where his father had set up a medical practice. He attended high school at St. Marys, Kansas where his teachers soon recognized the young man's artistic talent and encouraged his efforts at drawing and painting. In 1884 the Borglums moved to Los Angeles, California. Seventeen years old at the time, Gutzon was anxious to pursue a career in art. After two years the family moved back to Nebraska without Gutzon, who stayed behind and enrolled in art classes in San Francisco taught by the western painter Virgil Williams. Borglum's early paintings portray western themes and subjects, such as his *Horse Thief* and *Staging in California*, now at the Joslyn Art Museum.

From the sales of these early works, he financed a trip to Paris where he studied at the Académie Julien and the Ecole des Beaux-Arts. Along with paintings, he exhibited a small bronze sculpture variously titled *The Fallen Warrior* or *Death of a Chief* at the Salon of 1891. The piece won him membership in the Société Nationale des Beaux-Arts. Returning home to the United States, he vigorously pursued a career as a sculptor. Both he and his younger brother Solon Borglum specialized in depictions of horses, Indians, frontier themes, and in portrait sculpture of famous American statesmen and personalities. An early bust of Abraham Lincoln by Gutzon, cut from a single six-ton block of marble, gained him widespread recognition and was later purchased for the Capitol Rotunda in Washington.

Gutzon's greatest effort, and probably his most widely known work, is the Mount Rushmore Memorial to Presidents Washington, Jefferson, Lincoln, and Theodore Roosevelt near Rapid City, South Dakota. An earlier commission to produce a memorial to the heroes of the Confederacy at Stone Mountain near Atlanta, Georgia had progressed fitfully, plagued by a lack of funding and interrupted by the advent of World War I. The head of General Robert E. Lee was completed in 1924, but Borglum abandoned the project the following year and turned his attention to the presidential memorial at Mount Rushmore, one of the oldest granite outcroppings on the continent. Work began there in 1927 upon a surface measuring some 400 x

1000 feet with a 300-foot perpendicular face. Borglum moved his family to the town of Keystone, some three miles from the site, in June of that year. Funds from a private memorial association were supplemented by government revenues when on Washington's birthday in 1929, Congress agreed to finance the further effort. The last work on the monument was done by Borglum's son Lincoln in October of 1941, approximately six months following his father's death from a heart attack.

Today, the presidential heads at Mount Rushmore, more than four stories in height, are viewed by thousands of visitors annually. It has been estimated that the figures, if fully carved from head to toe, would stand some 465 feet tall. Nearby, the Borglum studio on the Borglum Ranch is open to visitors on a seasonal basis and exhibits family memorabilia as well as models of Borglum's designs for the Stone Mountain Memorial at Atlanta, the Lincoln bust in the Capitol Rotunda, and other sculptural and architectural projects undertaken by Borglum during his lifetime. His *Three Apostles* may be seen at the Cathedral of St. John in New York City.

In 1958 the State of Georgia financed the Stone Mountain memorial and commissioned sculptor Augustus Lukeman to complete it. Finished in 1967, it is now the largest sculpture in the world, measuring 190 x 305 feet and higher than a thirty story building.

SOLON HANNIBAL BORGLUM
1868-1922

The fourth child of Danish immigrant parents, Solon Borglum was born at Ogden, Utah and as a child moved with his family to Fremont, Nebraska. He attended public school at Fremont and later studied at Creighton University in Omaha. During his teenage years, he worked on his father's ranch in northwestern Nebraska where he developed a keen interest in animals, anatomy, and drawing. His sketches attracted the admiration of his elder brother Gutzon when the latter returned from his studies abroad, and Solon was encouraged to pursue a career in art. In 1893 he joined Gutzon in California. Renting studio space in Santa Ana, he made his first mature studies of human figures among the Indians and Mexicans of the Santa Ana Mountains.

Upon achieving local success, he traveled eastward

SOLON HANNIBAL BORGLUM
Man on Horseback (On the Trail)
Bronze
14½ x 13 x 8 in. (36.8 x 33.0 x 20.3 cm.)
Inscribed on ground inside horse's left hind hoof: Solon H. Borglum/ c. 1900
Stamped on the rear of base: Roman Bronze Works, NY
Gift of Mrs. C. N. Dietz, 1934
1934.151

Provenance:
Mrs. C. N. Dietz, Omaha, Nebraska.

Literature:
Joslyn, *Life on the Prairie: A Permanent Exhibit*, 1966 & 1969, p. 27; Broder, *Bronzes of the American West*, 1975, no. 71, p. 78; Joslyn, *Artists of the Western Frontier*, 1976, no. 125, p. 38.

48

SOLON HANNIBAL BORGLUM
New Born or *Just Born*
Bronze
4 x 6 x 2 in. (10.2 x 15.2 x 5.1 cm.)
Inscribed at right on base: Solon H. 1900 c; at
left: Roman Bronze Works NY
Gift of Mrs. C. N. Dietz, 1934
1934.296

Provenance:
Mrs. C. N. Dietz, Omaha, Nebraska.

Literature:
Broder, *Bronzes of the American West*, 1975,
no. 66, p. 76.

SOLON HANNIBAL BORGLUM
Our Slave
Marble, 1901
16 x 38¼ x 15¾ in. (40.6 x 97.2 x 40.0 cm.)
Listed in Copyright Office, Library of Congress,
1902
Gift of the artist's children, Monica B. Davies
and Paul A. Borglum, 1959
1959.13

Provenance:
Paul A. Borglum, New Canaan, Connecticut
and Monica B. Davies, Wilton, Connecticut.

in 1895 to seek further instruction at the Cincinnati Academy of Art. During this period he reputedly spent a great deal of his time sketching mounts at the nearby U.S. Mail stables. His clay figures of horses received the praise of Louis Rebisso, head of sculpture at the Academy, who thereafter allowed the young Borglum the use of his own studio. A trip to Paris followed. At the Academie Julien, he received further encouragement from fellow sculptor Alexander Phimister Proctor.

Borglum married in Paris in 1898. He continued producing western sculptures, mostly horses, which were widely exhibited and acclaimed. Commissioned to produce pieces of this type for the Paris Exposition of 1900, he returned to the American West to make firsthand studies of horses and Indians, arriving at the Crow Creek reservation in South Dakota in 1899. With the help of a local Episcopalian missionary, Borglum obtained many Indian models and also acquired considerable knowledge of native customs and ceremonials. Borglum and his wife eventually settled at Silvermine, Connecticut in 1907 and there established a permanent studio.

Although his reputation was largely overshadowed by the monumental works of his elder brother, Solon Borglum created numerous life-size pieces for expositions and civic monuments expressive of the character and spirit of pioneer life in the American West. He is represented today by important public sculptures at Prescott, Arizona; Atlanta, Georgia; and New Rochelle, New York. Among his most notable works found in collections throughout the United States are *Lassoing Wild Horses*, first exhibited at the Paris Salon of 1898; *On the Border of the White Man's Land*, now at The Metropolitan Museum of Art in New York City; *One in a Thousand; On the Trail; Burial on the Plains; Pioneer in a Storm;* and *The Intelligent Bronco.* Borglum also organized the School of American Sculpture in New York City and served as its director until his death in 1922.

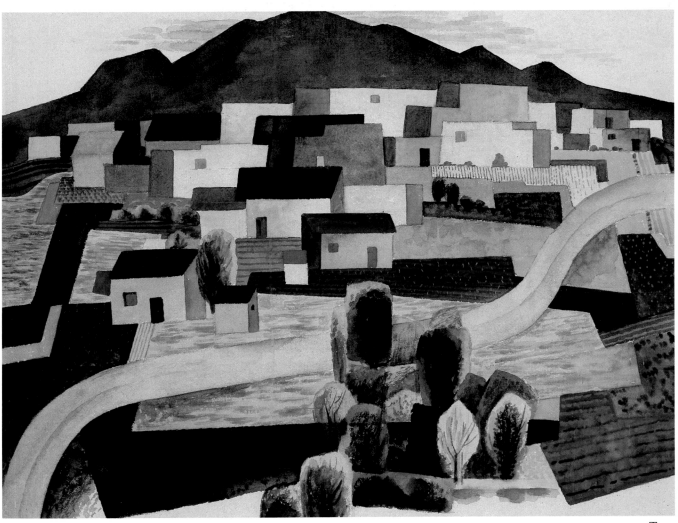

EMIL J. BISTTRAM *Taos*

GEORGE CATLIN
Indian Buffalo Hunter
Oil on board
9 x 12 in. (22.9 x 30.5 cm.)
Signed on verso: "With compliments—Geo. Catlin"
Purchase, 1953
1953.251

Provenance:
M. Knoedler & Co., Inc., New York.

Literature:
Joslyn, *CATLIN, BODMER, MILLER: Artist Explorers of the 1830's*, 1963 & 1967, p. 11; Joslyn, *Life on the Prairie: A Permanent Exhibit*, 1966 & 1969, p. 10.

GEORGE CATLIN
Buffalo Hunt
Oil on canvas
19 x 26½ in. (48.3 x 67.3 cm.)
Signed l.r.: Catlin
Gift of W. F. Davidson, 1966
1966.621

Provenance:
M. Knoedler & Co., Inc., New York.
W. F. Davidson, New York.

Literature:
Truettner, *The Natural Man Observed: A Study of Catlin's Indian Gallery*, 1979, no. 407a, p. 257.

GEORGE CATLIN
Buffalo and Grizzly Bear Fight
Oil on canvas
19 x 26½ in. (48.3 x 67.3 cm.)
Signed l.r.: Catlin
Gift of W. F. Davidson, 1966
1966.622

Provenance:
M. Knoedler & Co., Inc., New York.
W. F. Davidson, New York.

GEORGE CATLIN
Mandan Chief Mah-To-Toh-Pah
Watercolor on board, 1851
16 x 20¾ in. (40.6 x 52.7 cm.)
Signed and dated l.c.: G. Catlin 1851
Gift of W. F. Davidson, 1966
1966.623

Provenance:
M. Knoedler & Co., Inc., New York.
W. F. Davidson, New York.

Literature:
Joslyn, *CATLIN, BODMER, MILLER: Artist Explorers of the 1830's*, 1963, p. 8, 1967, p. 5;

GEORGE CATLIN
1796-1872

Trained as a lawyer, the profession he abandoned for a career in art, George Catlin was born at Wilkes-Barre, Pennsylvania and received his first instruction in painting at Philadelphia in 1821. Afterward specializing in portraiture and the production of miniatures, he became interested in the American Indian and made his first known Indian portrait of the Seneca orator Red Jacket at Buffalo, New York in 1826.

Desiring to paint among the tribes of the Far West in their native environment, Catlin set out for St. Louis in 1830 to explore the trans-Mississippi wilderness. During the summer of 1832, he traveled more than 4,000 miles round trip to Fort Union on the upper Missouri and made numerous and extensive studies of that region and its inhabitants. Continuing throughout the next four years to make periodic excursions into Indian country, he returned again to the East in 1836 to prepare his collection of aboriginal scenes for exhibition. At the urging of a friend who had accompanied one of his western tours, Catlin took his collection abroad and opened an exhibition in London in 1840 at the Egyptian Hall in Piccadilly. There it remained for the next five years.

While in London, Catlin lectured widely and published the first edition of his *Letters and Notes on the Manners, Customs and Condition of the North American Indians* (2 vols., 1841) and *North American Indian Portfolio* (1844), featuring twenty-five lithographic reproductions of subjects from his North American Indian Gallery. Following an exhibition in Paris at the invitation of King Louis Philippe, Catlin returned to England and published yet another narrative entitled *Eight Years Travel and Residence in Europe* (2 vols., 1848) as a sequel to his *Letters and Notes*. During this period, his wife and young son both died abroad, leaving Catlin with three small daughters to support.

Beset by chronic indebtedness, Catlin lost his Indian collection to creditors in 1852. Entrusting the care of his remaining children to a brother-in-law in the United States, he continued to travel, publish, and paint, making at least three excursions to South America and a visit to North America west of the Rockies between the years of 1853 and 1860. He eventually rented a studio in Brussels where he produced another series of paintings from sketches obtained during his

American Studies, "George Caleb Bingham as ethnographer; a variant view of his genre works", Fall 1978, Vol. XIX, No. 2, p. 46.

GEORGE CATLIN
A Prairie Picnic Disturbed by a Rushing Herd of Buffalo
Oil on canvas, 1854
18¾ x 26½ in. (47.6 x 67.3 cm.)
Signed and dated l.r.: Catlin 1854
Gift of Mr. Carman H. Messmore, 1966
1966.624

Provenance:
M. Knoedler & Co., Inc., New York.
Mr. Carman H. Messmore, New York.

Literature:
McCracken, *George Catlin and the Old Frontier*, 1959, p. 123; Felton, *Edward Rose, Negro Trail Blazer*, 1967, insert following p. 48; Joslyn, *The Growing Spectrum of American Art*, 1975, no. 15, p. 29; Truettner, *The Natural Man Observed: A Study of Catlin's Indian Gallery*, 1979, no. 584, p. 306.

GEORGE CATLIN
Buffalo Hunt, Upper Missouri
Oil on canvas, 1854
19 x 26½ in. (48.3 x 67.3 cm.)
Signed and dated l.r.: Catlin 1854
Gift of Mr. Carman H. Messmore, 1966
1966.625

Provenance:
M. Knoedler & Co., Inc., New York.
Mr. Carman H. Messmore, New York.

Literature:
McCracken, *George Catlin and the Old Frontier*, 1959, p. 126.

EANGER IRVING COUSE
Hunter in the Aspens
Oil on canvas, ca. 1904
24 x 29 in. (61.0 x 73.7 cm.)
Signed l.l.: E. I. Couse
Gift of Mrs. C. N. Dietz, 1934
1934.22

Provenance:
Mrs. C. N. Dietz, Omaha, Nebraska.

Literature:
C. M. Russell Gallery, *The Russell Years*, 1969, no. 6; Joslyn, *Artists of the Western Frontier*, 1976, no. 40, p. 24.

later travels as well as from earlier studies pertaining to the Indians of the trans-Mississippi West.

In 1870 Catlin returned to the United States after an absence of nearly thirty-two years and exhibited at the Smithsonian Institution in Washington at the invitation of its director, Joseph Henry, who allowed Catlin the use of his offices as a temporary studio. Having long dreamed of selling his Indian collection to the U.S. Government, Catlin died in Jersey City, New Jersey at the home of a daughter not knowing that his North American Indian Gallery would become one of the nation's prized possessions.

Endlessly copying his work for exhibition or sale to private patrons, Catlin produced two distinct collections of approximately 600 pictures each relating to his experiences among the Indians in the West, the second being the so-called "cartoon" collection based upon the original exhibited abroad in the 1840s. Today, the largest inventory of his work is found at the National Museum of American Art, formerly the National Collection of Fine Arts, at Washington, D.C. Another significant collection is owned by the Thomas Gilcrease Institute of American History and Art in Tulsa, Oklahoma. The Joslyn Art Museum lists six works by Catlin in its catalogue of the permanent collection, all of which are later versions of original paintings now in Washington. Three additional works are on permanent loan to the Museum from The Inter-North Art Foundation. Also of interest is a set of hand-colored lithographic plates from *Catlin's North American Indian Portfolio* published in London in 1844.

EANGER IRVING COUSE
1866-1936

Born in Saginaw, Michigan, the son of a hardware merchant, E. I. Couse exhibited a talent for art and began his formal training at the Chicago Art Institute at the age of seventeen. Following a brief period at the Art Students League in New York City, he went abroad for further study and spent approximately ten years in Paris where he was a frequent exhibitor at the Paris Salon. During this time he was largely influenced by William Adolphe Bouguereau, his principal instructor and a master of technique, from whom Couse learned the principles of composition. While studying in France, Couse met Virginia Walker, another American art student, whom he married in 1889.

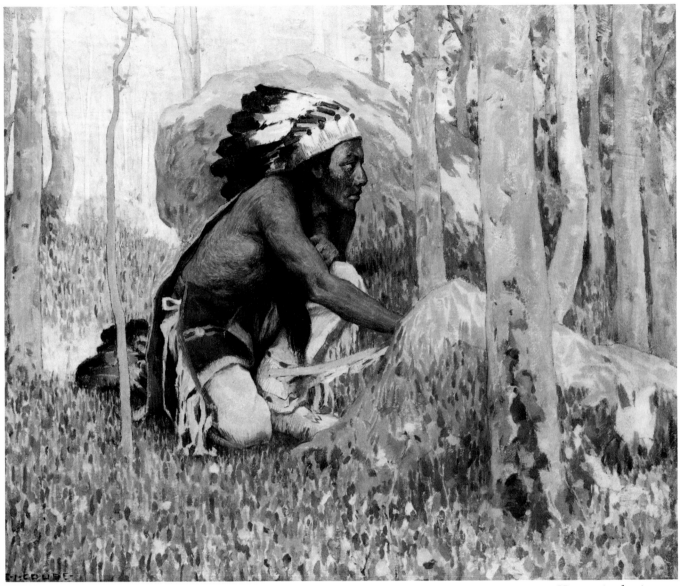

EANGER IRVING COUSE

Hunter in the Aspens

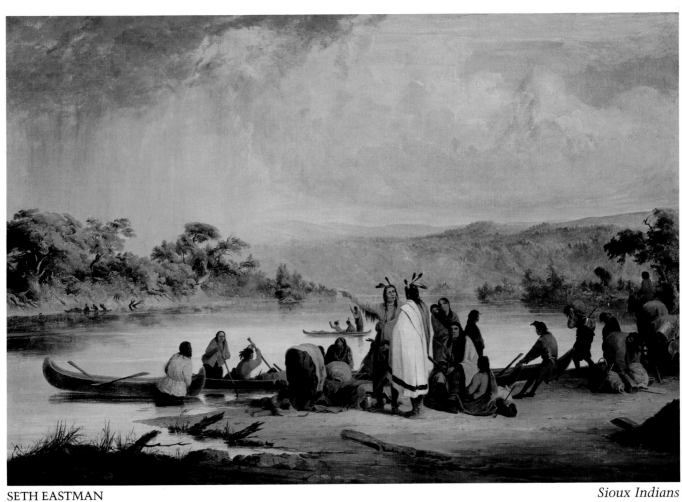

SETH EASTMAN

Sioux Indians

Returning to the United States, Couse and his wife visited her father at his sheep ranch near Arlington, Oregon, and thereafter spent several summers in Oregon between trips to New York and Paris. During one of these subsequent trips abroad, Couse met fellow American artist, Joseph Henry Sharp, who described for Couse the beauty of the primitive environment in and around Taos, New Mexico and encouraged him to see it for himself. Couse visited Taos in 1902 and returned to New Mexico for several summers afterward. He established a permanent studio there in 1909, although he continued to maintain his studio in New York City where he spent his winters developing paintings of the American Southwest from studies obtained at Taos.

Couse enjoyed widespread respect among the artists of his day and his life was highlighted by a succession of awards, commissions, and important sales. His standing in New York art circles enabled him to advance the cause of the growing group of artists at Taos when the Taos Society of Artists was formed in 1912. He was its first president and most successful member for over twenty years. The Indians of Taos furnished Couse with his chief subject matter and he painted them with great sensitivity and attention to detail. He was also one of the few artists of the time permitted to observe and record sacred and exclusive native rituals and ceremonials firsthand.

Couse was elected to membership in the National Academy of Design in 1911 and was offered its presidency on more than one occasion over the next several years. At the time of his death in Albuquerque in 1936, he was perhaps the best known of all the Taos artists with the possible exception of Sharp. Today he is represented in almost every important American museum and examples of his work are widely exhibited. The Santa Fe Railway, one of Couse's biggest patrons during his lifetime, still features reproductions of his paintings on calendars and advertisements, and his work continues to be in great demand among collectors.

FELIX OCTAVIUS CARR DARLEY
1822-1888

FELIX OCTAVIUS CARR DARLEY
Indian Pursuit
Sepia watercolor on paper
9⅛ x 11½ in. (23.2 x 29.2 cm.)
Signed in pencil, left margin: "Mrs. Ames. From her friend F. O. Darley"
Purchase, 1951
1951.17

Provenance:
Kennedy & Co., New York.

Probably the best known book illustrator in America during the first half of the nineteenth century, F. O. C. Darley was born at Philadelphia, the son of English comedian John Darley. Having shown a talent for drawing at an early age, he was apprenticed in his teens to a mercantile firm in Philadelphia in the hope that he might develop an interest in business. His interest in art eventually prevailed when he succeeded in bringing his studies of local firemen and city life to the attention of Philadelphia publishers, who gave Darley continual employment for the next several years.

Although Darley published *Scenes of Indian Life* in 1843, it is not known if he ever visited the trans-Mississippi West. In 1848 he moved to New York City where he achieved considerable success illustrating a series of books by Washington Irving, including *Rip Van Winkle* (1949), *The Legend of Sleepy Hollow* (1849), and *A History of New York . . . by Diedrich Knickerbocker* (1850). Completion of this series placed him in the front rank of the commercial designers of his day.

By far his most popular series of illustrations was done for the monumental *Works of James Fenimore Cooper*, issued over a period of years in thirty-two volumes featuring more than 500 engravings after Darley. Crayon copies of some of these were exhibited in 1858 at the National Academy of Design, where Darley had first exhibited thirteen years earlier, having become a member of that body in 1852. He later illustrated other works by Irving and an edition of Longfellow's epic poem, *The Courtship of Miles Standish*, in 1858-59.

Darley married in 1859 and moved to Claymont, Delaware, where he continued work on the volumes of Cooper and also illustrated editions of the works of Charles Dickens. In the 1860s he produced some Civil War subjects which are largely overlooked today. In the summer of 1866, he visited Europe for the first time. Upon his return home to the United States, he published an edition of his letters and European studies in *Sketches Abroad with Pen and Pencil* (1867). In 1879 he again exhibited at the National Academy a series of twelve pictures entitled "Compositions in Outline from Hawthorne's Scarlet Letter."

Original examples of Darley's work have become

collector's items and are now found in a number of museum collections. The Joslyn Art Museum owns one such illustration. Eleven similar works by this artist are on permanent loan to the Museum from The InterNorth Art Foundation.

SETH EASTMAN
1808-1875

A professional soldier and experienced topographical draftsman, Seth Eastman pursued a career in art in conjunction with his military service. A native of Brunswick, Maine, he was appointed to the U.S. Military Academy at West Point in 1824 and graduated four years later as a second lieutenant. Assigned to duty on the western frontier, he first served at Fort Crawford, Wisconsin on the Upper Mississippi in 1829-30, and afterward at Fort Snelling, Minnesota where he engaged in a topographical reconnaissance of the surrounding region.

In January of 1833, he was reassigned to the teaching staff at West Point as an assistant drawing instructor, a position he held until 1840. Returning to active duty that year, he served briefly in the Seminole War in Florida and was again at Fort Snelling as a captain in 1841. During his second stay at Fort Snelling he was joined by his wife, Mary Henderson Eastman, and their three children. At this time Eastman began to apply himself more seriously to recording frontier scenes and activities, especially Indian life, and made numerous studies that formed the basis for much of his later work.

Following a tour of duty in Texas in 1848-49, Eastman was ordered back to Washington where he turned his attention to painting. With his wife, a noted author in her own right, he collaborated on several books on Indian subjects, the first being entitled *Dakotah: Life and Legends of the Sioux* (1849). At about this time Eastman was chosen to prepare illustrations for Henry Rowe Schoolcraft's lengthy *Historical and Statistical Information Respecting. . .the Indian Tribes of the United States*, issued in six volumes in Washington between the years of 1851 and 1857-60. After serving for another period of time in Texas and at the office of the Quartermaster General in Washington, Eastman retired a brevet brigadier general in 1867. His last years were spent in Washington where he was commissioned

SETH EASTMAN
Sioux Indians
Oil on canvas, 1850
26⅜ x 38½ in. (67.0 x 97.8 cm.)
Signed and dated l.r.: S. Eastman 1850
Purchase, 1946
1946.27

Provenance:
Harry Shaw Newman Gallery, New York.
Old Print Shop, New York.

Literature:
McDermott, *The Art of Seth Eastman*, 1959, Fig. 1, no. 33, frontispiece; Spaeth, *American Art Museums and Galleries: An Introduction to Looking*, 1960, p. 167; McDermott, *Seth Eastman: Pictorial Historian of the Indian*, 1961, plate 6, opp. p. 64; Birmingham Museum of Art, *The Opening of the West*, 1963; Joslyn, *Life on the Prairie: A Permanent Exhibit*, 1966 & 1969, p. 14; Fronval, La *veritable histoire des Indiens Peaux-Rouges*, 1973, pp. 38-39; Joslyn, *Artists of the Western Frontier*, 1976, no. 43, p. 33; Hassrick, *The Way West: Art of Frontier America*, 1977, p. 55.

by Congress to execute a series of frontier scenes for the Senate and House chambers of the Capitol complex.

In addition to his government paintings, Eastman is represented today in a number of museum collections, principally at the Smithsonian Institution and the Corcoran Gallery of Art in Washington; the Minneapolis Institute of Art; the Thomas Gilcrease Institute of American History and Art in Tulsa, Oklahoma; and the Stark Museum of Art in Orange, Texas. The Joslyn Art Museum lists one painting by Eastman along with various related documentary material. Four works by this artist are on permanent loan to the Joslyn from The InterNorth Art Foundation.

ELLING WILLIAM GOLLINGS
1878-1932

E. W. "Bill" Gollings was born in Idaho and moved to Chicago with his parents when he was twelve years old. His first drawing experience in public school encouraged further interest in art, which he eventually pursued with only a minimum of formal instruction.

Upon graduation from the eighth grade, he worked at various jobs and from about 1893 to 1903 traveled about the West, occasionally working as a ranch hand in South Dakota. A great admirer of Frederic Remington, whom he later met and corresponded with, Gollings attempted a few western paintings of his own, but otherwise seems to have given little serious thought to art as a possible career.

In 1903 a furniture dealer in Sheridan, Wyoming bought several of his pictures. Thereafter, he started painting in earnest while living at a brother's ranch in the area and breaking horses as a part-time occupation. He returned to Chicago with the intention of studying art, but only stayed for a few months in the city. Longing to return to the West, he sold a painting and bought a train ticket back to Wyoming. By 1909 he devoted himself increasingly to the depiction of the life of the western cowboy, stockman, and ranching activities of the period. Currently, the majority of his work remains in private collections.

ELLING WILLIAM GOLLINGS
Hell in the Timber
Oil on canvas, 1905
19 x 13 in. (48.3 x 33.0 cm.)
Signed and dated l.l.: Gollings '05
Gift of Alvin F. Bloom, 1955
1955.265

Provenance:
Alvin F. Bloom, Omaha, Nebraska.

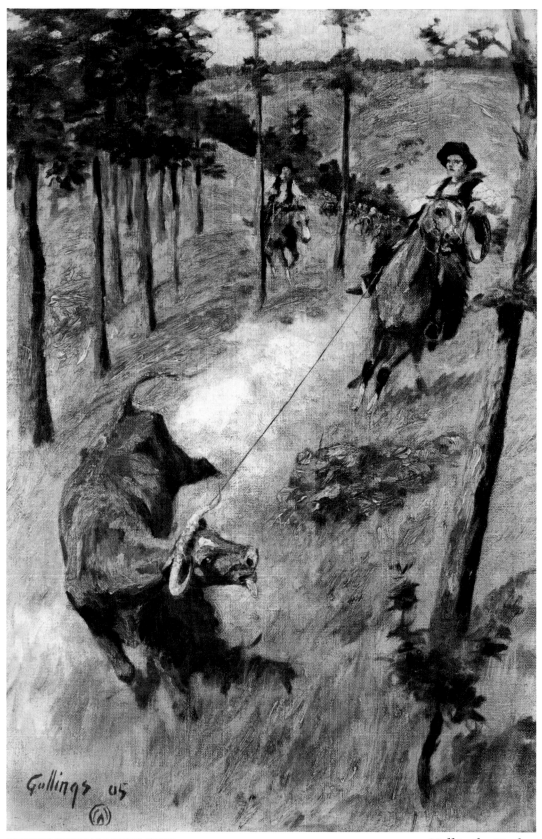

ELLING WILLIAM GOLLINGS · *Hell in the Timber*

CHARLES GRAHAM
1852-1911

CHARLES GRAHAM
Plains Indian Tipis
Watercolor on paper, 1885
5⅞ x 13⅛ in. (14.9 x 33.3 cm.)
Signed and dated l.l. in red: C. Graham '85
Gift of Mrs. D. D. Ashton, 1961
1961.503

Provenance:
Mrs. D. D. Ashton, Omaha, Nebraska.

Born at Rock Island, Illinois, Charles Graham seems to have had little formal art training before joining a topographical survey as a draftsman for the Northern Pacific Railroad under General T. L. Rosser about 1873. He later worked as a scenic artist in Chicago and New York City before joining the staff of *Harper's Weekly* in 1877.

Biographical information on this artist varies slightly according to the source, with some references mentioning that he began his professional career as a scenic painter for Hooley's Theatre in Chicago. According to a daughter, he had his first experience in the West in 1874 as a member of Villard's surveying expedition for an extension of the Northern Pacific Railroad into Montana and Idaho, but no reliable documentation exists to support this statement.

Some confusion also exists as to the exact date of his excursion with Rosser's survey, but it was probably during or shortly before 1873, the same year that the failure of Jay Cooke and Company, financial agents for the railroad, resulted in the suspension of all further construction on the Northern Pacific line until 1876. The survey in question was conducted through the State of Montana, and Graham later attended ceremonies marking the railroad's completion west of Helena on September 22, 1883.

Until hired by *Harper's Weekly*, he seems to have made his living in New York City painting theatre curtains and stage props. While working for *Harper's*, he became one of the most frequently published artists of the day. Also associated with *Harper's* at this time were better known western illustrators such as Frederic Remington, Rufus Zogbaum, and cartoonist William Allen Rogers. Between about 1880-89, Graham contributed over 120 illustrations to the magazine, more than any of the above-named artists.

Graham left *Harper's* in 1892 to serve as an official artist for the World Columbian Exposition in Chicago. Afterward he turned to free-lance illustration. He resided in San Francisco between 1893 and 1896 before returning once again to New York City. He began painting full-time, mostly in watercolor, and exhibiting frequently in the annual shows of the American Water Color Society until around 1900, when he turned to oil painting. Many of his western subjects were reproduced for commercial distribution by the American Lithography Company.

ALEXANDER F. HARMER
1856-1925

A native of Newark, New Jersey, Alexander Harmer exhibited an interest in drawing as a child and eventually turned to art as a full-time career. Enlisting in the U.S. Army in 1872 and again in 1881, he saw service in the frontier West. In the late 1870s between periods of enlistment, he studied at the Philadelphia Academy of Fine Arts, and afterward distinguished himself as a painter of western scenes and subjects.

Published illustrations by or after Harmer relating to the Apache wars in the Southwest appeared in *Harper's Weekly* in the summer of 1883. Others were featured in Army officer and ethnologist John Gregory Bourke's *The Snake-Dance of the Moquis of Arizona* (1884) and *An Apache Campaign in the Sierra Madre* (1886). Many of these were derived from sketches made on the spot or from drawings by Bourke during the period in question. These and similar notes and sketches served as the basis for many of Harmer's subsequent oil paintings and watercolors.

After 1890 Harmer turned his attention to the rapidly changing life of the old Spanish missions in California and to the mission Indians of the area. Devoting himself almost entirely to this subject, he spent his last years at Santa Barbara, California where he died in 1925.

Works by Harmer are found in both public and private collections. The Joslyn Art Museum owns an oil painting by this artist in addition to a collection of fourteen small ink drawings of Indian subjects, some of which appeared in publication, included in a donation of material relating to Bourke.

ALEXANDER F. HARMER
Capt. Bourke Dressed as Indian Snake Dancer
Oil on canvas, 1883
12 x 8¼ in. (30.5 x 21.0 cm.)
Signed and dated l.l.: A. F. Harmer '83
Gift of Mrs. A. H. Richardson, 1956
1956.96

Provenance:
Mrs. A. H. Richardson, Washington, D.C.

JOHN HAUSER
1859-1913

The son of a German cabinet maker, John Hauser was born in Cincinnati, Ohio. He showed an early aptitude for art and was sent for instruction to the Ohio Mechanic's Institute and later studied at the Cincinnati Art Academy and the McMicken Art School. In 1880 he went abroad to study at the Royal Academy of Fine Arts in Munich under Nicholas Gysis. Returning to Cincinnati, he taught drawing in the public schools for a brief period of time before returning to Europe for

JOHN HAUSER
Looking at the Past
Gouache on panel, 1902
19 x 12 in. (48.3 x 30.5 cm.)
Signed and dated l.r.: John Hauser, 1902; l.l.:
Pine Ridge, S.D.
Purchase, 1967
1967.385

Provenance:
W. E. Donaldson, China Lake, California.

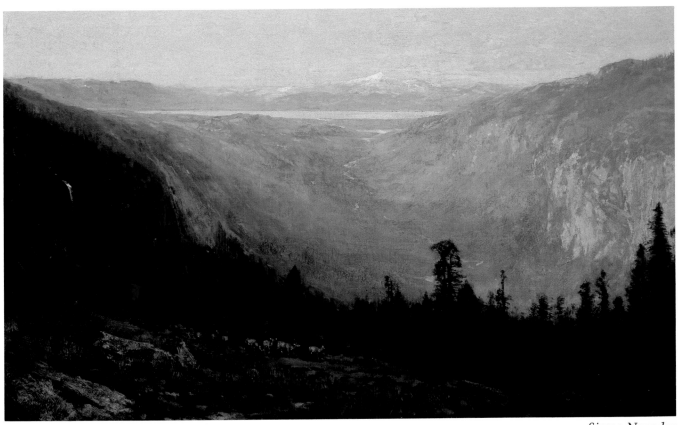

THOMAS HILL

Sierra Nevadas

further training in Munich, Dusseldorf, and lastly Paris at the École des Beaux Arts.

Returning home again to the United States in 1891, Hauser made a visit to New Mexico and Arizona where he became fascinated with the local Indian cultures. For the next several years, he made annual trips to various western reservations to paint Indian subjects and portraits. His sympathy for aboriginal life gained him the trust of his models, and in 1901 both he and his wife Minnie were formally adopted into the Sioux tribe.

Hauser was one of the founders of the Cincinnati Art Club and a member of the Cincinnati Art League. He is chiefly remembered today for his American Indian painting, to which he devoted the last twenty years of his life.

THOMAS HILL
1829-1908

Landscape painter Thomas Hill, a native of Birmingham, England, immigrated with his family to the United States about 1840 and grew up in Taunton, Massachusetts. He reportedly began his career in art as a decorative painter in Boston around 1844. He later studied at the Pennsylvania Academy of Fine Arts and in 1853 was awarded a first medal at the Maryland Institute of Art in Baltimore. In 1861 he traveled to California and worked for about four years in San Francisco, where in 1865 he won another first prize in painting in the San Francisco Art Union exhibition.

Hill studied briefly in Paris in 1866-67 but returned to the United States and lived in Boston until the early 1870s. He then moved back again to California where he resided for the next thirty years, traveling widely throughout the West and depicting the grand scenery of the Sierras and Pacific coastal areas for which he is best known today.

Although he earlier distinguished himself as a painter of genre and still life subjects, Hill became best known for his large-scale landscapes of Yosemite, Yellowstone, the Grand Canyon, Donner Lake, and other areas of the scenic West. Many of these are now in the collection of the Oakland Museum in Oakland, California. One of his largest canvases, depicting not a landscape but a historical subject, is entitled *The Last Spike*. Measuring 8 x 11 feet, it was painted to commemorate the completion of the first transcontinental

THOMAS HILL
Mountain Scene
Oil on canvas, 1892
113½ x 73¼ in. (288.3 x 186.1 cm.)
Signed and dated l.l.: T. Hill 1892
Gift of Friends of Art Collection, 1932
1932.13

Provenance:
Friends of Art Collection, Omaha, Nebraska.

THOMAS HILL
Sierra Nevadas
Oil on canvas, 1879
18 x 30 in. (45.7 x 76.2 cm.)
Signed and dated l.r.: T. Hill 1879
Gift of E. A. Kingman, 1956
1956.333

Provenance:
E. A. Kingman, Omaha, Nebraska.

Literature:
Friends of the Earth, Inc., *A Sense of Place: The Artist and the American Land*, 1973, Vol. II, no. 341, p. 39; Joslyn, *Artists of the Western Frontier*, 1976, no. 47, p. 18.

railroad at Promontory Point, Utah in 1869 and now hangs in the California State Capitol in Sacramento.

Hill experienced the same ups and downs in his career as most of his contemporaries, initially realizing great success in terms of commissions until the change in style and taste among critics and patrons alike brought about a marked decline in the sale of grandiose scenic views. Almost forgotten during the latter decades of his life, he continued painting his western landscapes until his death at Raymond, California in 1908. Interest in his work has only recently revived, with the first important retrospective of his work organized by the Oakland Museum in 1980.

A younger brother Edward (1843-1923) also spent several years in the West, chiefly in and around Denver, Colorado, where he exhibited occasionally between 1880 and 1905.

FRANK B. HOFFMAN
1888-1958

Born in Chicago and reared in New Orleans where his father raised and trained race horses, Frank Hoffman began drawing horses at his father's racing stables at an early age. Through the efforts of a friend of the family, he later secured a job as an illustrator with *The Chicago Daily American* and eventually became head of the newspaper's art department. During this period he studied privately with J. Wellington Reynolds, noted portrait and figure painter.

Rejected from military service for health reasons at the outbreak of World War I, Hoffman decided to travel in the West and see the country. Arriving in Montana, he worked as a public relations director at Glacier National Park. There he met the celebrated John Singer Sargent, from whom he learned ways to perfect his technique in portrait painting.

Visiting the art colony at Taos, New Mexico in the 1920s, Hoffman became acquainted with Leon Gaspard and through him with several other artists of this group. He moved to the area, established a permanent studio, and continued to submit work to national magazines. For many years he maintained a ranch near Taos where he raised quarter horses and a variety of other animals which he used as models for his paintings, most of which dealt with western scenes and subjects.

Hoffman was a frequent contributor of illustrations to *The Saturday Evening Post, Cosmopolitan,* and

FRANK B. HOFFMAN
Covered Wagon Attack
Oil on panel, ca. 1923
28 x 39½ in. (71.1 x 100.3 cm.)
No signature
Gift of the Chicago, Burlington & Quincy Railroad, 1967
1967.330

Provenance:
Chicago, Burlington & Quincy Railroad, Chicago, Illinois.

FRANK B. HOFFMAN
Wagon Train
Oil on panel, ca. 1923
25¼ x 37¼. in. (64.1 x 94.6 cm.)
Signed l.r.: Hoffman
Gift of the Chicago, Burlington & Quincy Railroad, 1967
1967.331

Provenance:
Chicago, Burlington & Quincy Railroad, Chicago, Illinois.

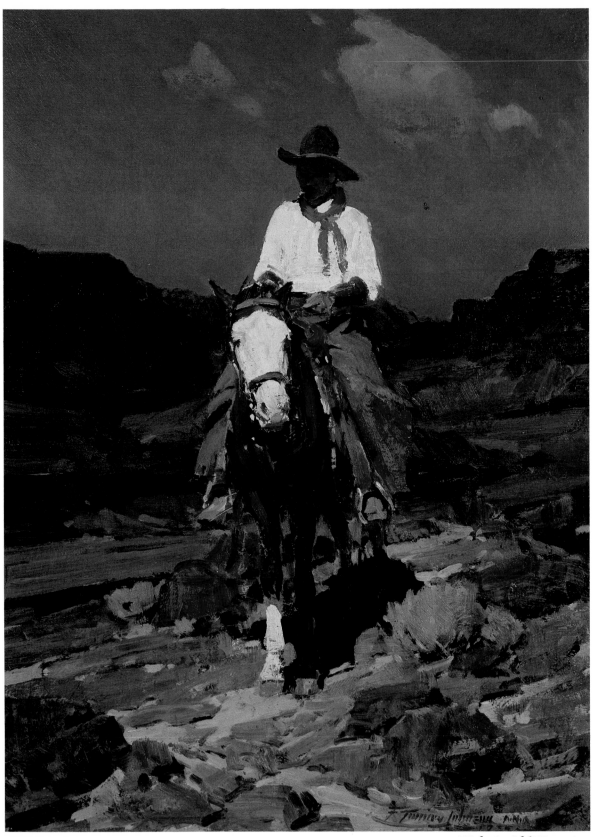

FRANK TENNEY JOHNSON

Night in Old Wyoming

McCall's magazines. He also handled advertising campaigns for such national corporations as General Motors and General Electric throughout the 1930s. In 1940 he signed an exclusive contract with the Brown and Bigelow Company and over the next fourteen years produced more than 150 canvases for calendar illustrations. Brown and Bigelow still own many of these.

Two original illustrations by Hoffman are included in the collection of the Joslyn Art Museum. Both were first reproduced as part of an advertising campaign created by the J. Walter Thompson Agency of Chicago for the Burlington, Great Northern, and Northern Pacific Railways in 1923.

OSCAR HOWE
b. 1915

Born on the Crow Creek Indian Reservation in South Dakota, Sioux artist Oscar Howe attended the Pierre Indian School until 1933 and completed his high school education at Santa Fe, New Mexico where he studied art under the direction of Dorothy Dunn Kramer. While in high school, he exhibited his work across the country from New York City to San Francisco and abroad in London and Paris.

Howe later taught art at the Pierre Indian School and studied mural painting at the Indian Art Center near Fort Sill, Oklahoma. During World War II, he served in the U.S. Army in the European theatre. While in Germany he met his future wife, who returned with him to the United States after the war.

In 1948 Howe was chosen Artist-in-Residence by Dakota Wesleyan University at Mitchell, South Dakota. Here he taught art while working toward his undergraduate degree. He received his M.F.A. degree from the University of Oklahoma in 1954. Meanwhile, he continued as director of art at the high school in Pierre until his appointment in 1957 as Assistant Professor of Fine Arts at the State University of South Dakota. This same year he held his first one-man retrospective in Santa Fe, New Mexico.

Recipient of numerous awards from 1947 to the present, Oscar Howe is represented by paintings in many private collections as well as museums and galleries such as the Gallup Art Gallery in Gallup, New Mexico; Museum of Mexico in Santa Fe; Philbrook Art Center in Tulsa, Oklahoma; Denver Art Museum; and the U.S. Department of the Interior in Washington, D.C.

OSCAR HOWE
The Origin of Corn
Tempera on paper
21⅜ x 29⅜ in. (54.3 x 74.6 cm.)
Signed l.r.: Oscar Howe
Gift of Morton Steinhart, 1949
1949.180

Provenance:
Oscar Howe, Vermillion, South Dakota.
Morton Steinhart, Nebraska City, Nebraska.

Literature:
University of Nebraska School of Journalism, *As Long as the Grass Shall Grow*, June 1971, p. 15; Mid-America Arts Alliance, *Native American Paintings*, 1980, cover.

OSCAR HOWE
Sioux Boat Race
Tempera on paper, 1955
11¾ x 22¼ in. (29.8 x 56.5 cm.)
Signed l.r.: Oscar Howe
Purchase, 1955
1955.374

Provenance:
Oscar Howe, Vermillion, South Dakota.
The Tipi Shop, Rapid City, South Dakota.

Literature:
The Mobile Art Gallery and The Birmingham Museum of Art, *Art of the Old West*, 1974.

OSCAR HOWE
Sioux Indian Flute Player
Tempera on paper, 1955
12½ x 19¼ in. (31.8 x 48.9 cm.)
Signed l.r.: Oscar Howe
Purchase, 1955
1955.375

Provenance:
Oscar Howe, Vermillion, South Dakota.
The Tipi Shop, Rapid City, South Dakota.

Literature:
Joslyn, *Oscar Howe*, 1967.

OSCAR HOWE
Sioux Rider
Tempera on paper
15⅜ x 20 in. (39.1 x 50.8 cm.)
Signed l.c.: Oscar Howe
Purchase, 1959
1959.198

Provenance:
Oscar Howe, Vermillion, South Dakota.

Literature:
Joslyn, *Life on the Prairie: A Permanent Exhibit*,
1966, p. 39; Joslyn, *Oscar Howe*, 1967; Fronval,
La veritable histoire des Indiens Peaux-Rouges,
1973, p. 113.

OSCAR HOWE
War Dance
Tempera on paper
17⅜ x 23½ in. (44.1 x 59.7 cm.)
Signed l.r.: Oscar Howe
Purchase, 1959
1959.199

Provenance:
Oscar Howe, Vermillion, South Dakota.

Literature:
Joslyn, *Oscar Howe*, 1967; University of
Nebraska School of Journalism, *As Long as the
Grass Shall Grow*, June 1971, p. 11.

JOHN DARE HOWLAND
Landscape, Lake in Background
Oil on wood panel
Image: diameter 11 in. on decorated panel:
15¼ x 15⅛ in. (38.7 x 38.4 cm.)
No signature
Gift of John R. McDonald, 1949
1956.363

Provenance:
John R. McDonald, Omaha, Nebraska.

JOHN DARE HOWLAND
*Angel holding a picture of Washington
(Guardian Angel)*
Oil on wood panel
Image: diameter 11 in. on decorated panel:
16½ x 15¼ in. (41.9 x 38.7 cm.)
No Signature
Gift of John R. McDonald, 1949
1956.364

His murals decorate several public buildings including the Carnegie Library and the Corn Palace in Mitchell, South Dakota, and the civic auditorium in Mobridge, South Dakota.

Five paintings by Howe are included in the permanent collection of the Joslyn Art Museum.

JOHN DARE HOWLAND
1843-1914

A man of varied talents, John D. Howland followed several careers during an adventurous life. Born at Zanesville, Ohio, he left home at the age of fourteen and made his way to St. Louis, where with the help of Robert Campbell he accompanied one of the American Fur Company steam boats to Fort Pierre on the upper Missouri River. Here the young man observed life on the remote frontier and reportedly traded with the Indians of the area. From Fort Pierre he next traveled overland to Fort Laramie, Wyoming, where he is believed to have painted a few pictures of Indians. News of a gold strike attracted him to the Pike's Peak area of Colorado, but discoveries were meager and Howland turned briefly to trapping for a living.

At the beginning of the Civil War, the eighteen-year-old Howland joined Company B of the First Colorado

Provenance:
John R. McDonald, Omaha, Nebraska

Literature:
Mumey, *The Art and Activities of JOHN DARE (JACK) HOWLAND, Painter, Soldier, Indian Trader and Pioneer*, 1973, p. 23.

JOHN DARE HOWLAND
Landscape with Stream in Foreground
Oil on wood panel
Image: diameter 11 in. on decorated panel:
16½ x 15¼ in. (41.9 x 38.7 cm.)
No signature
Gift of John R. McDonald, 1949
1956.365

Provenance:
John R. McDonald, Omaha, Nebraska.

JOHN DARE HOWLAND
Drummer Boy
Oil on wood panel
Image: diameter 11 in. on decorated panel:
16¾ x 15¼ in. (42.5 x 38.7 cm.)
No signature
Gift of John R. McDonald, 1949
1956.366

Provenance:
John R. McDonald, Omaha, Nebraska.

Literature:
American Heritage Magazine, October 1956, back cover; Mumey, *The Art and Activities of JOHN DARE (JACK) HOWLAND, Painter, Soldier, Indian Trader and Pioneer*, 1973, p. 21.

DUANE WOLF ROBE HUNT
Acoma Spear and Shield Dance
Casein on paper, ca. 1967
15½ x 11½ in. (39.4 x 29.2 cm.)
No signature
Gift of Forrest E. Jones, 1976
1976.31

Provenance:
Col. Forrest E. Jones, Grandview, Missouri.

Cavalry and saw action in several campaigns in New Mexico. He was later active in the Indian wars that followed, rising to the rank of Captain of Scouts. In 1864 he left military service and the following year sailed for Paris to study painting. Upon returning home to the United States, he served from 1867 to 1869 as Secretary to the Indian Peace Commission charged with negotiating treaties between the U.S. Government and the Plains Indian tribes.

During this and later periods, Howland worked intermittently as an artist on assignment for several eastern publishers, and his work appeared in *Harper's Weekly* and *Frank Leslie's Illustrated Newspaper*. After another period of study abroad, he returned to settle in Denver, where he founded the Denver Art Club in 1886. Regarded by contemporaries as a celebrity of sorts, he became one of Denver's foremost civic promoters. During the last few years of his life, he devoted more and more of his time to painting.

Four small panel paintings attributed to Howland are listed in the permanent collection of the Joslyn Art Museum. Records indicate that these were pictorial decorations painted to ornament the government railroad car originally designed for the use of President Abraham Lincoln. A large canvas entitled *A Western Jury*, painted by Howland in 1883 for Morton Frewen, manager of Wyoming's once famous Powder River Cattle Company, is on permanent loan to the Museum from The InterNorth Art Foundation. A good account of the artist's life was written by a daughter, Kate Howland Charles, and published in *Colorado Magazine* in July, 1952 under the title "Jack Howland, Pioneer Painter of the Old West."

DUANE WOLF ROBE HUNT
1905-1977

An accomplished painter and silversmith, Wolf Robe Hunt was born on the Acoma Indian Reservation west of Albuquerque, New Mexico. At the age of seventeen, he was initiated into his tribe's Sacred Hunter society and given the name of Wolf Robe. He learned the art of silversmithing from a brother in Albuquerque and later worked for a period of years with the Smithsonian Institution's Bureau of American Ethnology and for the National Geographic Society in Washington, D.C. as an artist and ethnographic consultant.

Settling in Tulsa, Oklahoma, he worked as a silver-

smith and operated a trading post there and later at Catoosa, Oklahoma for nearly thirty years. He taught silversmithing at the Philbrook Art Center in Tulsa where he received numerous awards both for his jewelry and painting. Hunt contributed illustrations to several books on Indian subjects and produced paintings in the traditional two-dimensional style associated with the early development of American Indian painting. Traveling widely for the U.S. Department of Commerce, he toured more than fourteen nations demonstrating his skills as a silversmith in many countries including Sweden, Belgium, Ireland, France, and Great Britain.

A painting by Wolf Robe Hunt is included in the permanent collection of the Joslyn Art Museum.

FRANK TENNEY JOHNSON
1874-1939

Born at Big Grove, Iowa, Frank Tenney Johnson spent his childhood near Council Bluffs and developed an early interest in western history and art. He later decided to pursue a career in art, and studied for a time at the Art Students League in New York City under Robert Henri. Following his stay in the East, he traveled in the West and worked on a ranch in Colorado.

Returning to New York City, he established a studio and began illustrating for various book and magazine publishers. His work appeared most often in association with the writings of author Zane Grey. In 1920 a friend and fellow artist, Clyde Forsythe, left New York and a successful career as a commercial illustrator to settle on the West Coast. Johnson and his wife soon followed.

For the next several years, Johnson and Forsythe shared a studio in Alhambra, California where Johnson began producing the romantic pictures of the West for which he is best known today. The two friends eventually founded the Biltmore Art Gallery at the Biltmore Hotel in Los Angeles where they handled the work of such artists as C. M. Russell, Ed Borein, Dean Cornwell, and Norman Rockwell. With Borein and several others, Johnson was also active in organizing the Rancheros Visitadores, a group which met annually at Borein's studio in Santa Barbara.

Johnson won numerous awards for painting, including the Shaw Prize from the Salmagundi Club in New York City in 1923, and his work gained wide recogni-

FRANK TENNEY JOHNSON
Night in Old Wyoming
Oil on board, 1935
17½ x 13½ in. (44.5 x 34.3 cm.)
Signed and dated l.r: F. Tenney Johnson, ANA / 1935
Label on verso reads: "Night in Old Wyoming, a reminder of happy days and nights in the Shoshone valley"
Gift in memory of Dr. and Mrs. Arthur C. Langmuir and Mr. and Mrs. J. W. B. Van de Water by their families, 1964
1964.762

Provenance:
Kennedy Galleries, Inc., New York.

Literature:
The Kennedy Quarterly, October 1964, Vol. V, no. 1, p. 53; Joslyn, *Life on the Prairie: A Permanent Exhibit*, 1966 & 1969, p. 27; Joslyn, *Artists of the Western Frontier*, 1976, no. 50, p. 20.

tion before his untimely death of spinal meningitis. He was elected an Associate of the National Academy of Design in 1929 and a full Member in 1937. His works are found today in western collections throughout the United States and abroad.

The oil painting by this artist in the collection of the Joslyn Art Museum exhibits what came to be known as "the Johnson moonlight technique." It represents him at his best as the artist who characteristically painted the American cowboy outdoors "under the stars."

GEORGE CAMPBELL KEAHBONE
b. 1916

Kiowa Indian painter George Keahbone was born at Anadarko, Oklahoma and later attended Bacone Indian School, now Bacone College near Muskogee, Oklahoma. He completed his studies in art at the Santa Fe Indian School in Santa Fe, New Mexico where he established his reputation as a noted painter of traditional Indian scenes and subjects. He continues today as one of the better known artists in the area.

He is represented by a single work in the permanent collection of the Joslyn Art Museum.

CHARLES BIRD KING
1785-1862

A native of Newport, Rhode Island, Charles Bird King received his first instruction in painting from a local Newport artist, Samuel King. He later studied in New York City under Edward Savage and in London under American expatriate Benjamin West. He returned to the United States in 1812 to pursue a professional career as a portraitist in Philadelphia.

In 1816 King moved to Washington, D.C. where he established a permanent studio and achieved a modest reputation painting the portraits of such notables as John C. Calhoun and Henry Clay. He is best known today for the series of American Indian portraits he produced for the U.S. Government at the request of Thomas L. McKenney, Superintendent of Indian Trade and later head of the Bureau of Indian Affairs under the War Department.

Throughout the first quarter of the nineteenth century, a great many delegations representing the Indian

GEORGE CAMPBELL KEAHBONE
Buffalo Hunt
Watercolor on paper
12¼ x 11½ in. (31.1 x 29.2 cm.)
Signed l.c.: Keahbone
Gift of George Barker, 1963
1963.630

Provenance:
George Barker, Pacific Palisades, California.

CHARLES BIRD KING
Portrait of Shaumonekusse (L'Ietan), an Oto Half Chief
Oil on canvas
29½ x 24½ in. (74.9 x 62.2 cm.)
No signature
Gift of M. Knoedler and Company, 1978
1978.267

Provenance:
M. Knoedler & Co., Inc., New York.

Literature:
The City Art Museum of St. Louis, *Westward The Way*, 1954, no. 44, p. 78; Irving, *Indian Sketches* (1833), 1955, opp. p. 70; Joslyn, *Life on the Prairie: A Permanent Exhibit*, 1966 & 1969, p. 14; Joslyn, *Artists of the Western Frontier*, 1976, no. 52, p. 21; Cosentino, *The Paintings of Charles Bird King (1785-1862)*, 1977, no. 446, p. 180.

tribes of the frontier West visited Washington on treaty business. From about 1821 through the mid 1830s, King reportedly painted from life over a hundred portraits of the leading members of some twenty tribes for the Government collection as well as replicas for himself and others. Displayed for many years at the offices of the War Department, King's gallery of Indian portraits was finally moved to the Smithsonian Institution for safekeeping and displayed there with numerous artifacts acquired by Congress in the course of its treaty-making activities. Nearly all of this material was destroyed when the wing at the Smithsonian where these collections were housed was consumed by fire in January, 1865.

Lithographic reproductions of King's Indian portraits were featured as illustrations in Thomas L. McKenney and James C. Hall's three-volume *History of the Indian Tribes of North America*, published in Philadelphia by E. C. Biddle in 1836-44.

A smaller collection of replicas by King himself, left to Newport's Redwood Library at his death, were sold at auction in 1971. A few other such works by King exist in scattered collections, chiefly at the Smithsonian and the Capitol in Washington, the Philadelphia Museum of Art, and the Thomas Gilcrease Institute in Tulsa, Oklahoma.

WILLIAM ROBINSON LEIGH
1866-1955

An accomplished technician and one of the best trained of the painters of the latter day American West, William R. Leigh was born at Falling Water in Berkeley County, West Virginia, and received his first instruction in art at the age of fourteen at the Maryland Institute in Baltimore. From 1883 through 1895 he studied abroad, chiefly at the Royal Academy in Munich, Germany, during which period he largely supported himself working on mural commissions and panoramas of European historical and religious subjects.

After some twelve years abroad, Leigh returned to the United States in 1896 and established a studio in New York City where he worked as an illustrator for *Scribner's Magazine*. He married for the first time in 1898, from which union was born a son, William Colston Leigh.

Dissatisfied with progress as an artist at the time, and desiring to free himself from the constraints of

WILLIAM ROBINSON LEIGH
A Double Crosser
Oil on canvas, 1946
28⅛ x 22 in. (71.4 x 55.9 cm.)
Signed and dated l.l.: W. R. Leigh 1946
Purchase, 1955
1955.164

Provenance:
William Robinson Leigh, New York.
Edward Eberstadt and Sons, New York.

Literature:
Collier's Magazine, "Sagebrush Rembrandt," November 11, 1950, p. 34; Joslyn, *Life on the Prairie: A Permanent Exhibit*, 1966 & 1969, p. 26; The Mobile Art Gallery and The Birmingham Museum of Art, *Art of the Old West*, 1974; Joslyn, *Artists of the Western Frontier*, 1976, no. 61, p. 26.

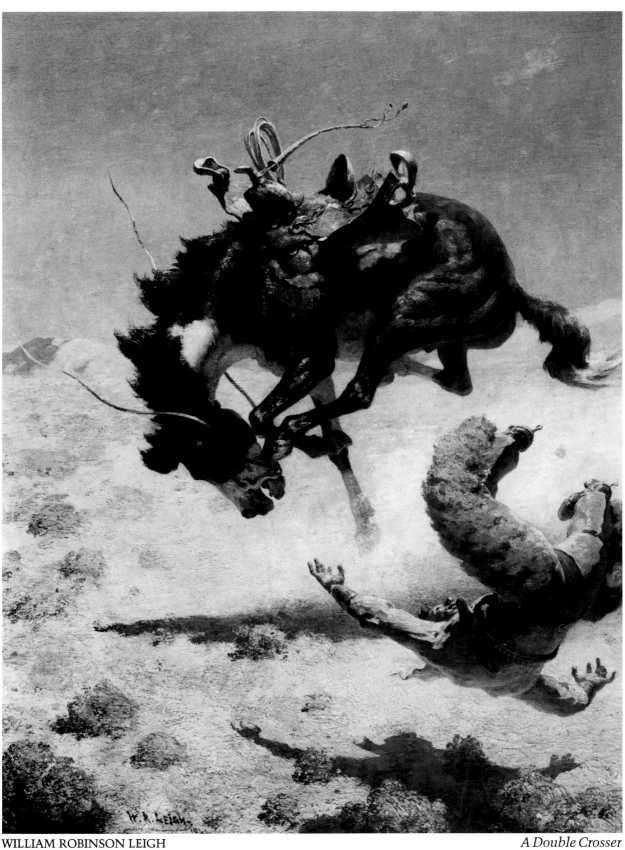

WILLIAM ROBINSON LEIGH *A Double Crosser*

commercial illustration, Leigh traveled to New Mexico in 1906 on a free railway pass in exchange for a painting commissioned by the Santa Fe Railroad. Captivated by the western environment, he afterward returned frequently and in time achieved widespread recognition as a painter of frontier scenes and subjects.

In 1921 Leigh married a second time to Ethel Traphagen, a women's fashion designer. Together they established the Traphagen School of Design in New York City, where Leigh taught drawing and painting. He continued to make periodic excursions into the western states to make studies of the Indians, animals, and landscape of that region which served as the basis for paintings completed at his studio on West 57th Street. In 1926 and 1928 he visited Africa, having been commissioned by the American Museum of Natural History to produce background murals for habitat groups in the museum's new African Hall.

Leigh won numerous awards during a long and productive life. A National Academician, he was also a founder of the Allied Artists of America and the Authors' League. He wrote several plays and published two books of note: *The Western Pony* (1933) and *Frontiers of Enchantment* (1938) relating to his experiences in Africa. Both were illustrated by the author. Following his death, the contents of his New York studio and other personal effects were donated by the Traphagen family to the Thomas Gilcrease Institute of American History and Art in Tulsa, Oklahoma. Included in this gift were more than 500 oil paintings and canvasboard studies, over 300 drawings, a collection of etchings, and a bronze casting of a buffalo, the only sculpture Leigh is known to have produced.

Leigh is also represented by a series of mural-sized western paintings at the Woolaroc Museum near Bartlesville, Oklahoma, as well as works in numerous collections throughout the United States and Europe.

RICHARD LORENZ
1858-1915

Born on a farm near Voigstadt in central Germany, Richard Lorenz had his first instruction in art at a preparatory school and at eighteen years of age enrolled in free evening classes at the Royal Academy of Arts in Weimar. Later he studied there as a regular student on scholarship under the noted animal painter Heinrich Albert Brendel. He was twice the recipient of impor-

RICHARD LORENZ
Chuck Wagon
Oil on panel
9 x 12 in. (22.9 x 30.5 cm.)
Signed l.l.: Lorenz
Purchase, 1968
1968.201

tant awards while at Weimar and also exhibited his work during this period in Berlin and at Antwerp.

In 1888 he immigrated to the United States at the urging of a former Weimar friend who was the brother-in-law of Frederick Pabst, Milwaukee shipping and brewing tycoon. Joining a group of German artists who had arrived in America only the year before to work on religious and historical panoramas, Lorenz was employed in painting horses for these large-scale projects in Milwaukee until 1887 when he traveled to San Francisco to assist in the installation of a panorama in that city. He remained on the West Coast for several months and afterward visited Arizona, Colorado, and Texas.

Returning to Milwaukee in 1888 to teach in the newly organized Milwaukee School of Art, Lorenz produced a number of easel paintings based upon his recent western travels. He visited the West again in the 1890s and traveled throughout the Dakotas, Wyoming, and Montana. He painted his first Indian subjects at the Crow reservation in eastern Montana in 1898, and this same year attended the Indian Conference associated with the Trans-Mississippi Exposition in Omaha, Nebraska.

An advocate of what was known as "outdoor" painting, Lorenz was chiefly noted for his landscapes and rural subjects, particularly Wisconsin snow scenes. His paintings became popular with Milwaukee collectors and were widely exhibited in regional, national, and international shows. Having joined the Society of Western Artists in 1896, he also continued to paint western scenes as well as nature and genre subjects. One of his last western trips was made to Utah in 1912, three years before his death in Milwaukee.

JULIAN MARTINEZ
1897-1943

A native of the San Ildefonso Pueblo in northern New Mexico, Julian Martinez did his best work in the field of pottery design, although he produced a few paintings of note. For several years he collaborated with his wife Maria in the making of her now famous blackware pottery. A son, Juan Martinez, born at Santa Fe, New Mexico followed in the artistic traditions of his parents after being variously educated at Bacone College near Muskogee, Oklahoma and at Santa Fe, the Georgia Military Academy, and Stanford.

JULIAN MARTINEZ
Indian Woman Carrying Basket on Head
Watercolor on paper
$10^{15}/_{16}$ x 7½ in. (27.8 x 19.1 cm.)
Signed l.c. in red: Julian Martinez
Gift of Mrs. Aurel M. Hare, 1947
1947.409

Provenance:
Mrs. Aurel M. Hare, Kansas City, Missouri.

Provenance:
Mr. and Mrs. A. J. Schrager, Milwaukee, Wisconsin.
Milwaukee Auction Galleries, Milwaukee, Wisconsin.

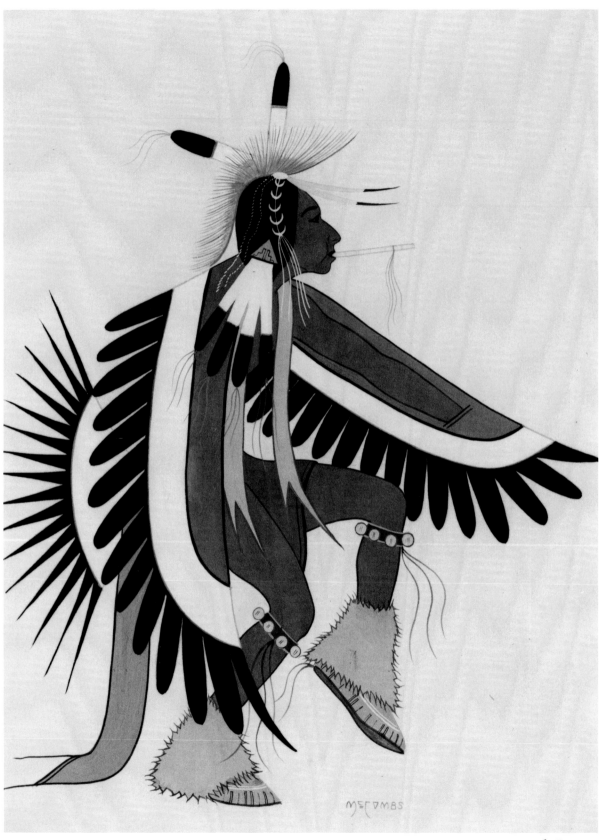

SOLOMON McCOMBS

Eagle Dancer

Julian Martinez is represented by a watercolor in the permanent collection of the Joslyn Art Museum. His wife Maria is also represented by a number of pottery pieces.

SOLOMON McCOMBS
1913-1980

Born near Vivian west of Eufala, Oklahoma, Solomon McCombs first exhibited an interest in art during a period of childhood illness that confined him to bed. In 1930 he entered Bacone Indian School near Muskogee as a sixth grade student and continued at Bacone through high school and one semester of junior college. During this time he studied art under the American Indian painter Acee Blue Eagle.

McCombs was employed for several years as a draftsman with the U.S. Army Corps of Engineers. Also active in community art circles, he developed his own reputation throughout the state and region as a painter of traditional Indian scenes and subjects. A winner of numerous awards in painting, he was chosen by the U.S. International Educational Service in 1955 to tour Africa, the Near East, and India on a goodwill mission. Under government auspices he traveled more than 35,000 miles with an exhibition of his work, giving lectures on Indian life and customs and making radio appearances in different countries.

He is represented by works in many collections and is best known for his highly stylized, two-dimensional paintings reflecting an earlier formal tradition in American Indian art.

ANDREW MELROSE
1836-1901

Primarily a landscape painter, Andrew Melrose immigrated to the United States from his native Scotland in 1856 and settled for a time in New York City before moving to the neighboring environs of New Jersey where he established a succession of studios in West Hoboken, Guttenberg, and West New York. Active as a painter throughout the 1870s and 80s, he traveled widely in the eastern United States, Great Britain, and Europe during this period and also visited the American West, although the dates of such excursions remain uncertain.

SOLOMON McCOMBS
Buffalo Hunt
Tempera on illustration board
21 x 30¼ in. (53.3 x 76.8 cm.)
Signed l.r.: McCombs
Gift of Morton Steinhart, 1949
1949.179

Provenance:
Solomon McCombs, Grand Island, Nebraska.
Morton Steinhart, Nebraska City, Nebraska.

SOLOMON McCOMBS
Eagle Dancer
Tempera on paper
13 x 10 in. (33.0 x 25.4 cm.)
Signed l.r.: McCombs
Purchase, 1950
1950.69

Provenance:
Solomon McCombs, Grand Island, Nebraska.

Literature:
University of Nebraska School of Journalism, *As Long as the Grass Shall Grow*, June 1971, p. 14.

ANDREW MELROSE
Indian Warfare at Mih-Tutta-Hangkusch, A Mandan Village on the Upper Missouri
Oil on canvas
30 x 48 in. (76.2 x 121.9 cm.)
Signature l.r.: indecipherable
Gift of the Girl Scouts of Omaha, 1955
1955.42

Provenance:
Dr. and Mrs. Willard Quigley, Omaha, Nebraska.
Girl Scouts of America, Omaha, Nebraska.

Between 1868 and 1882 he exhibited frequently at the National Academy of Design in New York City where he was represented primarily by city scenes or rural views of North Carolina, the Hudson Valley, and the Berkshire Hills. He also produced scenes of England, Ireland, and the Swiss Alps as well as replicas of works by other artists on commission. His last place of residence was at West New York, New Jersey, where he died shortly after the turn of the century.

The painting attributed to this artist in the Joslyn collection was discovered in a house in Omaha when the residence, the former home of a Dr. and Mrs. Willard Quigley, was acquired by the local Girl Scouts organization. It is apparently based upon a similar subject by the Swiss artist Karl Bodmer, who in the 1830s visited the area of the Missouri frontier depicted. The scene or event described is largely imaginary rather than historical.

ALFRED JACOB MILLER
1810-1874

One of the first artists to travel west of the Mississippi in the early decades of the nineteenth century, Alfred Jacob Miller had less actual experience in the West than almost any of his contemporaries in that field. Nevertheless, because of the great number of western views he produced following an excursion to the Rockies in 1837, he is generally acknowledged today among the most important western painters of this period.

Born in Baltimore, Maryland, the son of a grocer, Miller showed a marked talent for drawing as a youth and received instruction in painting from Thomas Sully in Philadelphia before traveling abroad in 1833 to Paris where he studied for a year at the École des Beaux-Arts. After visits to Rome and Florence, he returned to the United States in 1834 and set up a studio in Baltimore. He was not very successful in establishing himself at this time and subsequently moved to New Orleans, Louisiana, where he attempted to make a living as a portrait painter.

In New Orleans, Miller met British military officer and sportsman, Captain William Drummond Stewart, who was about to embark upon one of his periodic hunting expeditions into the Far West. Impressed by Miller's work, Stewart engaged him as an artist for the proposed trip, which was made in the summer of 1837 along what later was designated as the Oregon Trail

ALFRED JACOB MILLER
Encampment of Snake Indians, Wind River Mountains
Watercolor on paper
7³⁄₁₆ x 10⅞ in. (18.3 x 27.6 cm.)
No signature
On verso: pencil and ink sketch of a man's hand and arm
Gift of Jasper Hall and Elsworth Moser, 1952
1952.79

Provenance:
Edward Eberstadt & Sons, New York.

Literature:
Muench and Pike, *Rendezvous Country*, 1975, pp. 98-99.

ALFRED JACOB MILLER
Indian Camp, Nebraska Territory
Oil on canvas
9⅛ x 13⅝ in. (23.2 x 34.6 cm.)
No signature
Inscribed on back of canvas: Title of picture with note: "Copy of inscription on original canvas lined and restored by J. E. MacAlpine, 1924"
Purchase, 1954
1954.58

Provenance:
M. Knoedler & Co., Inc., New York.

Literature:
Knoedler's Art Galleries, *Portrait of the Old West*, 1952, no. 18; Joslyn, *Life on the Prairie: A Permanent Exhibit*, 1966 & 1969, p. 20.

ANDREW MELROSE *Indian Warfare at Mih-Tutta-Hangkusch, A Mandan Village on the Upper Missouri*

ALFRED JACOB MILLER
Portrait of Captain Joseph Reddeford Walker
Oil on canvas
24 x 20 in. (61.0 x 50.8 cm.)
Signed inside right rim of tondo: A. Miller
Purchase, 1963
1963.610

Provenance:
M. Knoedler & Co., Inc., New York.

Literature:
Conner, *Joseph Reddeford Walker and the Arizona Adventure*, 1956, opp. p. 58; Hafen, *The Mountain Men and the Fur Trade of the Far West*, 1968, Vol. V, p. 20; Ellsworth, *Utah's Heritage*, 1972, p. 111; Ewers, *Artists of the Old West*, 1973, p. 111; Gilbert, *The Trailblazers* (Old West series), 1973, p. 91; Mitchell Beazely Publishers Limited, *The Magnificent Continent*, 1975, p. 33; Joslyn, *Artists of the Western Frontier*, 1976, no. 66, p. 15; Hassrick, *The Way West: Art of Frontier America*, 1977, p. 47.

ALFRED JACOB MILLER
The Surround
Oil on canvas
66 x 94½ in. (167.6 x 240.0 cm.)
No signature
Purchase, 1963
1963.611

Provenance:
Sir William Drummond Stewart, Murthly Castle, Scotland.
Anderson Gallery, New York.
Gov. E. W. Marland, Ponca City, Oklahoma.
M. Knoedler & Co., Inc., New York.

Literature:
Philbrook Art Center, *Phases of Western History: The Artist's Record*, 1941, no. 4, p. 4; The City Art Museum of St. Louis, *Westward The Way*, 1954, no. 70, p. 103; Joslyn, *Life on the Prairie: The Artist's Record*, 1954, p. 4; Joslyn, *CATLIN, BODMER, MILLER: Artist Explorers of the 1830's*, 1963, p. 29, 1967, p. 33; Joslyn, *Life on the Prairie: A Permanent Exhibit*, 1966 & 1969, p. 15; Fronval, *La veritable histoire des Indiens Peaux-Rouges*, 1973, p. 56; Joslyn, *Artists of the Western Frontier*, 1976, no. 64, p. 14; Amon Carter Museum of Western Art, *The Bison in Art: A Graphic Chronical of the American Bison*, 1977, p. 105.

to Fort William on the Laramie River in present-day Wyoming. From Fort William or Laramie, as it was also called, the expedition crossed the northern Rockies to the fur trappers' rendezvous on the Green River in Oregon.

Stewart's party returned eastward in October of that year. Stewart himself proceeded on to Scotland to claim a title and estates recently inherited from a deceased brother. Miller returned to New Orleans to develop a series of paintings based upon the studies he had made during the summer's adventure. After exhibiting in Baltimore and New York City in 1839 and 1840, Miller sailed for Europe to visit Stewart at Murthly Castle, where he had previously shipped several large canvases to decorate Stewart's hunting lodge.

Following a winter in London, during which time Miller had an opportunity to view George Catlin's celebrated North American Indian Gallery on exhibit at the Egyptian Hall in Piccadilly, Miller returned to the United States in the spring of 1842 and established a permanent studio in his native Baltimore. For the next thirty years, he continued to paint portraits and western landscapes, Indian pictures, and hunting and trapping scenes for various patrons, producing a large volume of work illustrative of his early western experiences.

Today, the largest collections of his work are found at the Walters Art Gallery in Baltimore; the Thomas Gilcrease Institute in Tulsa, Oklahoma; and the Joslyn Art Museum in Omaha, Nebraska. Another important collection is owned by the Nelda C. and H. J. Lutcher Stark Foundation in Orange, Texas.

Nine paintings, including one mural-sized canvas originally painted for Stewart's lodge, are listed in the catalogue of the Joslyn Art Museum. A collection of 113 watercolors by Miller is on permanent loan to the Museum from The InterNorth Art Foundation.

Of related interest is a portrait at the Joslyn of Miller's patron, Sir William Drummond Stewart, by American artist Henry Inman.

ALFRED JACOB MILLER
The Trapper's Bride
Oil on canvas, 1850
30 x 25 in. (76.2 x 63.5 cm.)
Signed l.l.: Miller / 1850
Purchase, 1963
1963.612

Provenance:
M. Knoedler & Co., Inc., New York.

Literature:
Jones, *Trappers and Mountain Men*, 1961, p. 131;
American West, "Frenchmen, Englishmen, and
the Indian," Fall 1964, Vol. 1, no. 4, p. 5; Flint
Institute of Arts, *Artists of the Old West*, 1964,
no. 36; Joslyn, *Life on the Prairie: A Permanent
Exhibit*, 1966 & 1969, p. 13; O'Meara, *Daughters
of the Country: The Women of the Fur Traders
and Mountain Men*, 1968, following p. 178;
Rasky, *The Taming of the Canadian West*, 1968,
p. 125; Schomaekers, *Der Wilde Westen*, 1972,
p. 54; Price, *The VINCENT PRICE Treasury of
American Art*, 1972, front cover and p. 79;
Ewers, *Artists of the Old West*, 1973, p. 100;
Fronval, *La veritable histoire des Indiens
Peaux-Rouges*, 1973, p. 30; Getlein, *The Lure of
the Great West*, 1973, p. 73; Wayne, *Adventures
in Buckskin*, 1973, p. 117; National Geographic
Society, *The World of the American Indian*,
1974, p. 290; Joslyn, *The Growing Spectrum of
American Art*, 1975, no. 52, p. 28; Muench and
Pike, *Rendezvous Country*, 1975, p. 111; Joslyn,
Artists of the Western Frontier, 1976, no. 65,
p. 14; Reader's Digest, *The Best of the West, A
Treasury of Western Adventure*, 1976, Vol. 1,
p. 24; Wheeler, *The Chroniclers*, 1976, p. 109;
Across the Board, "The Great American Barter
Game," January 1981, Vol. XVIII, No. 1, p. 12.

ALFRED JACOB MILLER
Wind River Mountains
Oil on canvas
8 x 13⅛ in. (20.3 x 33.3 cm.)
Monogram in red l.r.: AJM
Purchase, 1963
1963.613

Provenance:
M. Knoedler & Co., Inc., New York.

Literature:
The Nebraska Art Association, The University
of Nebraska Art Galleries, and The Nebraska
Public Library Commission, *Nineteenth
Century American Landscapes*, 1968, no. 5;
Curry, *The American West: Painters from
Catlin to Russell*, 1972, no. 15, plate 32, p. 83.

ALFRED JACOB MILLER
Indians Watering Horses
Oil on wood panel
10 x 12 in. (25.4 x 30.5 cm.)
Inscribed on verso: Indians Watering Horses / By
A. J. Miller
Purchase, 1963
1963.614

Provenance:
M. Knoedler & Co., Inc., New York.

ALFRED JACOB MILLER
In the Rocky Mountains
Oil on canvas
14⅜ x 20 in. (36.5 x 50.8 cm.)
Signed l.l.: A. J. Miller
Purchase, 1963
1963.615

Provenance:
M. Knoedler & Co., Inc., New York.

Literature:
Curry, *The American West: Painters from
Catlin to Russell*, 1972, no. 16, plate 33, p. 84;
Getlein, *The Lure of the Great West*, 1973, p. 83;
American West, "World of the Mountain Man,"
September 1975, Vol. XII, no. 5, p. 28; Meunch
and Pike, *Rendezvous Country*, 1975, pp. 86-87.

ALFRED JACOB MILLER
River Scene: Indians in Canoes
Oil on canvas
10 x 16 in. (25.4 x 40.6 cm.)
No signature
Purchase, 1963
1963.616

Provenance:
M. Knoedler & Co., Inc., New York.

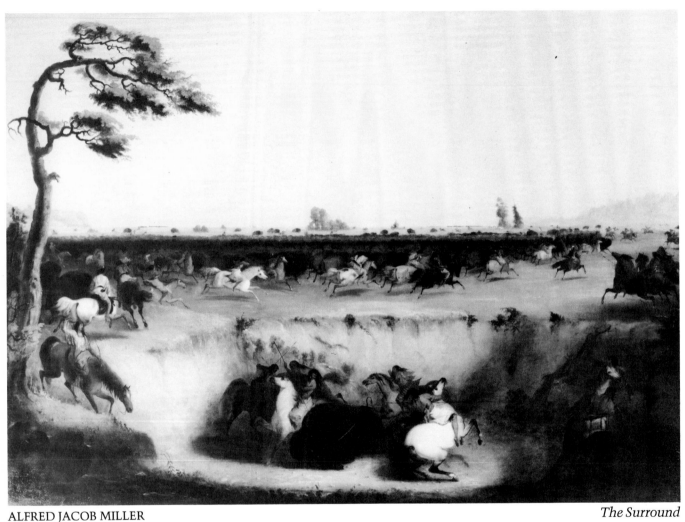

ALFRED JACOB MILLER *The Surround*

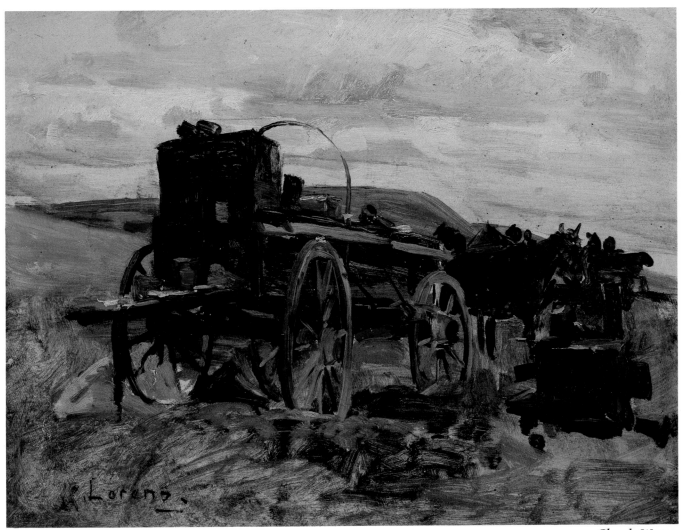

RICHARD LORENZ

Chuck Wagon

THOMAS MORAN
The Grand Canyon of the Colorado
Oil on canvas, 1913
25 x 30 in. (63.5 x 76.2 cm.)
Signed and dated l.l.: T. Moran 1913
Gift of Mrs. C. N. Dietz, 1934
1934.10

Provenance:
Mrs. C. N. Dietz, Omaha, Nebraska.

Literature:
Goetzmann, *Exploration and Empire*, 1966,
p. 226; Joslyn, *Life on the Prairie: A Permanent
Exhibit*, 1966, p. 35; Lakeview Center for the
Arts and Sciences, *Westward The Artist*, 1968,
no. 96; Friends of the Earth, Inc., *A Sense of
Place: The Artist and the American Land*, 1973,
Vol. II, no. 185, p. 4; Joslyn, *The Growing
Spectrum of American Art*, 1975, no. 53, p. 25;
Joslyn, *Artists of the Western Frontier*, 1976,
no. 73, p. 19.

THOMAS MORAN
1837-1926

Landscape painter Thomas Moran was born at Bolton in Lancashire, England and immigrated with his parents to the United States in 1844. Instructed in the rudiments of art by his elder brother Edward, he was first apprenticed to a wood engraver in Philadelphia and afterward toured and studied abroad in France, Italy, England, and Germany from about 1863 to 1867.

Returning to the United States, Moran found employment in New York City as an illustrator for *Scribner's Magazine*. On assignment for *Scribner's* in 1871, he accompanied geologist F. V. Hayden on his expedition to the headwaters of the Yellowstone River in northwestern Wyoming. In 1872 Moran again traveled westward and visited the Yosemite Valley of California. In 1873 he was with John Wesley Powell on Powell's exploration of the Colorado River.

Returning from each of these western excursions, Moran published a number of his illustrations in *Scribner's* and *Harper's Weekly* and produced several large landscapes, two of which, *The Great Canyon of the Yellowstone* and *Chasm of the Colorado*, were purchased by the U.S. Congress. Moran's studies of the Yellowstone area, together with Hayden's reports and the photographs of William H. Jackson, helped to convince the Government to establish Yellowstone National Park in 1872 as the first such public wilderness preserve in the country.

Over the next forty years, Moran traveled widely throughout the United States and Europe and many of his favorite sketching sites in the Far West eventually were set aside as national parks or monuments, including the Yosemite Valley and the Grand Canyon of the Colorado in Arizona. Elected to membership in the National Academy of Design in 1884, Moran produced an enormous body of work in his later years. His wife Mary Nimmo Moran (1842-1899) was also an accomplished landscapist and etcher. Brothers Edward and Peter Moran, son Paul Nimmo Moran, and nephews Edward Percy Moran and Leon Moran all were active as painters and engravers.

Today the largest collection of the works of Thomas Moran is found at the Thomas Gilcrease Institute of American History and Art in Tulsa, Oklahoma. Other important collections are owned by the U.S. Government and the National Parks Service; The Metropolitan Museum of Art in New York City; the Heckscher

Museum at Huntington, Long Island; the Walker Art Center in Minneapolis; and the Los Angeles County Museum of Art.

A portfolio of full-color chromolithographs after watercolors by Moran, published by Louis Prang of Boston, was issued in 1876 under the title *A Survey of Yellowstone Park* with an introduction by F. V. Hayden. Among the earliest and finest examples of color printing in the United States, this publication is exceedingly rare today in its complete and original form.

TITIAN RAMSAY PEALE
1799-1885

TITIAN RAMSAY PEALE
Lizard
Watercolor on paper
Trimmed oval, 4¾ x 6⅜ in. (12.1 x 16.2 cm.)
No signature
Gift of M. Knoedler and Company, 1978
1978.269

Provenance:
M. Knoedler & Co., Inc., New York.

Son of Philadelphia portraitist Charles Willson Peale, Titian Ramsay Peale received his first instruction in both art and natural history from his celebrated father. From the age of fourteen, he worked in the elder Peale's museum preparing animal specimens for display, and contributed illustrations of butterflies to Thomas Say's pioneer publication, *American Entomology*. At eighteen years of age, Peale was elected to membership in Philadelphia's Academy of Natural Sciences. At nineteen he was selected to accompany as naturalist and scientific illustrator Major Stephen Long's western expedition from Pittsburgh to the Rocky Mountains. Peale thus was one of the first, as well as the youngest, Anglo-American artists of the nineteenth century to record the Indian and animal life of the far western frontier.

Throughout much of 1819-20, Peale traveled with Long as far west as the modern Colorado and southward as far as the present state of Oklahoma. Returning home to Philadelphia via New Orleans, he assisted in the operation of his father's museum and succeeded his brother Franklin as manager in 1833. During this period he produced illustrations which were reproduced in the *American Ornithology* of Alexander Wilson and featured hand-colored engravings after Peale, John James Audubon, and others. Peale is chiefly represented in the first two volumes of this work.

Between the years of 1838 and 1842, Peale was a member of the Pacific exploratory expedition commanded by Charles Wilkes, Chief of the U.S. Naval Observatory and Hydrographic Office, and was again one of the first American artists to record the landscape and topography of the Hawaiian Islands. Returning to the United States in 1844, he settled in Washington,

D.C. and from 1849 to 1873 worked in the U.S. Patent Office. Meanwhile, his work was published in the portfolio of bird illustrations accompanying the reports of the U.S. Pacific expedition issued in two volumes in Philadelphia in 1858. This was issued by Wilkes and John Cassin and also featured plates by or after George White, William Hitchcock, and Edwin Sheppard which had first appeared in publication ten years earlier.

Few drawings were reproduced in Major Long's published report as compiled by botanist Edwin James in 1823. According to James, Peale executed some 122 sketches during his western travels, but of the eight plates appearing in the American edition of Long's report, six were credited to Samuel Seymour, who had also accompanied the Long expedition as its official painter. A collection of approximately fifty original watercolors and sketches by Peale are preserved in the collection of the American Philosophical Society in Philadelphia. Among these are the earliest known depictions by a white artist of Plains Indian subjects as well as illustrations of Great Plains wildlife such as antelope, deer, prairie chickens, and the grasshopper.

A collection of scientific drawings by Peale is owned by the Peabody Museum. Seven landscape views of Hawaii by Peale are preserved at the Bernice P. Bishop Museum in Honolulu. The Glenbow Alberta Museum in Canada owns a small sketch entitled *Bison Herd Near Pike's Peak in 1819* and signed "T. R. Peale, 1854."

A watercolor attributed to this artist is included in the catalogue of the Joslyn Art Museum. Another small painting in the Joslyn collection earlier attributed to Samuel Seymour is now thought to be the work of Titian Peale.

TONITA PENA
1895-1949

Pueblo Indian artist Tonita Pena was born at San Ildefonso, New Mexico and was reared by an aunt, the potter Martina Vigil, from whom she received her first instruction in art. Best known for her depictions of children and animals, Tonita Pena became the first woman of her generation to pursue a career as a painter. She taught art for a number of years at the Santa Fe Indian School and the Albuquerque Indian School.

She is represented by a watercolor in the permanent collection of the Joslyn Art Museum.

TONITA PENA
Corn Dance
Watercolor on paper, 1929
7½ x 10 in. (19.1 x 25.4 cm.)
Signed l.r.: Tonita Pena
Gift of Mrs. Iva Grover, 1967
1967.33

Provenance:
Mrs. Iva Grover, Omaha, Nebraska.

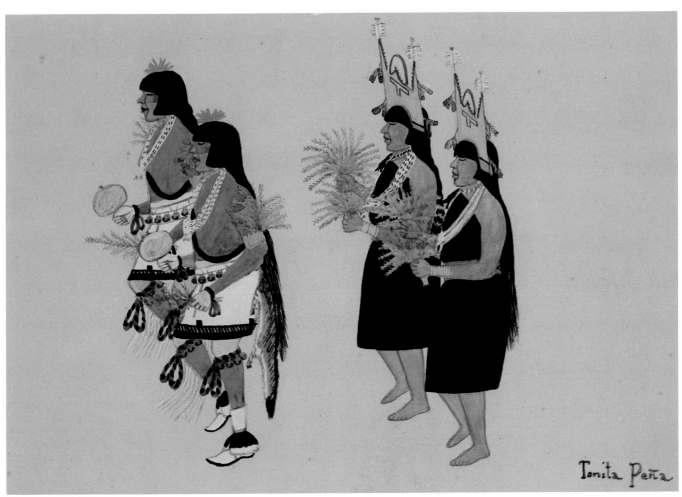

TONITA PENA

Corn Dance

DOEL REED
b. 1894

Although often referred to as a regionalist artist, Doel Reed has won international acclaim in the printmaking field and is considered by many to be the undisputed master of the aquatint in twentieth century American art.

Born in Fulton County, Indiana, Reed grew up in Indianapolis and began the formal study of architecture before deciding to pursue a career in fine art. He began his training at the Cincinnati Art Academy shortly before the advent of World War I. During the war he served briefly in France and afterward returned to the Cincinnati Art Academy to continue his studies under such teachers as L. H. Meaken and Frank Duveneck. It was during this period that he developed an interest in etching and in printmaking generally.

In 1924 Reed began his teaching career as an instructor of art at Oklahoma State University in Stillwater where he eventually rose to the position of Chairman of the Art Department. Here he remained until his retirement to Taos, New Mexico in 1959. Elected to full membership in the National Academy of Design in 1952, he is perhaps best known today for his portrayals of the Southwestern landscape, particularly in and around Taos. A recipient of numerous honors and awards, Reed is widely represented today by works in more than forty museum collections around the world including the Victoria and Albert Museum in London, The Metropolitan Museum of Art in New York City, Philadelphia Museum of Art, and the Library of Congress in Washington, D.C.

FREDERIC SACKRIDER REMINGTON
1861-1909

Probably the most widely known of all the artists of the American West at the present time, Frederic Remington was born at Canton, New York, the son of a locally prominent newspaper publisher. After attending a military prep school in Massachusetts, he entered Yale University in 1878 to study art and otherwise distinguish himself as an athlete. Following the death of his father in 1880, he left school and took a job in the Governor's office in Albany, having decided that the formal constraints of art school were not for him.

Desiring to travel and see something of the western

Art of Frederic Remington: An Exhibition Honoring Harold McCracken at the Whitney Gallery of Western Art, 1974, no. 34, p. 35.

FREDERIC SACKRIDER REMINGTON
Bronco Buster
Bronze
24½ x 15¼ x 7¼ in. (62.2 x 38.7 x 18.4 cm.)
Incised on top of base: Frederic Remington
Incised in "F" on top of base: 54
Incised on top rear of base: Cast by Henry - Bonnard Co., N-Y __95
Incised on right side of base: Copyrighted by Frederic Remington 1895
Purchase through bequest of N. P. Dodge, 1954
1954.303

Provenance:
Kennedy Galleries, Inc., New York.

Literature:
Joslyn, *Life on the Prairie: A Permanent Exhibit,* 1966 & 1969, p. 26; G. P. Putnam's Sons, *Great Art Treasures in America's Smaller Museums,* 1967, p. 118; Encyclopaedia Britannica, *Encyclopaedia Britannica,* 1974, 15th Edition, p. 503; The Reader's Digest Association, Inc., *The Story of America,* 1975, p. 383; Joslyn, *Artists of the Western Frontier,* 1976, no. 130, p. 38; Encyclopaedia Britannica, *Britannica Junior Encyclopaedia,* 1981 Edition, p. 271.

United States, Remington visited Montana briefly in 1881 and spent part of 1883 in Kansas where he tried his hand unsuccessfully at ranching. Returning eastward, he married his childhood sweetheart and afterward settled in Kansas City where he opened a small studio and invested as a partner in a local saloon.

Anxious to break into the field of commercial illustration, he sold his first western sketch to *Harper's Weekly* in 1886. This same year he moved to New York City where he established a permanent studio and studied for brief periods at the Art Students League. Over the next several years, he returned frequently to the West, for the most part on assignments from various publishers to document the action-packed life of the settling frontier. By 1890 more than 200 of his illustrations had appeared in *Harper's, Century,* and *Outing* magazines, among others.

Also a successful writer of short stories, articles, and books, most of which he illustrated himself, Remington came to be in great demand as an illustrator by other authors such as Owen Wister and Theodore Roosevelt. Ultimately, he became one of the world's highest paid illustrators. Meanwhile, from 1887 he began exhibiting regularly at the National Academy of Design and in shows of the American Watercolor Society and the Brooklyn Art Club. His *General Crook in Indian Country,* exhibited at the National Academy in 1891, won for him an associate membership in that body that same year.

In 1895 Remington produced his first western bronze, *Bronco Buster.* This was followed by twenty-one additional sculptures over the next fourteen years. His last sculpture, *Caught in a Stampede,* was also one of his largest. It was cast shortly after his death of acute appendicitis at the age of forty-eight.

During the last twenty years of his life, Remington produced over 2,700 paintings, drawings, and sculptures, the majority dealing with western themes and subjects. His illustrations appeared in forty-one different periodicals and 142 books. Today he is represented in many public and private collections, most notably at the Remington Memorial in Ogdensburg, New York; the Whitney Gallery of Western Art in Cody, Wyoming; the Thomas Gilcrease Institute of American History and Art in Tulsa, Oklahoma; and the Amon Carter Museum in Fort Worth, Texas. An important collection of Remington bronzes may be seen at the Stark Museum of Art in Orange, Texas.

A casting of his first bronze, *Bronco Buster,* is in the

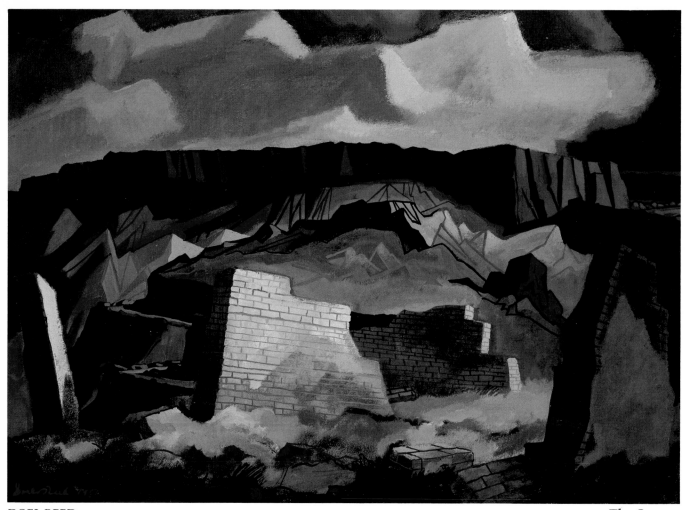

DOEL REED

The Canyon

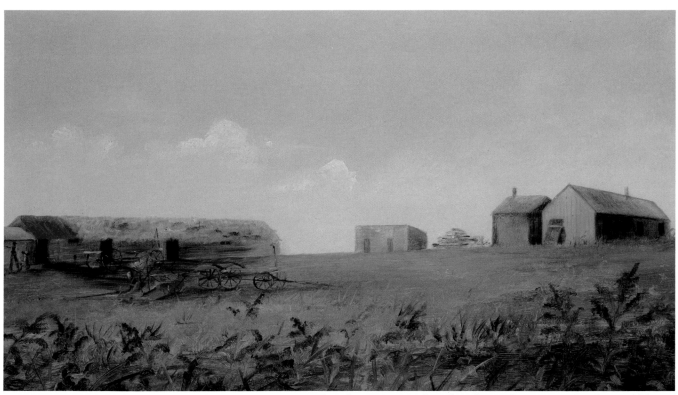

IMOGENE SEE *Nebraska Farmstead (Nebraska Sod House and Other Buildings)*

permanent collection of the Joslyn Art Museum. Also listed in the Joslyn catalogue is a small oil depicting a Canadian Northwest Mounted Policeman. Originally reproduced as an illustration in an issue of *Harper's Monthly*, June 7, 1891, it was one of eighteen illustrations by Remington appearing in Colonel Theodore Ayrault Dodge's four-part serial entitled "Some American Riders." Another painting entitled *The Waterhole* is on loan to the Joslyn from The InterNorth Art Foundation along with several previously published original illustrations by Remington.

STANISLAUS W. Y. SCHIMONSKI (TZSCHUMANSKY, SCHIMOUSKY) n.d.

A native of Schleswig-Holstein, where he is believed to have served at one time as an army officer, Stanislaus Schimonski immigrated to the United States around 1850 and settled for a time at St. Mary's, Iowa. By training he seems to have been a civil engineer or surveyor and draftsman. From about 1852 he owned and operated a farm near Bellevue, Nebraska. Several of his early views of the area, actually pen and ink illustrations tinted in watercolor, were made for James T. Allen of Bellevue in 1855. One of these is included in the collection of the Joslyn Art Museum.

A map of St. Mary's made by Schimonski was completed with a border painted by Gustav Sager, another German-born resident of St. Mary's. Schimonski sketched in an elaborate design with a border drawn in panels. These were filled with watercolors by Sager depicting local scenes. Two of these are preserved in the files of the Nebraska State Historical Society in Lincoln.

STANISLAUS W. Y. SCHIMONSKI
The Mission at Bellevue
Ink and watercolor on paper, 1855
6$^{15}/_{16}$ x 9½ in. (17.6 x 24.1 cm.)
Inscribed on verso: Schimonski (in pencil)
Inscribed at bottom: Mrs. J. T. Allen (in pencil)
Gift of Mr. Ross B. Johnson, 1977
1977.59

Provenance:
Mr. Ross B. Johnson, La Jolla, California.

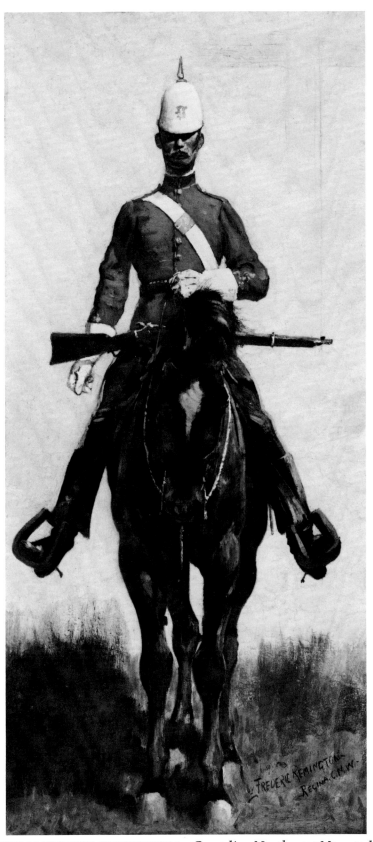

FREDERIC SACKRIDER REMINGTON *Canadian Northwest Mounted Police*

IMOGENE SEE
Nebraska Farmstead (Nebraska Sod House and Other Buildings)
Oil on academy board
10¼ x 18¼ in. (26.0 x 46.4 cm.)
No signature
Purchase, 1964
1964.617

Provenance:
Kennedy Galleries, Inc., New York.

Literature:
Kovinick, *The Woman Artist in the American West: 1860-1960,* 1976, p. 49.

SAMUEL SEYMOUR
Western Landscape
Oil on canvas
13½ x 8 in. (34.3 x 20.3 cm.)
No signature
Gift of M. Knoedler and Company, 1978
1978.268

Provenance:
Seymour Family.
Dr. Harold McCracken, Cody, Wyoming.
M. Knoedler & Co., Inc., New York.

Literature:
Joslyn, *CATLIN, BODMER, MILLER: Artist Explorers of the 1830's,* 1963, p. 6, 1967, p. 8; Monaghan, *The Book of the American West,* 1963, p. 568, Meriwether, *My Life in the Mountains and on the Plains,* 1965, p. 74; Joslyn, *Life on the Prairie: A Permanent Exhibit,* 1966 & 1969, p. 9; Montreal Museum of Fine Arts, *The Painter and the New World,* 1967, no. 288.

IMOGENE SEE
1848-1940

Little is known at the present time concerning the life or career of this artist, although it is established that she was a native of Ossining, New York and traveled westward at least as far as Nebraska about 1885. Whether she merely visited the region or settled there for any length of time is not known. A single painting attributed to this artist is included in the collection of the Joslyn Art Museum.

SAMUEL SEYMOUR
1796-1823

Believed to have been born in England, Samuel Seymour was variously employed as a scenic designer and landscape painter in Philadelphia and New York City during the first quarter of the nineteenth century. As early as 1796, he is known to have practiced engraving in Philadelphia under the instruction of William Birch. In 1810 Seymour was elected an associate member of the Society of Artists of the United States, later the Columbian Society, of which Thomas Sully was its first secretary. From 1814 Seymour exhibited with this group with some regularity.

Little else is known of his life or subsequent career, except that when he was about thirty-five years old he was chosen to accompany as an official artist Major Stephen Long's expedition to the Rocky Mountains. Sent to explore the western parts of Missouri Territory and to establish amicable relations with the Indian tribes along the way, Long's party met with the chiefs of several tribes in September, 1819 near Council Bluffs on the Missouri River. Seymour recorded the likenesses of several of the participants at this time and other Indian scenes and landscape views in the area, becoming one of the first artists of any training to depict life on the western frontier of his day.

Having traveled from Pittsburgh via the Ohio and Mississippi Rivers aboard the *Western Engineer,* first steamboat to navigate the Missouri River as far north as the modern Omaha, Nebraska, the explorers proceeded westward in June, 1820 by way of the Platte to what is now Colorado, returning east and southward

in the fall of that year. Seymour produced approximately 150 landscape views during the course of his travels with Long, of which sixty were finished upon his return to Philadelphia. Six of these were reproduced in the atlas accompanying Long's report as compiled by Edwin James, botanist and geologist for the expedition, and published in Philadelphia in 1823. This same year Seymour accompanied Long on another excursion to the headwaters of the Mississippi and the region surrounding Lake of the Woods and Lake Winnipeg in Canada. An account of this latter journey was published in London in 1825 featuring five more of Seymour's pictures.

No further documentation of Seymour's activities has been discovered to date. Original examples of his work are few and scattered. His *View of the Rocky Mountains on the Platte,* published with Long's official report, is now regarded as the earliest known picture of the Rockies made from first-hand observation, along with his view of James' or Pike's Peak and the headwaters of the Arkansas River system.

Copies of some of his western landscapes were exhibited at Peale's Museum in Philadelphia. A small collection of original watercolors, his principal medium, are preserved today in the Paul Mellon collection at Yale's Beinecke Library. Several were recently reproduced to illustrate a reprint of the Long report by Barre Publishers of Barre, Massachusetts. Yet another example is in the collection of the Academy of Natural Sciences in Philadelphia.

A small painting attributed to Seymour at the Joslyn Art Museum is now thought to be the work of Titian Ramsay Peale, elsewhere represented in the Joslyn catalogue, who also accompanied Long's western expedition in 1819-20.

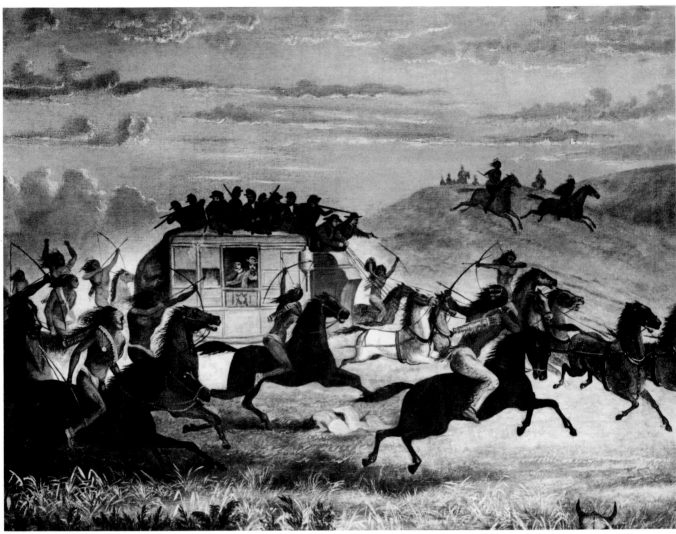

GEORGE SIMONS

Stagecoach Overtaken by Indians

GEORGE SIMONS
1834-1917

A midwestern artist of no apparent formal training, George Simons was a native of Streetor, Illinois. In 1853 he visited Council Bluffs, Iowa as a member of a party of surveyors under Grenville M. Dodge to lay a right-of-way for the future Rock Island Railway. He later settled at Council Bluffs and during the Civil War served with the First Iowa Volunteers, mustering out at Davenport following the cessation of hostilities.

Returning to western Iowa after the war, Simons farmed a small holding near Missouri Valley until he moved to Neola, Iowa in 1880. In Neola he operated a gunsmith shop before moving back to Council Bluffs where he set up a modest business as a photographer and painted local views on the side. His last years were spent in Long Beach, California.

During his first period of residence in Council Bluffs, Simons was engaged by N. P. Dodge, brother of Grenville Dodge, to produce a series of fifty pencil drawings of scenes and activities in and around Council Bluffs and nearby Bellevue, Nebraska. Dated between the years of 1853-56, these drawings are now in the possession of the Council Bluffs Public Library.

Simons also kept a diary of his activities during the period of his service in the Civil War which is now in the manuscript collection of the Joslyn Art Museum. It contains five illustrations in watercolor by Simons, who is further represented at the Joslyn by eleven oil paintings variously dated from 1853 to 1898.

GEORGE SIMONS
A Pause in the Journey
Oil on canvas, 1859
12 x 15¾ in. (30.5 x 40.0 cm.)
No signature
Louis A. Gobel Memorial, 1953
1953.193

Provenance:
Fanny Brown, Council Bluffs, Iowa.
Miss Louise Stegner, Omaha, Nebraska.

Literature:
Joslyn, *Life on the Prairie: The Artist's Record,* 1954, p. 12; Joslyn, *Thirtieth Anniversary, 1931-1961: special commemorative bulletin,* 1961, cover; *The Iowan,* "George Simons: Frontier Artist," Summer 1962, p. 24; Joslyn, *Life on the Prairie: A Permanent Exhibit,* 1966 & 1969, p. 22.

GEORGE SIMONS
Early Council Bluffs
Oil on canvas, 1853
16¼ x 20 in. (41.3 x 50.8 cm.)
No signature
Purchase, 1957
1957.101

Provenance:
Drew's Antiques, Omaha, Nebraska.

Literature:
Joslyn, *Thirtieth Anniversary, 1931-1961: special commemorative bulletin,* 1961; Joslyn, *Life on the Prairie: A Permanent Exhibit,* 1966 & 1969, p. 21; *Nebraska State Historical Society,* "The Great Platte River Road," 1969, Vol. XXV, following p. 140; Friends of the Earth, Inc., *A Sense of Place: The Artist and the American Land,* 1973, Vol. II, no. 383, p. 55.

GEORGE SIMONS
Mail Delivery on the Frontier
Oil on canvas
19⅞ x 27¾ in. (50.5 x 70.5 cm.)
No signature
Gift of Mr. Paul Barlow Burleigh given posthumously by his widow, 1958
1958.36

Provenance:
Mr. Paul Barlow Burleigh, Fullerton, California.

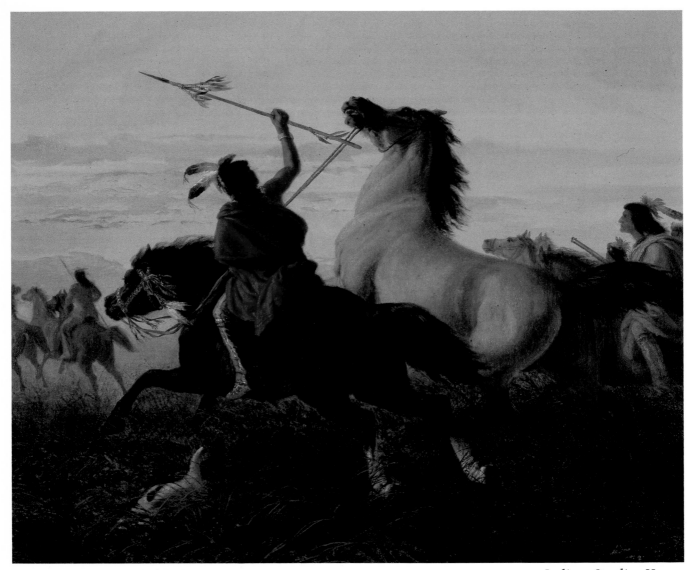

CARL FERDINAND WIMAR

Indians Stealing Horses

GEORGE SIMONS
Portrait of Logan Fontenelle (1825-1855)
Oil on canvas, 1853
24⅛ x 18¼ in. (61.3 x 46.4 cm.)
Inscribed on back of stretcher: "Logan Fontenelle
by George Simons"
Gift of J. M. Harding in memory of Frank J.
Burkley, 1959
1959.428

Provenance:
J. M. Harding, Omaha, Nebraska.

Literature:
Joslyn, *Thirtieth Anniversary, 1931-1961:
special commemorative bulletin*, 1961.

GEORGE SIMONS
Stagecoach Overtaken by Indians
Oil on canvas, 1880s
19 x 24⅞ in. (48.3 x 63.2 cm.)
Inscribed in pencil on back of canvas: "Painted
by G. Simons / Niolia, Ioway"
Purchase, 1962
1962.19

Provenance:
John Howell-Books, San Francisco, California.

Literature:
*The American Heritage History of The Great
West*, 1965 & 1969, p. 338; Nevin, *The
Expressmen* (Old West series), 1974, pp. 176-77;
Joslyn, *Artists of the Western Frontier*, 1976,
no. 109, p. 25; Hassrick, *The Way West: Art of
Frontier America*, 1977, p. 113.

GEORGE SIMONS
Cows Wading in Stream
Oil on canvas
13¾ x 20 in. (34.9 x 50.8 cm.)
No signature
Gift of Harry Norman Simons, 1962
1962.28

Provenance:
Harry Norman Simons, Lebanon, Oregon.

GEORGE SIMONS
Portrait of Harry Norman Simons
Oil on canvas
18 x 13 in. (45.7 x 33.0 cm.)
Inscribed on back of canvas: "Harry N. Simons,
Age 19, painted by his father, George N. Simons"
Label on back of canvas: "Harry Norman
Simons, painted in 1898"
Gift of Harry Norman Simons, 1962
1962.30

Provenance:
Harry Norman Simons, Lebanon, Oregon.

GEORGE SIMONS
Harry Norman Simons on Horseback
Oil on canvas
25¾ x 20 in. (65.4 x 50.8 cm.)
Signed l.r.: George Simons
Inscribed on back of canvas: "Harry N. Simons,
Age 18, Cody, Nebraska"
Gift of Harry Norman Simons, 1962
1962.31

Provenance:
Harry Norman Simons, Lebanon, Oregon.

GEORGE SIMONS
Forest Fire at Mount Rainier
Oil on canvas
27¼ x 20¼ in. (69.2 x 51.4 cm.)
Inscribed on back of stretcher: "Taken from Life
at Mt. Ranier by George N. Simons in 1888"
Gift of Harry Norman Simons, 1962
1962.32

Provenance:
Harry Norman Simons, Lebanon, Oregon.

GEORGE SIMONS
*Mormon Camp Meeting, Council Bluffs
(Mormon Encampment)*
Oil on canvas
17¼ x 26 in. (43.8 x 66.0 cm.)
No signature
Given in memory of Walter L. Burritt by Mrs.
Kenneth Parker, 1963
1963.416

Provenance:
Mrs. Kenneth Parker, Omaha, Nebraska.

GEORGE SIMONS
Sitting Bull
Oil on canvas
19⅞ x 16 in. (50.5 x 40.6 cm.)
No Signature
Permanent Loan, Omaha Public Library, 1962
39.1962

ALFRED SULLY
1821-1879

A professional soldier, draftsman, and watercolorist of some ability, Alfred Sully pursued an active life in the U.S. Army that spanned a period of nearly forty years, much of which was spent in the frontier West. Like his contemporary Seth Eastman, Sully was a career officer first and an artist second. A sensitive observer of U.S. Army and American Indian activities, he was also a voluminous writer whose surviving letters furnish a vivid description of conditions in the West during the mid-nineteenth century.

The son of American portraitist Thomas Sully, he was born in Philadelphia and is said to have begun painting at about the age of thirteen. Desiring better things for his son as an engineer, the elder Sully secured for him an appointment to the U.S. Military Academy at West Point where he graduated in 1841 as a second lieutenant.

Between the years of 1848 and 1852, Sully was stationed at Monterey, California where he married the daughter of a wealthy California family. His wife died within a year of their marriage at the birth of a son, who lived for only a few days. In 1853 Sully was reassigned to duty in the Midwest and promoted to the rank of captain.

Later active in the Indian wars, Sully was sent in 1862 to quell a Sioux uprising in southwestern Minnesota. The following year he commanded what was at that time the largest army ever put into the field against some 6,000 Sioux and Cheyenne in the Dakota Territory. In 1877 he was again in the Far West involved briefly in efforts to capture the elusive band of Nez Perces under Chief Joseph in Idaho. Sully afterward retired from active service, retaining the permanent rank of major general to which he had been promoted in 1865.

Sully produced many pictures relative to his experiences in the West, for the most part watercolors. Among his extant works is an early view of Monterey and a series of sketches of forts in Minnesota, produced during the late 1850s. Ten views of western forts by Sully are owned by the Thomas Gilcrease Institute in Tulsa, Oklahoma. Others are found in collections at West Point and at the Minnesota State Historical Society in St. Paul.

An oil painting attributed to Sully is in the permanent collection of the Joslyn Art Museum. An almost

identical painting by this same artist is on permanent loan to the Museum from The InterNorth Art Foundation.

PABLITA VELARDE
b. 1918

Born at the Santa Clara Pueblo, New Mexico, Pablita Velarde first studied art under Tonita Pena at the Albuquerque Indian School. She later credited her finely detailed style in painting to a temporary loss of eyesight resulting from a childhood disease. For many years she made her living as a full-time free-lance artist in Albuquerque. She is one of a very few American Indian women to have achieved success as a professional artist.

She is represented by a single painting in the permanent collection of the Joslyn Art Museum.

WALTER RICHARD WEST
b. 1912

Cheyenne Indian artist Dick West was born near Darlington, Oklahoma and reared by a great aunt and two uncles. Graduating from Haskell and Bacone Indian colleges, he received his B.A. and M.F.A. from the University of Oklahoma at Norman. He later studied art under Olaf Nordmark. During World War II, he served in the United States Navy. In 1964 he won the Waite Phillips Indian Artists Trophy Award. For a number of years, he has served as chairman of the Art Department of Bacone College near Muskogee, Oklahoma.

He is represented in a number of regional and American Indian collections. A tempera painting by West is included in the permanent collection of the Joslyn Art Museum.

PABLITA VELARDE
Zuni Olla Maidens
Casein, 1976
17¾ x 6⅞ in. (45.1 x 17.5 cm.)
Signed l.r.: Pablita Velarde
Gift of Forrest E. Jones, 1976
1976.38

Provenance:
Col. Forrest E. Jones, Grandview, Missouri.

WALTER RICHARD WEST
Wolf Dance
Tempera on paper
20½ x 30⅛ in. (52.1 x 76.5 cm.)
Signed l.r.: Wah-pah-nah-yah (Dick West)
Gift of Morton Steinhart, 1949
1949.181

Provenance:
Morton Steinhart, Nebraska City, Nebraska.

Literature:
Mid-America Arts Alliance, *Native American Paintings*, 1980, Plate K, p. 16.

THOMAS WORTHINGTON WHITTREDGE
1820-1910

Like many American artists throughout the nineteenth century, Thomas Worthington Whittredge received his principal training in the academies of Europe. He found his chief inspiration for his work in the United States, however, establishing a reputation as one of the leading exponents of the Hudson River School of American landscape painting.

Born at Springfield, Ohio, Whittredge later lived in West Virginia and from 1840-49 studied at the Cincinnati Art School. During this period he also worked as a portraitist and daguerreotypist. Encouraged by fellow artist Asher B. Durand to continue his art studies abroad, Whittredge sailed for Europe in 1849 and visited London, Paris, Antwerp, and Dusseldorf, where he spent the better part of four years. Following sketching trips through Switzerland and Italy, he settled in Rome for another period of time.

After ten years in Europe, Whittredge returned to the United States in 1859 and opened a studio in New York City where he devoted himself to the depiction of American rural and wilderness subjects. He made frequent excursions into the Catskill Mountains to paint and also visited western Pennsylvania, Massachusetts, and New Jersey, where he finally settled at Summit.

Elected a National Academician in 1861, Whittredge served as president of the Academy in 1865 and again from 1874 to 1877. During this same period, he made at least three trips into the West, principally to Colorado and New Mexico. He was also one of a very few Anglo-American artists at this time to have visited and sketched south of the U.S. border in Mexico.

At his death in Summit, New Jersey, Whittredge left a number of unsigned paintings in his studio which later were signed and dated by a member of the family.

Works by Whittredge are found today at the Worcester Art Museum, the Boston Museum of Fine Arts, the Peabody Museum at Yale, the Yale University Art Gallery, the Los Angeles County Museum of Art, and in numerous private collections.

A western landscape by Whittredge is included in the collection of the Joslyn Art Museum. Its date suggests that it probably resulted from the artist's first trip into the West with General John Pope. Two additional landscapes are on loan to the Museum from The InterNorth Art Foundation.

CARL (KARL, CHARLES) FERDINAND WIMAR
1828-1862

CARL FERDINAND WIMAR
Indians Stealing Horses
Oil on canvas
16⅛ x 20 in. (41.0 x 50.8 cm.)
Signed l.l.: C. Wimar
Purchase, 1951
1951.80

Provenance:
Mrs. O. S. Cole.
Joseph Saffron Galleries, St. Louis, Missouri.

Literature:
Bulletin, City Art Museum of St. Louis,
"Charles Wimar 1828-1862: Painter of the
Indian Frontier," July-October 1946, Vol. XXXI,
no. 17, p. 62; Joslyn, *Life on the Prairie: A
Permanent Exhibit*, 1966 & 1969, p. 16; Fronval,
La véritable histoire des Indiens Peaux-Rouges,
1973, p. 55; Goethe Institute, Boston, *America
Through the Eyes of German Immigrant
Painters*, 1975, p. 24; Joslyn, *Artists of the
Western Frontier*, 1976, front cover.

Although less than twenty years of his life were spent in the United States, Carl Wimar devoted most of his brief career as an artist to the depiction of American subjects. Born near the modern Bonn, West Germany, he immigrated with his parents to the United States at the age of fifteen and settled in St. Louis, Missouri. Here he received his first instruction in art from Leon Pomarede, a local sign painter, muralist, and panoramist.

Pomarede, himself a native of France, had arrived in America in 1830 and had collaborated with landscape painter Henry Lewis on the production of a large movable panorama of scenes of the Mississippi Valley. In 1849 Pomarede undertook to produce one of his own. With the young Wimar as an assistant, he journeyed up the Mississippi that same year from St. Louis to the Falls of St. Anthony near St. Paul, Minnesota. Returning to St. Louis to complete his project, Pomarede exhibited his *Panorama of the Mississippi River and Indian Life* in New Orleans and several eastern cities. It was later destroyed by fire in Newark, New Jersey.

Meanwhile, Wimar left Pomarede's employ in 1851 and opened a painting studio in St. Louis. The following year an opportunity to go abroad for further study presented itself, and Wimar left for Europe where he spent the next four years chiefly at the academy in Dusseldorf under the instruction of Emanuel Leutze. Returning again to St. Louis in 1856, Wimar opened another studio and began painting western scenes in earnest.

While at Dusseldorf Wimar had painted several western subjects including his *Attack on an Emigrant Train*, which was later reproduced in lithograph and commercially distributed. Back in America he made an excursion in 1858-59 on the Missouri River to Forts Clark and Union. Thereafter he devoted himself almost exclusively to the painting of Indians and buffalo hunting scenes on the Great Plains. He is thought to have made one or possibly two more visits to the Upper Missouri, but documentation of his subsequent travels is uncertain.

In 1861 Wimar married and that same year received a commission to execute a series of mural decorations for the rotunda of the St. Louis County Courthouse. He had just completed this assignment when he died

of consumption at the age of thirty-four. His murals, restored once about 1888, did not survive the years and are now lost to posterity.

Original examples of his work are relatively scarce today. A collection of ten oils by this artist is included in the collection of the Thomas Gilcrease Institute of American History and Art in Tulsa, Oklahoma. A painting by Wimar in the catalogue of the Joslyn Art Museum depicts a characteristic western subject. It is signed but not dated, although a letter by the artist written from Dusseldorf in 1855 makes reference to this work as having been recently painted.

Western Print Catalogue Entries

BY DAVID C. HUNT

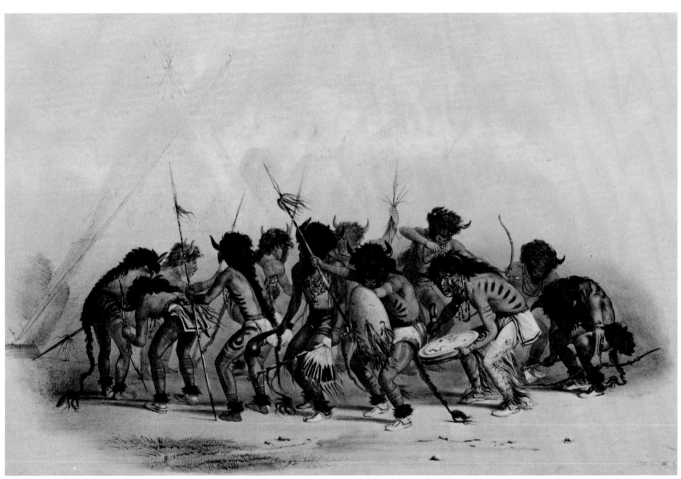

GEORGE CATLIN

Buffalo Dance (lithograph)

CASSILY ADAMS
1843-1921

Custer's Last Fight
Chromolithograph by Otto Becker after Adams
Issued by Anheuser-Busch Brewing Assn.,
St. Louis, 1896
Sheet: 31½ x 41¾ in. (80.0 x 106.0 cm.)
Permanent Loan, Omaha Public Library, 1949
794.4.1949

An American genre and historical painter, Cassily Adams was born in Zanesville, Ohio and received his art education at the Boston Academy of the Arts. After 1870 he lived in Cincinnati where he attended the Cincinnati Art School, and later at St. Louis, Missouri where he worked as an engraver.

His most famous work, *Custer's Last Fight,* was commissioned by the St. Louis Art Club in 1884 and completed by the artist the following year. Sold to a saloon owner in St. Louis, the painting eventually found its way into the hands of a representative of the Anheuser-Busch Brewing Company which reproduced it as a color lithograph in 1896.

The original canvas, offered to the 7th Cavalry stationed at Fort Riley, Kansas, was subsequently forgotten. It came to light again in 1925 in a storage building at Fort Bliss, Texas and was restored by the art division of the WPA in Boston. Returned to Fort Bliss in 1938, the painting was destroyed by a fire in the officer's club in 1946.

Copies of the Anheuser-Busch print by Otto Becker of the Milwaukee Lithographic and Engraving Company survive in various collections, although there are minor points of conflict about the similarity of the print to the lost original.

JOHN JAMES AUDUBON
1785-1851

From *The Birds of America* by John James Audubon. London: Robert Havell, 1827-1838 (4 vols.). Plates are inscribed "Drawn from Nature by J. J. Audubon, F.R.S.F.L.S./ Engraved, Printed & Coloured by R. Havell . . ."

Picus Thidactylis—Three Toed Woodpecker
(Plate CXXXII)
Engraving with aquatint (hand-colored)
Sheet: 38¹/₁₆ x 25⅛ in. (96.7 x 63.8 cm.)
Image: 25¹⁵/₁₆ x 20¾ in. (65.9 x 52.7 cm.)
Gift of Omaha Delphian Council, 1951
1952.81

Son of a French naval officer, John James Audubon was born in the West Indies and reared in France. Encouraged at an early age to take an interest in natural history, he later studied art in Paris. At the age of eighteen, he was sent to the United States to occupy an estate of his father's near Philadelphia where he gave himself to the study of American bird life. In 1808 he married the daughter of a neighboring family and afterward resided for a time in Louisville, Kentucky where he managed a general store. Unsuccessful at commercial ventures, he eventually found employment as a taxidermist for the newly-founded Western Museum in Cincinnati, Ohio.

In 1820 Audubon made his first trip to New Orleans where he made an uncertain living as an instructor of languages and music and continued his pursuit of

Sylvia Celata—Orange Crowned Warbler
(Plate CLXXVIII)
Engraving with aquatint (hand-colored)
Sheet: 39 x 26 in. (99.1 x 66.0 cm.)
Image: 18¾ x 12¼ in. (47.6 x 31.1 cm.)
Gift of Mrs. Richard Eipstein, 1961
1961.454

From *The Viviparous Quadrupeds of North America* by John James Audubon and the Rev. John Bachman. New York: J. J. Audubon, 1845-1848 (3 vols.). Plates are inscribed "Drawn from Nature by J. J. Audubon, F.R.S.F.L.S./Lith. Printed and Col. by J. T. Bowen Phil."

Bos Americanus—American Bison or Buffalo
(Plate LVIII)
Lithograph (hand-colored)
Sheet: 21¾ x 27½ in. (55.2 x 69.9 cm.)
Purchase, 1964
1964.704

Canis Lupis—Black American Wolf (Plate LXVII)
Lithograph (hand-colored)
Sheet: 22 x 28 in. (55.9 x 71.1 cm.)
Purchase, 1951
1951.9

Antelope Americana—Prong Horned Antelope
(Plate LXXVII)
Lithograph (hand-colored)
Sheet: 21⅞ x 27½ in. (55.6 x 69.9 cm.)
Purchase, 1964
1965.708

From *The Quadrupeds of North America* by John James Audubon and the Rev. John Bachman. New York: V. G. Audubon, 1849-1860 (3 vols.). 8vo. Plates are inscribed "On Stone by W. E. Hitchcock/Drawn from Nature by J. J. Audubon F.R.S.F.L.S./Lith. Printed and Col. by J. T. Bowen Phil."

American Bison or Buffalo (Plate LVI)
Lithograph (hand-colored)
Sheet: 6⅞ x 10¼ in. (17.5 x 26.0 cm.)
Purchase, 1966
1966.510

American Bison or Buffalo (Plate LVII)
Lithograph (hand-colored)
Sheet: 6⅞ x 10¼ in. (17.5 x 26.0 cm.)
Purchase, 1966
1966.511

American Elk—Wapiti Deer (Plate LXII)
Lithograph (hand-colored)
Sheet: 6⅞ x 10¼ in. (17.5 x 26.0 cm.)
Purchase, 1966
1966.512

natural history. Seeking a publisher to reproduce a collection of his bird paintings, he went first to Philadelphia in 1824 and then in 1826 to Great Britain where he exhibited his work with considerable success. By 1827 he had obtained enough subscribers to enable him to begin publication of his now famous *The Birds of America.* When completed in 1838, this featured 1,055 individual, life-sized figures engraved and hand-colored on 435 double-elephant folio sheets or leaves. With the help of Scottish naturalist William MacGillivray, Audubon brought out a text to accompany these plates.

In 1842 Audubon bought an estate on the Hudson River, now Audubon Park in New York City, and the following year made an excursion to the upper reaches of the Missouri River. In 1844 he issued an American edition of *The Birds of America* and the following year initiated a new work, *The Viviparous Quadrupeds of North America*, completed in 1848. A text for the latter series was begun in 1846 and an Octavo edition of both plates and text was begun this same year and completed in 1854. A second edition was completed in 1859. Meanwhile, Audubon died at his home in New York, leaving the publication of subsequent editions of his works to his sons Victor Gifford Audubon and John Woodhouse Audubon.

The original watercolors for *The Birds of America* are preserved today in the collection of the New York Historical Society.

Several artists and printers were involved in publishing various editions of Audubon's folios. Robert Havell, Jr., who assisted the elder Havell in producing the first or London edition of *The Birds of America*, followed Audubon to the United States in 1839 and remained to establish a reputation among the painters of the Hudson River School. John T. Bowen, another English-born printer active first in New York and then Philadelphia, issued the American editions of *The Birds* and later published the *Quadrupeds* series.

A chromolithographic edition of approximately 100 subjects from *The Birds of America* was issued to the scale of the original by Julius Bien in New York in the 1860s. The Bien edition is of further interest today among collectors as being one of the earliest examples of full-color printing in America.

JOHN WOODHOUSE AUDUBON
1812-1862

From *The Quadrupeds of North America* by John James Audubon and the Rev. John Bachman. New York: V. G. Audubon, 1849-1860 (3 vols.). 8vo. Plates are inscribed "On Stone by W. E. Hitchcock/Drawn from Nature by J. W. Audubon/Lith. Printed and Col. by J. T. Bowen Phil."

Grizzly Bear (Plate CXXXI)
Lithograph (hand-colored)
Sheet: 6¾ x 10¼ in. (17.1 x 26.0 cm.)
Purchase, 1966
1966.513

The younger of two sons of John James Audubon, John Woodhouse Audubon was born at Henderson, Kentucky and trained by his father to assist in the production of the celebrated Audubon bird and animal folios. J. W. Audubon worked on both drawings and lithographic plates for various editions of *The Birds of America* and *The Viviparous Quadrupeds of North America*, reducing the size of his father's original illustrations for the Octavo edition of *The Birds* (1840-44) with the aid of a Camera Lucida. Eventually he married Maria Bachman, eldest daughter of Charleston naturalist John Bachman, who assisted J. J. Audubon in the publication of *The Quadrupeds* series.

From about 1839 John Woodhouse Audubon resided in New York City and frequently exhibited at the American Art-Union and the National Academy of Design. Contributing nearly half of the subjects reproduced in the *Quadrupeds* series, he made a trip to Texas in 1845-46 to gather material for this publication and in 1849 joined a gold rush expedition to California. Returning to New York the following year, he continued to be active in the publication of editions of both the *Birds* and *Quadrupeds* folios.

ALBERT BIERSTADT
1830-1902

A Halt in Yosemite Valley
Engraving
Printed below image: A. Bierstadt, pinxt/
A. Willmore, sculpt.
Image: 7 x 9⅞ in. (17.8 x 25.1 cm.)
Purchase, 1947
1947.328

The Last of the Buffalo
Engraving: proof sheet before title, uncolored
Signed l.r. (on plate): A. Bierstadt; Inscribed l.r. (on margin): Gen. G. M. Dodge with the compliments of Albert Bierstadt; u.r.: Copyright 1891 by Albert Bierstadt.
Image: 16½ x 27½ in. (41.9 x 69.9 cm.)
Gift of G. M. Dodge Estate, 1950
1950.143

Sunset
Chromolithograph 1868
Printed l.r.: monogram; below image: Published by L. Prang and Company.
Image: 12 x 18 in. (30.5 x 45.7 cm.)
Gift of Mrs. Jasper Hall, 1979
1979.10

Remembered today for his grandiose depictions of the western wilderness, Albert Bierstadt became in his day one of the most successful landscape painters in America. His dramatic views of Rocky Mountain scenery, exhibited at the National Academy of Design in 1860, brought him immediate acclaim and his works soon were bringing higher prices than any painter in his field had previously commanded. Traveling abroad several times between the years of 1867 and 1883, he received a number of German and Austrian decorations and was designated as a chevalier of the French Legion of Honor.

Bierstadt's later years were less happy. In 1882 his palatial studio on the Hudson River burned. In 1889 a painting entitled *The Last of the Buffalo* was rejected by a committee of New York artists for inclusion in the American Exhibition in Paris. Increasingly ignored by art dealers, Bierstadt continued to paint his western landscapes in a rented studio in New York. He

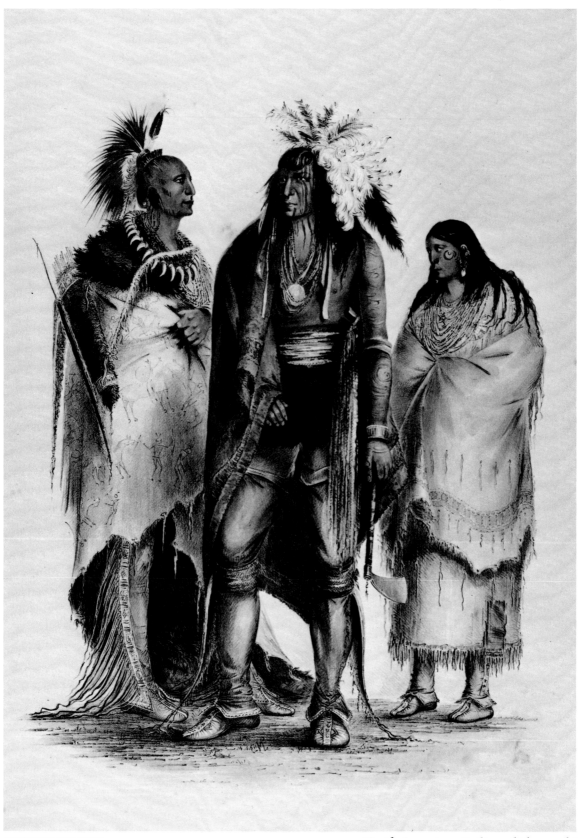

GEORGE CATLIN *North American Indians* (lithograph)

died at the age of seventy-two, for the most part forgotten in American art circles.

As with other of his works appearing in engraved and chromolithographic editions, *The Last of the Buffalo* was commercially reproduced and sold. The original may be seen today at the Whitney Gallery of Western Art in Cody, Wyoming.

KARL BODMER
1809-1893

From the atlas for *Travels in the Interior of North America* by Maximilian, Prince of Wied. Koblenz, Paris, and London: various publishers, 1839-43.

Boston Lighthouse (Vignette 1)
Engraving with aquatint (hand-colored)
Image: 6 x 8½ in. (15.2 x 21.6 cm.)
Purchase, 1965
1965.110

View on the Delaware near Bordentown
(Vignette 2)
Engraving with aquatint (hand-colored)
Image: 6¾ x 10⅜ in. (17.1 x 26.4 cm.)
Purchase, 1965
1965.198

View of Bethlehem (Pennsylvania) (Vignette 3)
Engraving with aquatint (hand-colored)
Image: 7⅛ x 10⅜ in. (18.1 x 26.4 cm.)
Purchase, 1965
1965.109

Penitentiary near Pittsburgh (Vignette 4)
Engraving with aquatint (hand-colored)
Image: 6⅞ x 10¾ in. (17.5 x 27.3 cm.)
Purchase, 1965
1965.199

View of Mauch-Chunk (Pennsylvania)
(Vignette 5)
Engraving with aquatint (hand-colored)
Image: 7⅛ x 10¾ in. (18.1 x 27.3 cm.)
Purchase, 1965
1965.107

Skin Lodge of an Assiniboin Chief (Vignette 16)
Engraving with aquatint (hand-colored)
Image: 17½ x 23⅞ in. (44.5 x 60.6 cm.)
Purchase, 1955
1955.45

Beaver Hut on the Missouri (Vignette 17)
Engraving with aquatint (hand-colored)
Image: 6¾ x 10 in. (17.1 x 25.4 cm.)
Purchase, 1966
1966.112

Born at Zurich, Switzerland, Karl Bodmer received his first formal instruction in art from his maternal uncle, Johann Jacob Meier, under whom he studied with his elder brother Rudolph. Later active as an artist at Koblenz, Bodmer came to the attention of Alexander Philip Maximilian, Prince of Wied Neuwied in Rhenish Prussia, who selected him as the artist to accompany a forthcoming expedition to North America.

Prince Maximilian had made a scientific exploration of Brazil in 1815-17 and had published an account of this experience at Frankfurt in 1820-21. No illustrator other than Maximilian himself had accompanied the South American expedition, and the Prince was encouraged by friends to take along a competent, professional artist on his next adventure. Anxious to insure that a complete pictorial record of his intended travels in the United States and its western territories would be made, Maximilian hired Bodmer for this purpose. Bodmer was only twenty-three years of age at the time, but already he was a skilled draftsman and watercolorist.

Following a stormy Atlantic passage, Bodmer and his patron arrived in Boston, Massachusetts on July 4, 1832. They afterward visited New York and Philadelphia before traveling on to St. Louis, then the gateway to the western frontier. Here they were welcomed in March of 1833 by retired explorer William Clark who was serving as Superintendent of Indian Affairs for the western tribes. After first considering accompanying a traders' caravan bound overland for Oregon Territory, Maximilian decided to visit the American Fur Company outposts on the Upper Missouri River where he felt that better opportunities for scientific research and the observation of native peoples could be realized.

Maximilian's party set out in April from St. Louis on the steamer *Yellowstone*, following the historic route into the interior of the country first taken by

Mandeh-Pahchu, a Young Mandan Indian
(Vignette 24)
Engraving with aquatint (hand-colored)
Image: 13⅝ x 10½ in. (34.6 x 26.7 cm.)
Purchase, 1948
1948.28

Dance of the Mandan Indians (Vignette 25)
Engraving with aquatint (hand-colored)
Image: 10 x 13½ in. (25.4 x 34.3 cm.)
Purchase, 1948
1948.27

Dog Sledges of the Mandan Indians (Vignette 29)
Engaving with aquatint (hand-colored)
Image: 9¾ x 12⅛ in. (24.8 x 30.8 cm.)
Purchase, 1951
1951.22

**Bellevue, Mr. Dougherty's Agency on the
Missouri** (Vignette 31)
Engraving with aquatint (hand-colored)
Image: 7½ x 10½ in. (19.1 x 26.7 cm.)
Purchase, 1954
1954.180

Entry to the Bay of New York from Staten Island
(Vignette 33)
Engraving with aquatint (hand-colored)
Image: 7¼ x 10¼ in. (18.4 x 26.0 cm.)
Purchase, 1965
1965.108

**Massika, Saki Indian/and Wakusasse, Musquake
Indian** (Tableau 3)
Engraving with aquatint (hand-colored)
Image: 11½ x 13¼ in. (29.2 x 33.7 cm.)
Purchase, 1951
1951.14

The Steamer Yellowstone (Tableau 4)
Engraving with aquatint (hand-colored)
Image: 10⅛ x 12½ in. (25.7 x 31.8 cm.)
Purchase, 1953
1953.78

Snags (Sunken Trees) on the Missouri (Tableau 6)
Engraving with aquatint (hand-colored)
Image: 10½ x 12⅞ in. (26.7 x 32.7 cm.)
Purchase, 1953
1953.77

Missouri Indian/Oto Indian/Chief of the Puncas
(Tableau 7)
Engraving with aquatint (hand-colored)
Image: 12½ x 16 in. (31.8 x 40.6 cm.)
Purchase, 1949
1949.146

Wahk-ta-ge-li, a Sioux Warrior (Tableau 8)
Engraving with aquatint (hand-colored)
Image: 14 x 10½ in. (35.6 x 26.7 cm.)
Purchase, 1951
1951.12

Lewis and Clark nearly thirty years before. After stopping briefly at Forts Pierre and Clark, Bodmer and Maximilian continued upriver to Fort Union on the present border of the states of North Dakota and Montana. From Fort Union they pushed farther upriver by flatboat to Fort McKenzie near today's Fort Benton, Montana north of Great Falls. Throughout the arduous voyage into the interior of the country, the prince took copious notes on the geology, flora, and fauna of the area, while Bodmer made portraits among the Indian tribes and sketched the wild scenery and animal life of the region.

Returning downriver in September, 1833, the party again visited Fort Union and wintered at Fort Clark where the explorers made extensive studies of the Mandan and Hidatsa tribes in that area. After nearly thirteen months spent on the upper Missouri, Bodmer and Maximilian arrived back at St. Louis where they packed their collections for shipment abroad and made plans to return home to Europe. Maximilian returned to Germany to edit his field journals and published an account of his travels in North America which was issued in successive German, French, and English language editions between the years of 1839 and 1843. A picture atlas of eighty-one hand-colored aquatint engravings after paintings by Bodmer accompanied Maximilian's publications. This atlas is now acknowledged as one of the earliest and most comprehensive visual surveys of the Far West ever produced.

For Bodmer, the relatively brief experience in the American West gave him practical experience as an observer of nature and probably sharpened his skills as an illustrator. Back in Europe in 1834 to supervise the production of the platebook, Bodmer exhibited some of his American scenes at the Paris Salon. He did not again visit North America, but instead moved to Barbizon, France, where he settled permanently in 1854. At Barbizon he associated with such notables as Francois Millet, Emile Corot, and other painters of the Barbizon School.

Chiefly a landscape painter in his later years, Bodmer also contributed frequently to periodicals such as *Magasin Pittoresque* and *L'Illustration*. His *Inside the Forest in Winter* was exhibited at the Paris Salon in 1850 and later purchased by the French Government and displayed at the Luxembourg Museum.

In 1875 Bodmer was named a Chevalier of the French Legion of Honor. He married this same year. He remained chiefly devoted to depictions of nature and

Fort Pierre on the Missouri (Tableau 10)
Engraving with aquatint (hand-colored)
Image: 9½ x 12½ in. (24.1 x 31.8 cm.)
Purchase, 1951
1951.13

Noapeh, an Assiniboin Indian/Psihdja-Sahpa, a Yanktonan Indian (Tableau 12)
Engraving with aquatint (hand-colored)
Image: 11 x 14¾ in. (27.9 x 37.5 cm.)
Purchase, 1948
1948.30

Noapeh, an Assiniboin Indian/Psihdja-Sahpa, a Yanktonan Indian (Tableau 12)
Engraving with aquatint (hand-colored)
Image: 11 x 14¾ in. (27.9 x 37.5 cm.)
Purchase, 1966
1966.113

Mih-tutta-hangkusch, a Mandan Village (Tableau 16)
Engraving with aquatint (hand-colored)
Image: 9½ x 12½ in. (24.1 x 31.8 cm.)
Purchase, 1951
1951.16

The Interior of the Hut of a Mandan Chief (Tableau 19)
Engraving with aquatint (hand-colored)
Image: 10⅞ x 16 in. (27.6 x 40.6 cm.)
Purchase, 1955
1955.248

Sih-Chida and Mahchsi-Karehde, Mandan Indians (Tableau 20)
Engraving with aquatint (hand-colored)
Image: 15¼ x 14 in. (38.7 x 35.6 cm.)
Purchase, 1966
1966.114

Fort Union on the Missouri (Tableau 28)
Engraving with aquatint (hand-colored)
Image: 9¾ x 12¼ in. (24.8 x 31.1 cm.)
Purchase, 1951
1951.11

Indians Hunting the Bison (Tableau 31)
Engraving with aquatint (hand-colored)
Image: 12 x 16¼ in. (30.5 x 41.3 cm.)
Purchase, 1954
1954.181

Remarkable Hills on the Upper Missouri (Tableau 34)
Engraving with aquatint (hand-colored)
Image: 11¾ x 17 in. (29.8 x 43.2 cm.)
Purchase, 1966
1966.95

Herd of Bison on the Upper Missouri (Tableau 40)
Engraving with aquatint (hand-colored)
Image: 13⅝ x 17 in. (34.6 x 43.2 cm.)
Purchase, 1951
1951.15

the forest landscape of Fontainebleau near Barbizon until he moved to Paris in 1884. He died in Paris nine years later after a lengthy period of failing health.

The aquatints accompanying the publication of Maximilian's travel account were issued in a consecutive series and in various editions, both colored and uncolored. The series eventually totaled thirty-three vignettes and forty-eight tableaus or plates on Imperial Atlas folio paper. Respective titles to all pictures were rendered in German, French, and English. The atlas for the English edition was issued in a single volume in 1844.

Today the aquatint versions of Bodmer's North American paintings are much sought after by collectors. Complete sets of the entire series of plates in good condition are extremely rare. After the publication of the picture atlas, Bodmer's watercolor illustrations and the copperplates used in producing the atlas were returned to Prince Maximilian. They remained at the Wied estate on the Rhine until rediscovered by U.S. military occupation forces following the end of World War II.

In 1953 a selection of more than one hundred of the Bodmer watercolors was brought to the United States and exhibited under the joint auspices of the Smithsonian Institution and the Newberry Library of Chicago. They were later exhibited in Omaha. In 1962 they were acquired by the then Northern Natural Gas Company of Omaha and subsequently deposited with the Joslyn Art Museum. Included in this remarkable collection are more than 400 sketches and watercolors by Bodmer pertaining to the North American expedition of 1832-34. With Maximilian's original journals and related material, these now form one of the Museum's most important western holdings.

Fort McKenzie (Tableau 42)
Engraving with aquatint (hand-colored)
Image: 16½ x 21⅛ in. (41.9 x 53.7 cm.)
Gift of Mr. and Mrs. R. L. Turner, 1954
1954.51

Chief of the Blood Indians/War-Chief of the Piekann Indians/Koutani Indian (Tableau 46)
Engraving with aquatint (hand-colored)
Image: 12½ x 18 in. (31.8 x 45.7 cm.)
Purchase, 1948
1948.29

Herds of Bison and Elk on the Upper Missouri (Tableau 47)
Engraving with aquatint (hand-colored)
Image: 10¼ x 12½ in. (26.0 x 31.8 cm.)
Purchase, 1966
1966.96

From *Catlin's North American Indian Portfolio*. London: the artist, 1844. Plates are inscribed "Catlin Del/on Stone by McGahey/Day and Haghe, Lithrs to the Queen."

North American Indians (No. 1)
Lithograph (hand-colored)
Sheet: 23 x 17 in. (58.4 x 43.2 cm.)
Image: 17¾ x 13¹⁄₁₆ in. (45.1 x 33.2 cm.)
Purchase, 1963
1963.271

Buffalo Bull Grazing (No. 2)
Lithograph (hand-colored)
Sheet: 17 x 23 in. (43.2 x 58.4 cm.)
Image: 12 x 17½ in. (30.5 x 44.5 cm.)
Purchase, 1965
1965.152

Wild Horses at Play (No. 3)
Lithograph (hand-colored)
Sheet: 17 x 23 in. (43.2 x 58.4 cm.)
Image: 12⅛ x 17¾ in. (30.8 x 45.1 cm.)
Purchase, 1953
1953.85

Buffalo Hunt, Chase (No. 5)
Lithograph (hand-colored)
Image: 12¼ x 17¼ in. (31.1 x 43.8 cm.)
Purchase, 1966
1966.115

Buffalo Hunt, Chase (No. 6)
Lithograph (hand-colored)
Image: 12 x 17½ in. (30.5 x 44.5 cm.)
Purchase, 1966
1966.87

GEORGE CATLIN
1796-1872

Initially trained as a lawyer, George Catlin practiced law with a brother in Lucerne County, Pennsylvania until about 1821 when he moved to Philadelphia to pursue the private study of art. He afterward specialized in portraiture in Philadelphia and New York City. He was elected to membership in the Pennsylvania Academy of Fine Art in 1824 and to the National Academy of Design in 1826. In the latter year he produced his earliest known Indian portrait of Seneca orator Red Jacket at Buffalo, New York.

In 1830 he set out for St. Louis and the Far West and for the next six years he devoted his considerable energies to the depiction of the Indian tribes of North America. Between the years 1836 and 1839 he exhibited a large collection of Indian paintings throughout the eastern United States, hoping to interest the U.S. Congress in purchasing it for the nation. In 1839 he sailed for England with nearly eight tons of paintings, artifacts, and related paraphernalia which opened in London in 1841 to enthusiastic, if mixed, reviews. For the next several years, he continued to exhibit and lecture in England and on the continent.

While in London Catlin published his *Letters and Notes on the Manners, Customs and Condition of the North American Indians* (2 vols., 1841) featuring 312 engraved illustrations, and *Catlin's North American Indian Portfolio* (1844) presenting a collection of lithographic reproductions of figures, portraits, and scenes included in the London show. Following a tour of France and an exhibition in Paris, he published his

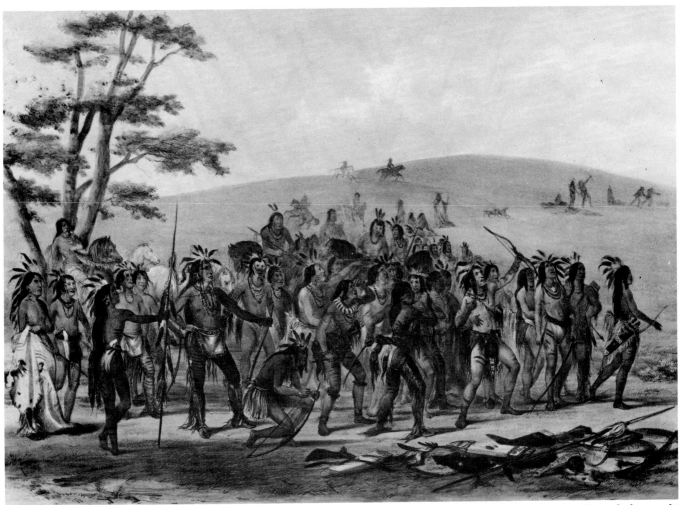

GEORGE CATLIN

Archery of the Mandans (lithograph)

Buffalo Hunt (No. 7)
Lithograph (hand-colored)
Image: 11⅝ x 17¾ in. (29.5 x 45.1 cm.)
Purchase, 1963
1963.276

Buffalo Dance (No. 8)
Lithograph (hand-colored)
Image: 12 x 17¾ in. (30.5 x 45.1 cm.)
Purchase, 1963
1963.272

Buffalo Hunt, White Wolves Attacking a Buffalo
(No. 10)
Lithograph (hand-colored)
Image: 12 x 17½ in. (30.5 x 44.5 cm.)
Purchase, 1966
1966.88

Buffalo Hunt, Approaching in a Ravine (No. 11)
Lithograph (hand-colored)
Image: 12⁹⁄₁₆ x 17¾ in. (31.9 x 45.1 cm.)
Purchase, 1963
1963.273

Buffalo Hunt, Chasing Back (No. 12)
Lithograph (hand-colored)
Image: 12 x 17½ in. (30.5 x 44.5 cm.)
Purchase, 1966
1966.117

Buffalo Hunt, Under White Wolf Skin (No. 13)
Lithograph (hand-colored)
Image: 12 x 17½ in. (30.5 x 44.5 cm.)
Purchase, 1966
1966.89

Buffalo Hunt on Snowshoes (No. 15)
Lithograph (hand-colored)
Image: 12 x 17½ in. (30.5 x 44.5 cm.)
Purchase, 1966
1966.90

Wounded Buffalo Bull (No. 16)
Lithograph (hand-colored)
Image: 12 x 17½ in. (30.5 x 44.5 cm.)
Purchase, 1966
1966.485

Dying Buffalo Bull, in Snow Drift (No. 17)
Lithograph (hand-colored)
Image: 12 x 17½ in. (30.5 x 44.5 cm.)
Purchase, 1966
1966.62

The Bear Dance (No. 18)
Lithograph (hand-colored)
Image: 12¼ x 17¼ in. (31.1 x 43.8 cm.)
Purchase, 1966
1966.116

Attacking the Grizzly Bear (No. 19)
Lithograph (hand-colored)
Image: 12 x 17½ in. (30.5 x 44.5 cm.)
Purchase, 1966
1966.91

Eight Years' Travel and Residence in Europe (2 vols., 1848) as a sequel to *Letters and Notes.* While traveling abroad, his wife Clara died of pneumonia in 1845 and their young son of typhoid in 1846. Catlin was left with three small daughters to support by any means at hand.

Although well attended, Catlin's European exhibitions did not generate enough revenue to enable him to subsist without other income. His publications failed to make much more than production costs. Plagued by indebtedness, he began selling parts of his collection and created numerous replicas for sale to private collectors. In 1852 he lost his collection to creditors and spent the next twenty years in self-imposed exile abroad, recreating from memory his lost North American Indian Gallery and producing another series based upon his subsequent travels in South America.

In 1870 he returned to the United States after an absence of nearly thirty-two years and exhibited in New York City and at the Smithsonian Institution in Washington. Catlin stayed in Washington, still hoping to gain for his work the national recognition he felt it deserved, until he was taken seriously ill in the latter part of 1872 and remanded to the care of his daughters in Jersey City, New Jersey. He died in December of that year at the age of seventy-six and was buried in a Brooklyn cemetery beside his wife and son.

Catlin produced two distinct collections between the years 1830 and 1870: the original Indian Gallery and a "cartoon" collection, as it is called. Each of these numbered approximately 600 works. Catlin duplicated many scenes and subjects in the original collection, reducing earlier compositions to simple designs of outline and color referred to as cartoons by his contemporaries. His later South American studies, on paperboard colored with a thin wash of oil or watercolor, were also rendered as cartoons.

Oil on canvas copies of some of these were acquired in the 1850s by Frederick Wilhelm IV of Prussia and King Leopold I of Belgium. Ten paintings commissioned by the King of Prussia are found today at the Museum für Völkerkunde in Berlin. A collection of thirty-three paintings belonging to Leopold I eventually was acquired by the Royal Ontario Museum in Toronto. Following Catlin's death, the bulk of the cartoon collection passed to his surviving daughters, who left it in the care of the Smithsonian Institution until 1876. It was finally purchased by the American

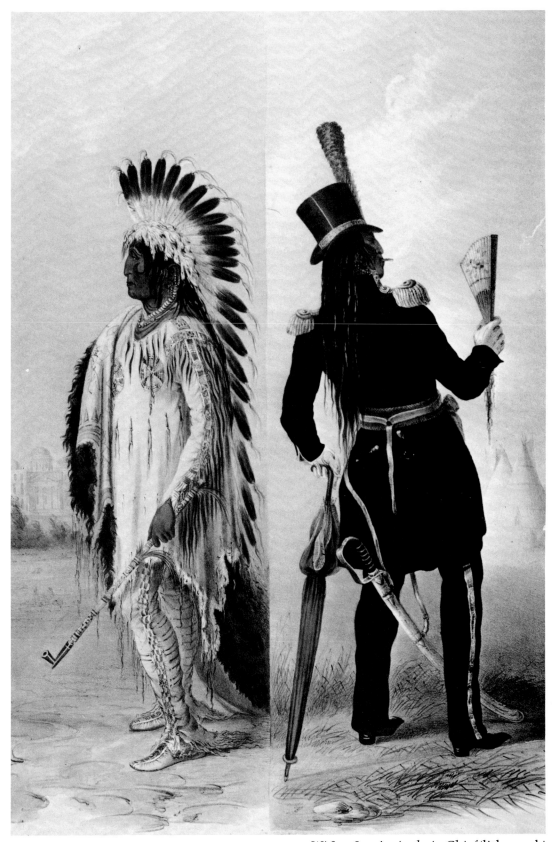

GEORGE CATLIN *Wi-Jun-Jon Assineboin Chief* (lithograph)

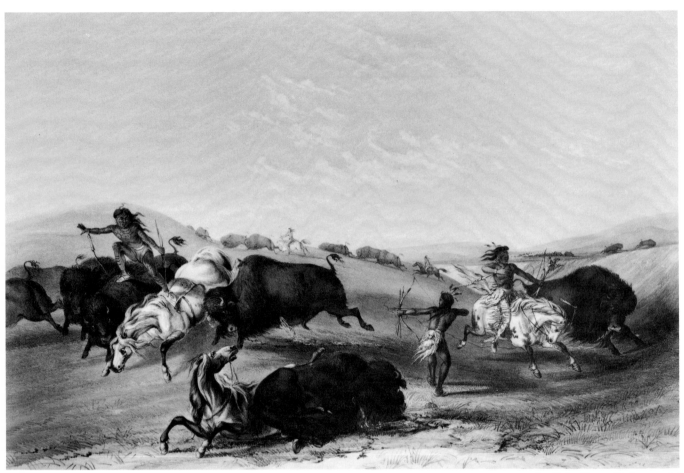

GEORGE CATLIN *Buffalo Hunt* (lithograph)

Antelope Shooting (No. 20)
Lithograph (hand-colored)
Image: 12 x 17½ in. (30.5 x 44.5 cm.)
Purchase, 1966
1966.93

Ball Players (No. 21)
Lithograph (hand-colored)
Image: 12 x 17¼ in. (30.5 x 43.8 cm.)
Purchase, 1966
1966.162

Ball-Play Dance (No. 22)
Lithograph (hand-colored)
Image: 12⅜ x 18 in. (31.4 x 45.7 cm.)
Purchase, 1966
1966.94

Archery of the Mandans (No. 24)
Lithograph (hand-colored)
Image: 12 x 17⅜ in. (30.5 x 44.1 cm.)
Purchase, 1963
1963.277

Wi-Jun-Jon, Assiniboin Chief (Going to Washington/Returning to His Home) (No. 25)
Lithograph (hand-colored)
Image: 17½ x 12⅛ in. (44.5 x 30.8 cm.)
Purchase, 1963
1963.275

Buffalo Hunting (No. 30)
Lithograph (hand-colored)
Image: 12 x 17½ in. (30.5 x 44.5 cm.)
Purchase, 1966
1966.454

From *The Natural History of Man: Comprising Enquiries into the Modifying Influence of the Physical and Moral Agencies on the Different Tribes of the Human Family.* New York and London: H. Bailliere, 1855.
Engravings listed are by J. Harris after Catlin, inscribed "Dr. Prichard's Natural History of Man."

Mah-to-toh-pa, the Four Bears, Second Chief of the Mandans
Engraving (hand-colored)
Image: 9¹/₁₆ x 5⅝ in. (23.0 x 14.3 cm.)
Purchase, 1948
1948.35-a

Mi-Nee-ee-sunk-te-ka, The Mink, a Mandan Girl
Engraving (hand-colored)
Image: 9¹/₁₆ x 5⅝ in. (23.0 x 14.3 cm.)
Purchase, 1948
1948.35-b

Museum of Natural History in New York City. In the 1960s a number of pieces from this collection were privately acquired and later donated to the National Gallery of Art in Washington, D.C.

Today the Smithsonian Institution owns the major portion of the original Indian Gallery, acquired by American collector Joseph Harrison in 1852 and bequeathed to the Smithsonian by Harrison's widow in 1879. Another important collection of works produced before 1852 is owned by the Thomas Gilcrease Institute in Tulsa, Oklahoma, acquired from the ex-collection of Catlin's friend and patron, Sir Thomas Phillipps. Other examples of Catlin's work are found in both public and private collections in this country and abroad.

Also of interest today are several surviving Catlin publications in addition to those earlier referenced. Catlin published on widely ranging topics including *The Steam Raft, Suggested as a Means of Security to Human Life upon the Ocean* (1860) and *The Breath of Life: or Mal-respiration and Its Effects upon the Enjoyments and Life of Man*, which appeared in several versions and editions under the briefer title *Shut Your Mouth and Save Your Life*. Better known is his last narrative entitled *Last Rambles Amongst the Indians of the Rocky Mountains and the Andes* published in 1869 before the artist finally returned home to the United States. Several unpublished albums containing original watercolor reproductions by Catlin of various subjects from his Indian Gallery, referred to as "albums unique," are preserved today in both public and private collections.

The Black Hawk, A Sac Chief
Engraving (hand-colored)
Image: 9⅛ x 5¹¹⁄₁₆ in. (23.2 x 14.4 cm.)
Purchase, 1949
1949.130

The Little White Bear
Engraving (hand-colored)
Image: 8¹⁵⁄₁₆ x 5¹¹⁄₁₆ in. (22.7 x 14.4 cm.)
Purchase, 1949
1949.131

JOHN CAMERON
1828-1863

See Currier & Ives
1954.52

NATHANIEL CURRIER
1813-1888

Lithographer Nathaniel Currier was born at Roxbury, Massachusetts and was only fifteen when he went to work as an apprentice lithographer with the Boston printing firm of John and W. S. Pendleton. He later worked for a year in Philadelphia and in 1834 moved to New York City. Here he established his own reputation as a lithographer and publisher of American genre subjects. At the time of his death, his name was nationally known and his pictures were scattered throughout the world.

The Prairie Hunter: One Rubbed Out
Colored lithograph after A. F. Tait, copyright Nathaniel Currier, 1852
Printed below image: Painted by A. F. Tait-Entered According to Act of Congress in the year 1852 by N. Currier—Lith. of N. Currier, N.Y.
Image: 14⅛ x 20⅞ in. (35.9 x 53.0 cm.)
Purchase, 1965
1965.196

CURRIER AND IVES

Having established himself as a commercial printer in New York City at the age of twenty-one, Nathaniel Currier (1813-1888) gained wide recognition in 1840 with the publication of a print depicting the destruction of the celebrated steamship *Lexington*. Currier and his associates worked around the clock to supply the demand for copies of this print and were still receiving orders eleven months later.

In 1852 he hired a twenty-eight-year-old bookkeeper, James Merritt Ives (1824-1895). An artist and lithographer in his own right, Ives soon proved that he had even more talent as a businessman. Currier made him a full partner in the business in 1857. From this time until the turn of the century, Currier and Ives were the best known printmakers in America.

The Rocky Mountains: Emigrants Crossing the Plains
Colored lithograph, copyright Currier and Ives, 1866
Printed l.l.: F. F. Palmer, Del.; l.r.: Currier & Ives, Lith., N.Y.; below image: Entered According to Act of Congress, AD 1866, by Currier & Ives. . .
Image: 17½ x 26⅞ in. (44.5 x 68.3 cm.)
Purchase, 1953
1953.195

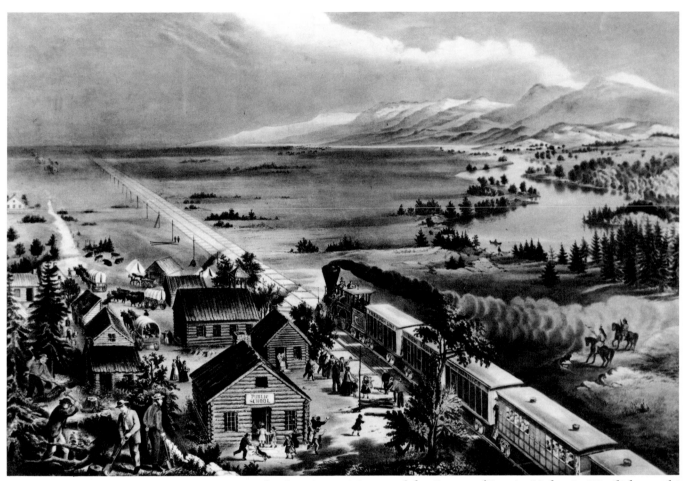

CURRIER AND IVES *Across the Continent: Westward the Course of Empire Makes its Way* (lithograph)

Trappers on the Prairie
Colored lithograph after John Cameron, copyright Currier and Ives, 1866
Printed l.l.: J. Cameron, Del.; l.r.: Currier & Ives, Lith., N.Y.; below image: Published by Currier & Ives. Entered According to Act of Congress in the Year 1866. . .
Image: 17⅛ x 26½ in. (43.5 x 67.3 cm.)
Purchase, 1954
1954.52

The Trapper's Last Shot
Colored lithograph after William T. Ranney, n.d.
Printed below image: New York, Published by Currier & Ives, 152 Nassau St./Lith. Currier and Ives, N.Y.
Image: 10¾ x 15½ in. (27.3 x 39.4 cm.)
Purchase, 1954
1954.53

Prairie Fires of the Great West
Colored lithograph, copyright Currier & Ives, 1871
Printed below image: Published by Currier & Ives. Entered According to Act of Congress in the year 1871 by Currier and Ives. . .
Image: 8⅝ x 12½ in. (21.9 x 31.8 cm.)
Purchase, 1954
1954.182

Through to the Pacific
Colored lithograph, copyright Currier & Ives, 1870
Printed below image: Published by Currier and Ives. Entered According to Act of Congress in the year 1870 by Currier & Ives. . .
Image: 8 x 12 in. (20.3 x 30.5 cm.)
Gift of E. A. Kingman, 1956
1956.373

Across the Continent: Westward the Course of Empire Makes its Way
Colored lithograph, copyright Currier and Ives, 1868
Printed l.l.: J. M. Ives, Del.; l.r.: Drawn by F. F. Palmer; below image: Entered According to Act of Congress 1868 by Currier & Ives. . .
Image: 17⅝ x 27⅛ in. (44.8 x 68.9 cm.)
Gift of E. A. Kingman, 1963
1963.499

The Rocky Mountains
Colored lithograph, copyright Currier & Ives, 1872
Printed below image: F. F. Palmer, Del.; Currier & Ives, Lith., N.Y.; Entered According to Act of Congress in the Year 1872 by Currier & Ives. . .
Image: 8⅜ x 12⅜ in. (21.3 x 31.4 cm.)
Purchase, 1965
1965.6

Billing their pictures as "Colored Engravings for the People," the house of Currier and Ives published such widely diverse subjects as views of cities, portraits, dramatizations of historical events, political cartoons, religious scenes, steamboat races, hunting and sporting scenes, horse races, and Civil War battles. Advertising themselves as publishers of "Cheap and Popular Pictures," they reproduced the works of many of the most famous artists of the day including Louis Maurer, William Ranney, and Arthur Tait. Two of their most popular and frequently used artists were George Durrie and Charles Parsons. Another artist, Fanny Palmer, contributed her own talents to the firm as both painter and lithographer and is represented by a number of western subjects despite the fact that she never traveled west of the Mississippi.

Original pictures were copied on stone by various artists and the prints were then colored by a staff of a dozen young women. The firm itself never printed colors directly from the stone, a process known as chromolithography, but sometimes had work done in this method by outside jobbers. Currier and Ives supplied agents throughout the United States and Europe with editions of various prints and mailed out large catalogues which are invaluable today as guidebooks for modern collectors. After the death of Currier in 1888 and Ives in 1895, their sons carried on the business until the turn of the century. Eventually sold to the son of a former sales manager of the firm, the business was finally disposed of in 1907. Thus ended a period of nearly seventy-three years of printmaking in America in which Currier and Ives supplied more pictures of American life than any publisher in existence.

Following the demise of the firm, Currier and Ives lithographs were relegated to forgotten parlor corners, attics, and antique shops as curiosities of a bygone day. Thus they remained for nearly half a century, supplanted by the art of photo reproduction and modern offset printing techniques.

More recently, however, Currier and Ives prints have experienced a revival of interest among those who recognize them as unique and authentic documents of nineteenth century America. Once sold by the thousands for only a few cents apiece, examples now are eagerly sought by knowledgeable buyers at prices that may range into the thousands of dollars for a single print, depending upon the subject depicted.

The most popular prints remain those that illustrate American rural and frontier life. Among the best

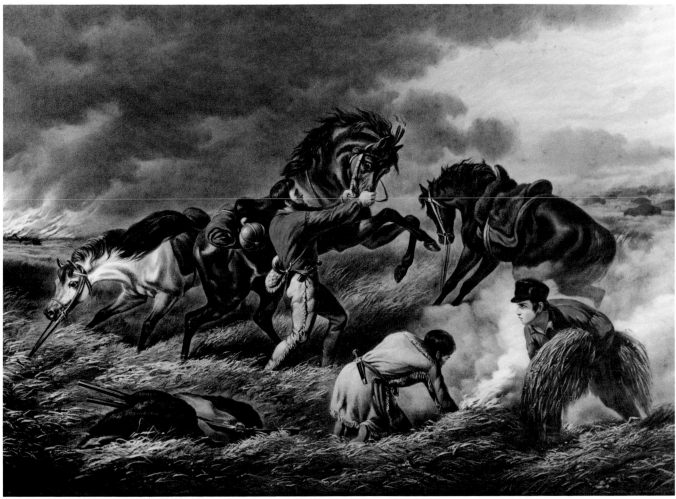

CURRIER AND IVES

The Trapper's Defense: Fire Fight Fire (lithograph)

Indian Lake - Sunset
Colored lithograph after B. Hess, copyright Currier & Ives, 1860
Printed below image: Painted by B. Hess—
Entered According to Act of Congress in the Year 1860 by Currier & Ives. . .Lith. of Currier & Ives, N.Y.
Image: 14⅝ x 22¾ in. (37.1 x 57.8 cm.)
Gift of Wilton L. Jaffee, 1967
1967.250

Among the Pines: A First Settlement
Colored lithograph, n.d.
Printed below image: Published by Currier & Ives, 125 Nassau St., N.Y.
Image: 8⅜ x 12½ in. (21.3 x 31.8 cm.)
Gift of Wilton L. Jaffee, 1967
1967.258

The Trapper's Defense: Fire Fight Fire
Colored lithograph after A. F. Tait, copyright Currier & Ives, 1862
Printed below image: Painted by A. F. Tait—
Entered According to Act of Congress in the Year 1862 by Currier & Ives. . .Lith. of Currier & Ives, N.Y.
Image: 18 x 27 in. (45.7 x 68.6 cm.)
Gift of Mr. N. P. Dodge, 1969
1969.220

Lassooing Wild Horses
Colored engraving after Darley by W. M. Rice, 1872
Printed l.l.: F. O. C. Darley; l.r.: W. M. Rice
Image: 7¾ x 11¼ in. (19.7 x 28.6 cm.)
Purchase, 1951
1951.18

Attack by Bears
Colored engraving after Darley, 1861
Image: 8 x 10 in. (20.3 x 25.4 cm.)
Gift in memory of Mrs. E. T. Manning, 1966
1966.104

known titles are *American Forest Scene, Maple Sugaring* after Charles Parsons, and *Central Park, Winter, The Skating Pond,* also after Parsons. The latter is one of the most famous of all Currier and Ives prints along with Fanny Palmer's *The "Lightning Express" Trains: "Leaving the Junction"* and her equally celebrated *Across the Continent: Westward the Course of Empire Makes its Way.* Modern offset copies of such prints also abound, and it is often hard to distinguish between these and surviving, original editions.

FELIX OCTAVIUS CARR DARLEY
1822-1888

American book illustrator F. O. C. Darley, as he usually signed himself, was born in Philadelphia. He was the son of English comedian John Darley, sometimes spelled as Darly. The young artist began his notable career as an illustrator in his native Philadelphia about 1842. Moving to New York City in 1848, he gained wide popularity as a result of his illustrations for the works of Washington Irving and James Fenimore Cooper throughout the 1850s.

After his marriage in 1859, Darley moved to Claymont, Delaware where he made his home until his death. An exhibitor at the National Academy of Design from 1845 and a member of the Academy from 1852, Darley was not only a book and magazine illustrator, but also an accomplished pen-and-ink and watercolor artist. He also designed bank note vignettes for Toppan, Carpenter and Company. His brother and a sister-in-law, Jane Cooper Darley, also were artists of note.

SETH EASTMAN
1808-1875

Indians Offering Food to the Dead
Chromolithograph, ca. 1860
Printed l.l.: Capt. S. Eastman, U.S. Army Del.;
l.r.: Chromolith of J. T. Bowen, Philad.
Image: 7⅛ x 9¹¹⁄₁₆ in. (18.1 x 24.6 cm.)
Purchase, 1949
1949.136

From *American Aboriginal Portfolio* by
Mary Henderson Eastman. Philadelphia:
Lippincott, Grambo and Co., 1853. The
plates are inscribed "S. Eastman, Capt., U.S.
Army, Del."

Dog Dance of the Dahcotas
Engraving (hand-colored)
Printed below image: S. Eastman, Capt., U.S.
Army, Del.; l.r.: C. E. Wagstaff and J. Andrews,
Engrs.
Image: 9¼ x 12½ in. (23.5 x 31.8 cm.)
Purchase, 1954
1954.54

Indian Woman Dressing Buffalo Skin
Engraving (hand-colored)
Printed below image: Capt. S. Eastman, U.S.
Army Del.
Image: 6⅛ x 5½ in. (15.6 x 14.0 cm.)
Purchase, 1967
1967.310

Dance to the Giant
Engraving (hand-colored) after Eastman by
C. K. Burt
Printed below image: Capt. S. Eastman, U.S.
Army, Del.
Image: 7⅜ x 5½ in. (18.7 x 14.0 cm.)
Purchase, 1967
1967.311

Indians Shooting Fish
Engraving (hand-colored) after Eastman by
C. K. Burt
Printed below image: Capt. S. Eastman, U.S.
Army, Del.
Image: 7½ x 5⅞ in. (19.1 x 14.9 cm.)
Purchase, 1967
1967.312

Striking the Post
Engraving (hand-colored) after Eastman by J. C.
McRae
Printed below image: Drawn by Captn. S.
Eastman, U.S.A.
Image: 5½ x 7¾ in. (14.0 x 19.7 cm.)
Purchase, 1967
1967.313

Career army officer Seth Eastman, noted today for his paintings of American Indian life, spent many years of active duty on the Anglo American frontier at posts from Minnesota to Texas. His wife Mary Henderson Eastman, daughter of the surgeon general of the U.S. Army, accompanied Eastman on several of his western tours. Considered by contemporaries as an accomplished writer, Mrs. Eastman published several books on Indian subjects. These were illustrated by her husband, notably *Romance of Indian Life* and *The Aboriginal Portfolio*, both issued in 1853. Eastman later supplied illustrations for the publications of Henry R. Schoolcraft, pioneer American ethnologist, who served as Indian agent for the northern tribes in Michigan Territory from 1822 to 1841. With artist-explorer Edward Kern, Eastman is chiefly represented in Schoolcraft's six-volume *Statistical Information Respecting the History, Conditions and Prospects of the Indian Tribes of the United States*, first published for the Bureau of American Ethnology in 1857.

Eastman spent his last years in Washington, D.C. where he executed a series of murals for the Senate and House Chambers. A highly respected painter in his day, he promoted, if unsuccessfully, a bill before Congress in the 1850s to purchase the Indian collection of fellow artist John Mix Stanley. Eastman is also believed to have been one of the first artists of his day to use photographs as a practical alternative to field sketches, employing for this purpose an early model of a daguerreotype camera.

Eastman was one of the few artists of his time to depict the ordinary aspects of Indian life on the Anglo-American frontier. He documented his subjects in a relatively straightforward manner and his paintings reflect little of the dramatic or sensational. He was also one of the first to describe the topography of America's frontier West, his earliest known sketches of this type having been made at Fort Crawford near Prairie du Chien, Wisconsin in 1829.

From his first tour of duty in the Old Northwest Territory to his final years in Washington as artist for the House Committee on Indian and Military Affairs, he continued to be active as both a soldier and a painter. He became most widely known during his lifetime through his published illustrations, especially those he produced for Henry R. Schoolcraft. At the

Spearing Fish from a Canoe
Engraving (hand-colored) after Eastman by J. C. McRae
Printed below image: Capt. S. Eastman, U.S. Army, Del.
Image: 5½ x 8 in. (14.0 x 20.3 cm.)
Purchase, 1967
1967.314

From *History of the Indian Tribes of North America* by Thomas L. McKenney and James Hall. Philadelphia: E. C. Biddle and others, 1836-1844 (3 vols.). The plates are variously inscribed as "Published by E. C. Biddle" or "Published by F. W. Greenough, Philada./Drawn, Printed and Coloured at J. T. Bowen's Lithographic Establishment" or "Lehman & Duval Lith. Phila."

Okee-Maakee-Quid, A Chippeway Chief
Lithograph (hand-colored) after original by J. O. Lewis
Printed below image: Painted by C. B. King. . . Lehman & Duval Lith. Phila. . .Philadelphia/ Published by E. C. Biddle/1836
Image: 13 x 9½ in. (33.0 x 24.1 cm.)
Purchase, 1949
1949.138

Shin-ga-ba W'Ossin
Lithograph (hand-colored) after original by J. O. Lewis
Printed below image: Philadelphia. Published by E. C. Biddle, 1835.
Image: 10½ x 8 in. (26.7 x 20.3 cm.)
Purchase, 1949
1949.139

Sha-ha-ka, the Big White
Lithograph (hand-colored)
Printed below image: Philadelphia. Published by E. C. Biddle, 1837.
Image: 11 x 8 in. (27.9 x 20.3 cm.)
Purchase, 1949
1949.141

height of his artistic fame, Eastman was regarded by many as the most effective pictorial historian of his day and its foremost painter of the American Indian.

JAMES MERRITT IVES
1824-1895

See Currier & Ives
1963.499

CHARLES BIRD KING
1785-1862

Rhode Island painter Charles Bird King is remembered today for a series of Indian portraits painted in Washington in the 1820s for Thomas L. McKenney, then head of the U.S. Bureau of Indian Affairs. King's portraits formed the heart of McKenney's own National Indian Portrait Gallery, housed for many years at the offices of the War Department, later transferred to the Smithsonian Institution, and destroyed by fire in 1865.

Lithographic versions of the King portraits, several copied after earlier portraits by frontier artist James Otto Lewis, appeared in publication in McKenney and James Hall's *History of the Indian Tribes of North America* issued in Philadelphia between 1836 and 1844. These plates in turn were reproductions of copies of the paintings in McKenney's Indian Gallery made by artist Henry Inman. The Inman copies survive to the present day.

Thomas L. McKenney had been a Georgetown merchant for several years when he received an appointment from President James Madison to serve as Superintendent of Indian Trade in 1816. McKenney held this position until federal control of Indian trade was abolished in 1822. In 1824 he was named Superintendent of Indian Affairs for the newly organized Bureau of Indian Affairs under the War Department. In this capacity he made several trips into the western territories on treaty-making business and remained active in Indian causes until the accession of Andrew Jackson to the U.S. Presidency in 1830.

McKenney afterward retired from public office and during the next ten years collaborated with Judge James Hall in the production of the three-volume

Chon-ca-pe, the Big Kansas
Lithograph (hand-colored)
Printed below image: Philadelphia. Published
by E. C. Biddle. . .1837.
Image: 10 x 8 in. (25.4 x 20.3 cm.)
Purchase, 1949
1949.142

Keokuk, Chief of the Sauk & Fox Nation
Lithograph (hand-colored)
Printed below image: Drawn, Printed and
Colored at J. T. Bowen's Lithographic Establish-
ment. Philadelphia, F. M. Greenough.
Image: 11 x 8½ in. (27.9 x 21.6 cm.)
Purchase, 1949
1949.144

Naw-Kaw, or Wood
Lithograph (hand-colored) after original by J. O.
Lewis
Printed below image: Published by F. W.
Greenough, Philad. . .J. T. Bowen's Lith.
Establishment. . .1836.
Image: 12 x 11 in. (30.5 x 27.9 cm.)
Purchase, 1949
1949.147

Pushmataha
Lithograph (hand-colored)
Printed l.l.: Painted by C. B. King; l.r.: Lehman
& Duval Lithrs; below image: Push-ma-Ta-Ha,
Chactaw Warrior. . .Philadelphia. Published by
E. C. Biddle. . .1833.
Image: 10 x 8 in. (25.4 x 20.3 cm.)
Purchase, 1951
1951.3

Wa-na-ta, the Charger, Grand Chief of the Sioux
Lithograph (hand-colored)
Printed l.r.: Lehman & Duval, Lithrs.; below
image: Philadelphia. Published by E. C. Biddle.
Entered According to Act of Congress in the
Year 1837. . .
Image: 14 x 8 in. (35.6 x 20.3 cm.)
Purchase, 1951
1951.4

Tshusick
Lithograph (hand-colored)
Printed below image: Published by E. C. Biddle,
Philadelphia. Drawn, Printed and Colored at
J. T. Bowen's Lithographic Establishment. . .
Entered According to Act of Congress. . .1837.
Image: 11¾ x 10 in. (29.8 x 25.4 cm.)
Purchase, 1951
1951.5

History. McKenney is also represented in publication by his *Sketches of a Tour to the Lakes* (1827). This relates to the signing of a treaty at Fond du Lac in 1826 whereby the Chippewa formally acknowledged U.S. sovereignty over the tribe and ceded territory, including important mineral deposits, to the government. A few illustrations after J. O. Lewis were featured in this publication.

Dedicated to the then Secretary of War, James Barbour, McKenney's *Tour of the Lakes* failed to convince Congress at the time of the need for a department of Indian affairs independent of the War Department. It did, however, find an appreciative audience among Christian missionary groups working with displaced Indian tribes along the frontier. A duplicate manuscript was sent to Robert Gallatin, U.S. minister to Great Britain, but Gallatin did little to promote its publication abroad. McKenney realized neither fame nor fortune from this or subsequent publishing efforts, and his first book was soon forgotten.

McKenney had first proposed the creation of a national Indian archives shortly after taking office in 1816. During the winter of 1820-21, a sizable delegation of Pawnee, Sioux, Chippewa, and representatives of other western tribes visited Washington to pay its respects to President James Monroe. McKenney commissioned artist Charles Bird King to paint portraits of the Indian visitors. These became the basis for the later celebrated Indian Gallery.

King continued to paint Indian portraits for McKenney until 1825, when a Congressional committee investigating government expenditures charged McKenney with spending too much money on his Indian pictures. McKenney managed for a while longer to overcome such criticism and continued to supply King with commissions.

Jacksonians in Congress later attacked McKenney's political views with regard to government-Indian relations and subjected him and the Adams administration generally to considerable criticism over the handling of Indian affairs. Secretary Barbour resigned his post in 1828. McKenney was dismissed from office two years later. In 1832 a new Bureau of Indian Affairs was created by the government. Meanwhile, McKenney turned to writing and lecturing on the subject of the American Indian.

Freed from the constraints of official duties, he undertook the publication of the large folios featuring

Chippeway Squaw and Child
Lithograph (hand-colored) after original by J. O.
Lewis
Printed below image: Published by E. C. Biddle,
Philadelphia. Printed and Coloured at J. T.
Bowen's Lithographic Establishment. . .
Entered According to Act of Congress. . .
1837. . .
Image: 10½ x 8 in. (26.7 x 20.3 cm.)
Purchase, 1951
1951.6

Petalesharoo, A Pawnee Brave
Lithograph (hand-colored)
Printed below image:
Philadelphia. Published by E. C. Biddle. . . in
the year 1836.
Image: 11 x 8½ in. (27.9 x 21.6 cm.)
Purchase, 1952
1952.3

Ong-pa-Ton-ga, Big Elk, Chief of the Omahas
Lithograph (hand-colored)
Printed below image: Painted by C. B. King. . .
Lehman & Duval Lithrs. Phila. E. C. Biddle,
1836.
Image: 10 x 8 in. (25.4 x 20.3 cm.)
Purchase, 1966
1966.55

Okee-Maakee-Quid, A Chippeway Chief
Lithograph (hand-colored) after original by J. O.
Lewis
Printed below image: Painted by C. B. King. . .
Lehman & Duval Lith. Phila. . .Philadelphia/
Published by E. C. Biddle/1836.
Image: 13 x 9½ in. (33.0 x 24.1 cm.)
Gift in Memory of Mrs. E. T. Manning, 1966
1966.105

Naw-Kaw, or Wood
Lithograph (hand-colored) after original by J. O.
Lewis
Printed below image: Published by F. W.
Greenough, Philad. . .J. T. Bowen's Lith.
Establishment. . .1836.
Image: 12 x 11 in. (30.5 x 27.9 cm.)
Gift in Memory of Mrs. E. T. Manning, 1966
1966.106

colored lithographic reproductions of the King portraits in the Indian Gallery. These were accompanied by a descriptive text. Volume I of the first folio was issued by Philadelphia publisher Edward C. Biddle in 1836. Biddle reissued this volume in 1837, and the same year first volumes also appeared in London. Volume II came out in 1838 from a different publisher, and Volume III appeared in 1844. The text for all three volumes was written for the most part by James Hall, a former Ohio lawyer, judge, and newspaperman, from material supplied by McKenney.

McKenney and Hall's *History of the Indian Tribes of North America* proved to be an expensive project costing an estimated $100,000 over the eight years that it was in production. The original three-volume set is now a highly prized item found only in rare book libraries and a few private collections. Individual plates from this series still appear occasionally. They are among the finest examples of the early development of the art of commercial lithography in nineteenth century America.

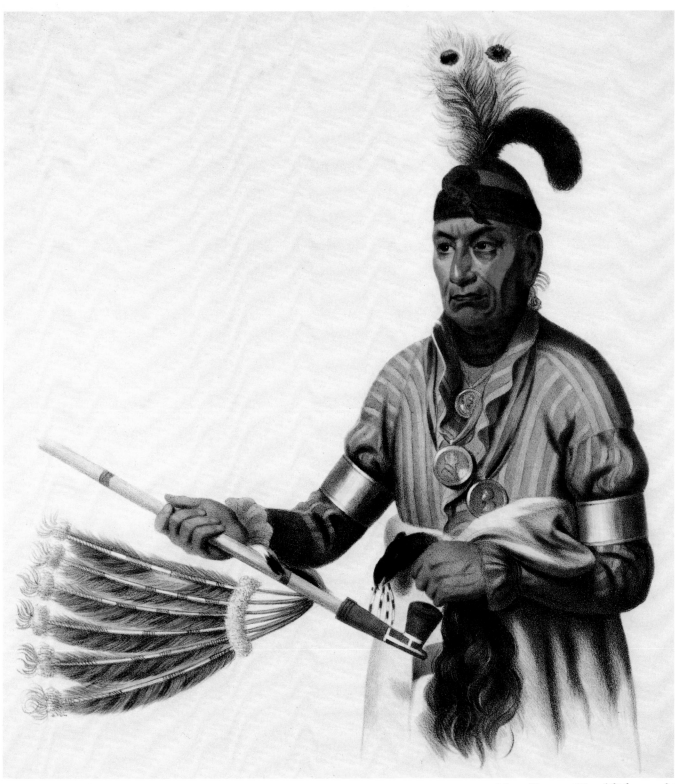

CHARLES BIRD KING

Naw-Kaw, or Wood (lithograph)

Medizinflaschendorf (Indian Medicine Village)
Color lithograph, *Das Illustrirte Mississip-
pithal* (Dusseldorf: Arnz & Company, 1857)
Image: 5⅜ x 7¹¹/₁₆ in. (13.7 x 19.5 cm.)
Purchase, 1953
1953.83

HENRY LEWIS
1819-1904

A landscape painter and panoramist, Henry Lewis
was born in England and traveled to the United States
with his father and brothers in 1829. In 1836 he settled
in St. Louis where he found work as a scenic designer.
Largely self-taught, Lewis traveled extensively on the
Mississippi River from 1846 to 1848 painting scenes
of the countryside, its inhabitants, frontier towns, and
river life. During 1848-49 he produced a large panorama
of the Mississippi Valley which was exhibited in the
East with considerable success.

In 1850 Lewis took his show to Europe and finally
settled at Dusseldorf where he commenced the formal
study of art. While at Dusseldorf he undertook to pub-
lish a book descriptive of the Mississippi Valley. This
work was issued in both English and German, although
the English version was never finished and only a frag-
ment of one copy is known to exist today. The German
edition, published under the title *Das Illustrirte
Mississippithal* in 1857, was only slightly more suc-
cessful and featured seventy-eight colored lithographs
based on Lewis's earlier paintings. Nearly all copies of
the book were finally destroyed except for a few rescued
by Lewis. Today perhaps fifty copies survive, now
considered among the prized rarities of American
documentary production.

From *Aboriginal Portfolio* by J. O. Lewis.
Philadelphia: Lehman & Duval, 1835-1836
(10 parts). Plates variously inscribed.

**Wah-ka-tai, Foremost in Battle, Chief of the
Sioux Tribe**
Lithograph (hand-colored)
Image: 9 x 7 in. (22.9 x 17.8 cm.)
Purchase, 1949
1949.137

The Rattlesnake, A Winnebago Chief
Lithograph (hand-colored)
Printed below image: Lehman & Duval, Lithrs.
Painted at the Treaty of Prairie du Chien 1825
by J. O. Lewis.
Image: 9¼ x 7 in. (23.5 x 17.8 cm.)
Purchase, 1967
1967.317

JAMES OTTO LEWIS
1799-1858

An engraver and painter of Indian portraits of western
scenes, James Otto Lewis was born in Philadelphia
and began his active career there as an engraver in
1815. In 1819 he traveled westward with Governor
Lewis Cass of Michigan Territory to the Great Lakes
region, and from 1823 to 1834 was officially employed
by Cass and others to paint Indian portraits. Lewis is
known to have done some engraving at St. Louis in
1820 or 1821. He later settled in Detroit where he
painted portraits and did copperplate printing until
about 1833. In his official government capacity he
attended a number of Indian councils in Wisconsin
and Indiana during the 1820s and made portraits of the
the native participants. A collection of these was litho-
graphed and published in Philadelphia in 1835-36 in a
series of ten parts under the title *Aboriginal Portfolio*.

Chat-o-mis-see, Pottawattomie Chief
Lithograph (hand-colored)
Printed below image: Lehman & Duval Lithrs.
Painted at the Treaty of Fort Wayne by J. O.
Lewis 1827.
Image: 8½ x 8½ in. (21.6 x 21.6 cm.)
Purchase, 1967
1967.318

A Sioux Chief
Lithograph (hand-colored)
Printed below image: Lehman & Duval Lithrs.
Painted at the Treaty of Prairie du Chien by J. O.
Lewis, 1825.
Image: 13 x 8¼ in. (33.0 x 21.0 cm.)
Purchase, 1967
1967.319

Central City
Color lithograph, *Pencil Sketches of Colorado*
(New York: the artist, 1866).
Printed below image: Lith. by J. Bien, N.Y.
Entered Acc'd. to Act of Congress in the Year
1866 by A. E. Mathews. . .A. E. Mathews, Del.
Image: 9 x 16 in. (22.9 x 40.6 cm.)
Purchase, 1966
1966.98

Efforts to follow this up with subsequent editions in New York and London proved unsuccessful, and Lewis spent his later years in relative obscurity.

Lewis's *Portfolio* was the first publication of its kind issued in the United States. Complete copies are today extremely rare, and individual surviving prints are widely scattered. Some of Lewis's portraits were copied by other artists and later appeared in Thomas L. McKenney and James Hall's *History of the Indian Tribes of North America* (1836-44). Lewis is also credited with illustrations earlier appearing in McKenney's *Sketches of a Tour to the Lakes* resulting from an expedition made by McKenney to Fond du Lac in 1826 to secure a treaty with the Chippewa. Over the next two years, Lewis accompanied this excursion as well as others to Green Bay, Buttes des Morts, and Fort Wayne.

ALFRED EDWARD MATHEWS
1831-1874

A topographical artist, landscape painter, and lithographer, A. E. Mathews, or Matthews as it is sometimes spelled, was born in Bristol, England and brought as an infant by his parents to the United States. He grew up in Rochester, Ohio. Before the Civil War, he traveled as a bookseller and painter and served with the Union Army during the war. At this time he produced a number of battle sketches which he later incorporated into a moving panorama of campaigns in the South.

After the war he visited the American West and established a studio in Denver, Colorado. For the next several years, he devoted himself to the production of lithographic views of the western scene. Many of these were issued in book form, including *Pencil Sketches of Colorado* and *Pencil Sketches of Montana*, both published in 1866, and *Gems of Rocky Mountain Scenery* issued in 1869. From about 1869 to 1872 he was engaged in promoting the settlement of Canon City, Colorado.

Mathews visited southern California in 1872. He died two years later at his ranch near the present Longmont, Colorado.

The Lost Scout
Color lithograph, n.d.
Printed below image: Published by H. Hurd, Jr.
639 Broadway, N.Y.
Image: 17½ x 20¼ in. (44.5 x 51.4 cm.)
Purchase, 1955
1955.12

Views —Zuni (Pueblo)
Color lithograph, Lt. Henry Whipple's *Report
of. . .Surveys along the 35th Parallel*
(Washington, 1853-54).
Printed below image: A. Hoen & Co., Baltimore.
Image: 5¾ x 8¹¹⁄₁₆ in. (14.6 x 22.1 cm.)
Purchase, 1948
1948.33

ALFRED JACOB MILLER
1810-1874

Alfred Jacob Miller created a considerable body of work based upon his one experience in the West with Scottish sportsman Sir William Drummond Stewart in the summer of 1837. Returning to his native Baltimore, he settled down as a portrait painter and duplicated his scenes of western life for numerous private patrons and collectors over the next twenty years. Few of his paintings were commercially reproduced in book or print form. Such examples may be regarded as relatively rare items today. The largest collections of his original work are found at the Walters Art Gallery in Baltimore, at the Thomas Gilcrease Institute in Tulsa, Oklahoma, and in The InterNorth Art Foundation collection at the Joslyn Art Museum in Omaha.

HEINRICH BALDUIN MÖLLHAUSEN
1825-1905

A scientific draftsman, author, and illustrator, Heinrich B. Möllhausen was born near the modern Bonn, West Germany. Following several years of military service, he sailed to the United States in 1849 and in the spring of 1851 accompanied Duke Paul of Württemberg on an expedition to the Rocky Mountains. Returning to Europe in 1852, Möllhausen afterward met Alexander von Humboldt, who encouraged him to continue his American travels. In 1853 he again visited the States and while in Washington was appointed as topographer and draftsman with Lt. A. W. Whipple's surveying expedition along the 35th Parallel through the American Southwest. He returned again to Berlin in 1854 and was appointed by Frederick Wilhelm IV of Prussia as custodian of libraries in the royal residences at Potsdam. He held this position throughout the remainder of his life.

In Berlin Möllhausen began the preparation of a diary of his first American experience for publication. At about this time he received a letter of appointment from Lt. J. C. Ives, a former member of the Whipple survey, offering him a position as artist and collector of natural history with another expedition to explore the Colorado River of the West. Following this expedition he once more sailed for Berlin and never returned to the United States.

Möllhausen's experiences in the American West

provided the basis for a later career as a writer. After publishing an account of his travels with Ives, he produced a series of short stories in 1860. The following year he published a four-volume novel entitled *The Half Breed.* This was soon followed by yet another called *The Fugitive.* Before his death Möllhausen authored some forty-five novels and collections of stories regarded today as documentaries of historical importance. An extensive collection of drawings relating to his first experience in the American West with Duke Paul was destroyed in 1945 during the Allied entry into Berlin at the close of World War II.

FRANCES FLORA PALMER
1812-1876

See Currier & Ives
1953.195
1963.499

WILLIAM TYLEE RANNEY
1813-1857

A historical and genre painter born at Middletown, Connecticut, William T. Ranney was apprenticed as a youth to a tinsmith in Fayetteville, North Carolina and later settled in Brooklyn, New York where he studied drawing and painting. During the 1840s he maintained a portrait studio in New York City. Ranney served at least once, and possibly twice, with the U.S. Army in Texas. He later married and settled down at West Hoboken, New Jersey. The last eighteen years of his life he devoted to the depiction of American rural and frontier life. He is best remembered today for his nostalgic western scenes, several of which were commercially reproduced and widely sold as art prints.

The Trapper's Last Shot
Colored lithograph by W. Waffenschmidt after Ranney, n.d.
Printed l.l.: Lith-o by Gibson & Co. . . .Cinn. O.
Image: 16½ x 23 in. (41.9 x 58.4 cm.)
Purchase, 1965
1965.197
See also Currier & Ives
1954.53

Hunting the Buffalo
Lithograph (hand-colored), Frontispiece, Vol. II,
McKenney & Hall's *History of the Indian
Tribes of North America.* 3 vols. (Philadelphia:
E. C. Biddle, 1836-44).
Image: 7 x 10½ in. (17.8 x 26.7 cm.)
Gift of Margaret Gettys Hall, 1962
1962.347

From *Reports of Explorations and Surveys
to Ascertain the Most Practicable and
Economical Route for a Railroad from the
Mississippi River to the Pacific Ocean.*
Washington, D.C.: U.S. Government,
1855-1861 (12 vols.). All plates are in-
scribed "U.S.P.R.R. EXP. & SURVEYS-
47TH & 49TH PARALLELS/GENERAL
REPORT/G. Sohon, Del./J. Bien N.Y.
Lith."

PETER RINDISBACHER
1806-1834

Swiss born Peter Rindisbacher received only a limited amount of schooling before emigrating with his family to North America in 1821 to join a party of settlers destined for the Earl of Selkirk's Red River Colony near present day Winnipeg, Manitoba. Traveling overland from Hudson's Bay to Fort Douglas, the young Rindisbacher made many sketches of the Indians and animals of the northern wilderness and for the next five years contributed to his family's support through the sale of his drawings and watercolors.

In 1827 and 1828 many of the original settlers left Canada and moved south into Wisconsin Territory. The Rindisbachers settled at St. Louis, Missouri where, in 1829, Peter Rindisbacher established a studio and began contributing to the *American Turf Register* and other magazines. He was beginning to make a name for himself as an illustrator of western life when he died at the age of only twenty-eight years.

At least ten lithographic reproductions of his work are known to have appeared in the *American Turf* magazine. A portfolio of six *Views in Hudson's Bay* was issued in London before his death. Other of his pictures were selected for inclusion in Thomas L. McKenney and James Hall's *History of the Indian Tribes of North America* (Philadelphia, 1836-44). The largest collection of his original watercolors is preserved today in the Public Archives of Canada. Regarded by many as the earliest paintings to document English settlement in western Canada, they are probably the first genre works by any artist in the interior of North America.

GUSTAV SOHON
1825-1903

Gustav or Gustavus Sohon, a topographical draftsman and portraitist, was born at Tilsit in East Prussia and emigrated to the United States at the age of seventeen. He worked as a bookbinder in Brooklyn, New York until he enlisted in the U.S. Army in 1852. During the next five years, Sohon served as an artist on several government sponsored exploratory surveying expeditions into the western territories and from 1858 to 1862 acted as guide and interpreter for a military road-building enterprise in the Pacific Northwest. Return-

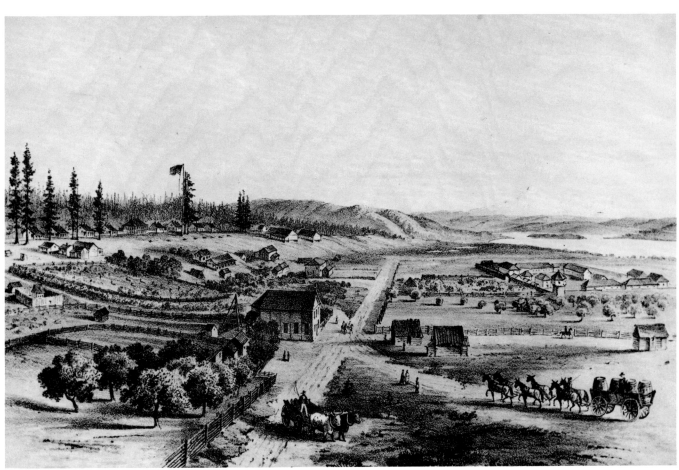

GUSTAV SOHON

Fort Vancouver, W.T. (lithograph)

Fort Vancouver, W. T. (Plate L)
Color lithograph
Sheet: 7⅞ x 11¼ in. (20.0 x 28.6 cm.)
Gift of Mrs. James A. Cline, Jr., 1954
1954.274

Hot Spring Mound, in the Deer Lodge Prairie, of the Rocky Mountains (Plate LIII)
Color lithograph
Sheet: 8 x 11¼ in. (20.3 x 28.6 cm.)
Gift of Mrs. James A. Cline, Jr., 1954
1954.277

Camas Prairie of Pena D'Oreilles Indians in the Rocky Mountains (Plate LVII)
Color lithograph
Sheet: 7½ x 11¼ in. (19.1 x 28.6 cm.)
Gift of Mrs. James A. Cline, Jr., 1954
1954.280

Clarks Fork and Ridge South of Flathead Lake (Plate LVIII)
Color lithograph
Sheet: 7¾ x 11¼ in. (19.7 x 28.6 cm.)
Gift of Mrs. James A. Cline, Jr., 1954
1954.281

Entrance to Bitter Root Mountains (Plate LXI)
Color lithograph
Sheet: 7⅝ x 11¼ in. (19.4 x 28.6 cm.)
Gift of Mrs. James A. Cline, Jr., 1954
1954.282

Hot Springs Lo Lo from Bitter Root Mountains (Plate LXII)
Color lithograph
Sheet: 7¾ x 11¼ in. (19.7 x 28.6 cm.)
Gift of Mrs. James A. Cline, Jr., 1954
1954.283

Cantonment Stevens — Looking Westward (Plate LXIII)
Color lithograph
Sheet: 7⅞ x 11¼ in. (20.0 x 28.6 cm.)
Gift of Mrs. James A. Cline, Jr., 1954
1954.287

Source of the Palouse (Plate LXV)
Color lithograph
Sheet: 8 x 11¼ in. (20.3 x 28.6 cm.)
Gift of Mrs. James A. Cline, Jr., 1954
1954.284

From *Reports of Explorations and Surveys to Ascertain the Most Practicable and Economical Route for a Railroad from the Mississippi River to the Pacific Ocean.* Washington, D.C.: U.S. Government, 1855-1861 (12 vols.). The plates are variously inscribed "U.S.P.R.R. EXP. & SURVEYS-

ing to Washington, D.C. in 1862, he assisted in the preparation of the reports of the latter expedition which featured several lithographs after Sohon's original drawings. From 1863 to 1865 he operated a photographic studio in San Francisco, California, but in 1865 or 1866 returned again to Washington. For the remainder of his life he managed a Washington theatre.

JOHN MIX STANLEY
1814-1872

Born at Canandaigua in western New York and reared in Naples and Buffalo, John Mix Stanley received his first instruction in art as a sign painter and carriage decorator. He began painting portraits about 1835 after moving to Detroit and made his living as an itinerant artist in this area until 1839. After 1839 Stanley resided

47TH & 49TH PARALLELS/GENERAL
REPORT/Stanley Del/J. Bien N.Y. Lith" or
"Sarony, Major & Knapp Liths. 449 Broadway, N.Y."

Saint Paul, M. T. (Plate I)
Color lithograph
Sheet: 7½ x 11¼ in. (19.1 x 28.6 cm.)
Gift of Mrs. James A. Cline, Jr., 1954
1954.248

Sauk River (Plate III)
Color lithograph
Sheet: 7½ x 11¼ in. (19.1 x 28.6 cm.)
Gift of Mrs. James A. Cline, Jr., 1954
1954.249

White Bear Lake (Plate V)
Color lithograph
Sheet: 7½ x 11¼ in. (19.1 x 28.6 cm.)
Gift of Mrs. James A. Cline, Jr., 1954
1954.250

Pike Lake M. T. (Plate VI)
Color lithograph
Sheet: 7½ x 11¼ in. (19.1 x 28.6 cm.)
Gift of Mrs. James A. Cline, Jr., 1954
1954.251

Shayenne River (Plate IX)
Color lithograph
Sheet: 7½ x 11¼ in. (19.1 x 28.6 cm.)
Gift of Mrs. James A. Cline, Jr., 1954
1954.252

Herd of Bison Near Lake Jessie (Plate X)
Color lithograph
Sheet: 7½ x 11¼ in. (19.1 x 28.6 cm.)
Gift of Mrs. James A. Cline, Jr., 1954
1954.253

Camp Red River Hunters (Plate XII)
Color lithograph
Sheet: 7½ x 11¼ in. (19.1 x 28.6 cm.)
Gift of Mrs. James A. Cline, Jr., 1954
1954.254

Distribution of Goods to the Assiniboines
(Plate XIV)
Color lithograph
Sheet: 8½ x 11½ in. (21.6 x 29.2 cm.)
Image: 5¾ x 8¾ in. (14.6 x 22.2 cm.)
Purchase, 1954
1954.211

Distribution of Goods to the Assiniboins
(Plate XV)
Color lithograph
Sheet: 7½ x 11¼ in. (19.1 x 28.6 cm.)
Gift of Mrs. James A. Cline, Jr., 1954
1954.255

variously in Baltimore, Philadelphia, and Troy, New York. Never remaining long in one place, he ventured west of the Mississippi in the fall of 1842 with Summer Dickerman, a friend from Troy, to make studies among the tribes in Indian Territory, now Oklahoma. He may have been inspired to do so by the example of George Catlin, who had visited this same area eight years before.

Stanley set up a temporary studio at Tahlequah, then capitol of the Cherokee Nation in Indian Territory. In 1843 he attended the grand council of all the tribes called by Cherokee Chief John Ross and painted a large view of the proceedings which survives today in the collections of the Smithsonian Institution. This same year Stanley also accompanied P. M. Butler, Cherokee agent, to a council of the Comanche and other tribes along the Red River near the present Lawton, Oklahoma, and painted other views and portraits at this time. The purpose of this council was to arrange a treaty of peace between the Indians and representatives of the Republic of Texas who ultimately failed to appear.

Stanley remained in Indian Territory until 1845 when Dickerman returned eastward to tour an exhibition of Stanley's paintings. Stanley joined a wagon train bound for Santa Fe and arrived there at about the same time that Col. Stephen W. Kearney's troops entered to take possession of the city following the declaration of war between the United States and Mexico. Stanley accompanied Kearney's subsequent expedition to California as a member of his scientific staff and afterward prepared a number of botanical plates illustrating Kearney's report of the campaign to the 30th Congress. This was concerned mainly with the taking of San Diego, but also incorporated a geographical reconnaissance of the then largely unexplored regions of New Mexico and Arizona.

Stanley continued his wanderings northward to San Francisco and Oregon Territory in 1847. In 1848 he sailed to the Hawaiian Islands and remained there for the better part of a year. In 1849 he sailed for Boston and home. For the next two or three years, he exhibited his collection of western paintings in various eastern cities. In 1852 he took a series of pictures under the title of Stanley's North American Indian Gallery to Washington, D.C. and arranged for its display at the Smithsonian Institution. He tried to interest the U.S. Congress in purchasing it for the nation, and with Captain Seth Eastman's help was able to bring his

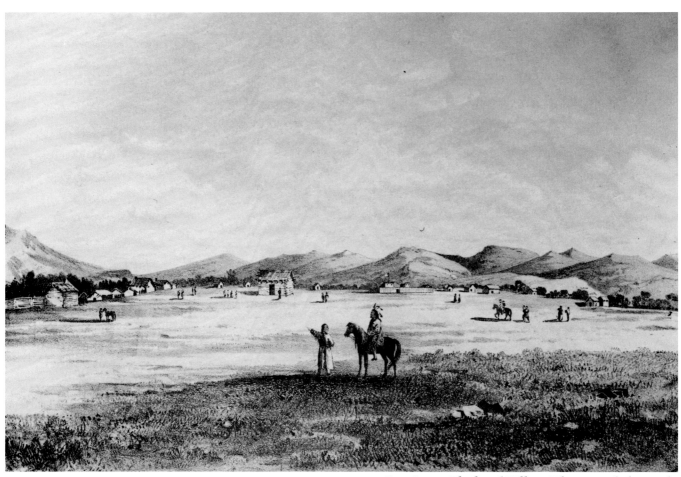

JOHN MIX STANLEY *Fort Owen-Flathead Village* (Plate xxx) (lithograph)

Ft. Union and Distribution of Goods to the Assinniboines (Plate XVI)
Color lithograph
Image: 5¾ x 8⅞ in. (14.6 x 22.5 cm.)
Purchase, 1953
1953.79

Ft. Union and Distribution of Goods to the Assinniboines (Plate XVI)
Color lithograph
Sheet: 7½ x 11¼ in. (19.1 x 28.6 cm.)
Gift of Mrs. James A. Cline, Jr., 1954
1954.256

Council with White Man's Horse (Plate XVII)
Color lithograph 1855
Image: 5¾ x 8⅞ in. (14.6 x 22.5 cm.)
Purchase, 1949
1949.133

Council with White Man's Horse (Plate XVII)
Color lithograph
Sheet: 7½ x 11¼ in. (19.1 x 28.6 cm.)
Gift of Mrs. James A. Cline, Jr., 1954
1954.289

Distribution of Goods to the Gros Ventres (Plate XXI)
Color lithograph 1855
Image: 5⅜ x 8¹⁵⁄₁₆ in. (13.7 x 22.7 cm.)
Purchase, 1949
1949.134

Distribution of Goods to the Gros Ventres (Plate XXI)
Color lithograph
Sheet: 7½ x 11¼ in. (19.1 x 28.6 cm.)
Gift of Mrs. James A. Cline, Jr., 1954
1954.257

Fort Benton (Plate XXIII)
Color lithograph
Image: 6⅛ x 9¼ in. (15.6 x 23.5 cm.)
Purchase, 1951
1951.20

Fort Benton (Plate XXIII)
Color lithograph
Sheet: 7½ x 11¼ in. (19.1 x 28.6 cm.)
Gift of Mrs. James A. Cline, Jr., 1954
1954.258

Bear's Paw (Plate XXIV)
Color lithograph
Sheet: 7½ x 11¼ in. (19.1 x 28.6 cm.)
Gift of Mrs. James A. Cline, Jr., 1954
1954.259

Teton Valley (Plate XXV)
Color lithograph
Sheet: 7½ x 11¼ in. (19.1 x 28.6 cm.)
Gift of Mrs. James A. Cline, Jr., 1954
1954.260

work to the attention of the Senate Committee on Indian Affairs which recommended purchase of 200 of Stanley's Indian paintings for the sum of $19,200. A bill to this effect was defeated in 1853. Meanwhile, Stanley was appointed to accompany Isaac Stevens's northern transcontinental railroad survey to the Pacific coast. He returned from this expedition in 1854 to assist in the preparation of the lithographic views illustrating Stevens's reports. These were part of twelve illustrated volumes on the subject published by the government between 1855 and 1861.

Stanley remained in Washington until 1863 when he moved back to Buffalo, New York, leaving behind his large western gallery, nearly all of which was consumed by a fire at the Smithsonian on the night of January 24, 1865. Another fire at P. T. Barnum's Museum in New York and yet another at his studio in Detroit, where he had finally settled, destroyed nearly everything the artist had ever produced relative to his western experiences.

Five paintings by Stanley remain at the Smithsonian to the present time. Four of these depict scenes or events associated with Stanley's sojourn in Indian Territory in the 1840s. Other works, for the most part produced after 1865, are to be found at the Buffalo Historical Society. Fourteen paintings are owned by the Thomas Gilcrease Institute in Tulsa, Oklahoma. The majority of these are portraits of various members of the John Ross family. Sixteen of Stanley's western studies purchased from his granddaughter, Mrs. Dean Acheson, are owned by the Stark Museum of Art in Orange, Texas.

Like Catlin before him, Stanley was unsuccessful in his attempts to sell his Indian collection to the government. The only significant collection of art owned by the nation in Stanley's day was the gallery of Indian portraits by C. B. King and others commissioned in the 1820s by Thomas L. McKenney, then head of the Bureau of Indian Affairs. After hanging at the War Department for several years, these pictures were removed to the Smithsonian for display and likewise destroyed by the fire of 1865.

Meanwhile, Catlin's collection had been taken to Europe for exhibition and eventually lost abroad to the artist's creditors. A portion of the Senate Record for February 27, 1847 alludes to a proposal to purchase 600 of Catlin's paintings for the sum of $50,000, to be paid in ten annual installments. The record relates that this was debated at some length among the Senators

Blackfeet Indians—Three Buttes (Plate XXVII)
Color lithograph 1855
Image: 5¾ x 8⅞ in. (14.6 x 22.5 cm.)
Purchase, 1948
1948.32

Blackfeet Indians—Three Buttes (Plate XXVIII)
Color lithograph
Sheet: 7½ x 11¼ in. (19.1 x 28.6 cm.)
Gift of Mrs. James A. Cline, Jr., 1954
1954.262

Approach to Cadotte's Pass (Plate XXIX)
Color lithograph
Sheet: 7½ x 11¼ in. (19.1 x 28.6 cm.)
Gift of Mrs. James A. Cline, Jr., 1954
1954.263

Fort Owen — Flathead Village (Plate XXX)
Color lithograph
Image: 5¾ x 8⅞ in. (14.6 x 22.5 cm.)
Purchase, 1954
1954.159

Fort Owen — Flathead Village (Plate XXXII)
Color lithograph
Sheet: 7½ x 11¼ in. (19.1 x 28.6 cm.)
Gift of Mrs. James A. Cline, Jr., 1954
1954.264

Victor's Camp-Hell Gate Ronde (Plate XXXIII)
Color lithograph
Sheet: 7½ x 11¼ in. (19.1 x 28.6 cm.)
Gift of Mrs. James A. Cline, Jr., 1954
1954.265

Awaiting the Return of Mr. Tinkham
(Plate XXXIV)
Color lithograph
Sheet: 7½ x 11¼ in. (19.1 x 28.6 cm.)
Gift of Mrs. James A. Cline, Jr., 1954
1954.266

Nez Perces (Plate XXXV)
Color lithograph
Sheet: 7½ x 11¼ in. (19.1 x 28.6 cm.)
Gift of Mrs. James A. Cline, Jr., 1954
1954.267

Hell Gate-Entrance to Cadotte's Pass from West
(Plate XXXVI)
Color lithograph
Sheet: 7½ x 11¼ in. (19.1 x 28.6 cm.)
Gift of Mrs. James A. Cline, Jr., 1954
1954.268

Fort Okinakane (Plate XXXIX)
Color lithograph
Sheet: 7½ x 11¼ in. (19.1 x 28.6 cm.)
Gift of Mrs. James A. Cline, Jr., 1954
1954.269

Ishimikaine Mission (Plate XLII)
Color lithograph
Sheet: 7½ x 11¼ in. (19.1 x 28.6 cm.)
Gift of Mrs. James A. Cline, Jr., 1954
1954.270

and then decided in the negative, as was the subsequent proposal for Stanley's Indian Gallery in 1853.

The cause of the fire that destroyed the bulk of Stanley's Indian gallery in 1865 is fully explained by the Secretary of the Smithsonian Institution in his Annual Report for the year in question. A subsequent article in the Annual Report for 1872 again mentions estimates of the monetary loss sustained by the Institution as a result of the fire and by individuals such as Stanley, whom Congress is urged to reimburse at least in part. No record of restitution to Stanley apparently exists. He died in Detroit in 1872, in the same year that Catlin died. Catlin's Indian collection was later acquired by the Smithsonian from the estate of Joseph Harrison, a Philadelphia railroad equipment manufacturer and collector of art, who had obtained it under the terms of receivership in London in 1852.

Mouth of Pelouse River (Plate XLIII)
Color lithograph
Sheet: 7½ x 11¼ in. (19.1 x 28.6 cm.)
Gift of Mrs. James A. Cline, Jr., 1954
1954.271

Old Fort Walla Walla (Plate XLV)
Color lithograph
Sheet: 7½ x 11¼ in. (19.1 x 28.6 cm.)
Gift of Mrs. James A. Cline, Jr., 1954
1954.272

Cascades of the Columbis (Plate XLVIII)
Color lithograph
Sheet: 7½ x 11¼ in. (19.1 x 28.6 cm.)
Gift of Mrs. James A. Cline, Jr., 1954
1954.273

Grand Coulee (Plate LI)
Color lithograph
Sheet: 7½ x 11¼ in. (19.1 x 28.6 cm.)
Gift of Mrs. James A. Cline, Jr., 1954
1954.275

Big Hole Prairie from the North (Plate LII)
Color lithograph
Sheet: 7½ x 11¼ in. (19.1 x 28.6 cm.)
Gift of Mrs. James A. Cline, Jr., 1954
1954.276

Bearsteeth, Missouri River (Plate LV)
Color lithograph
Sheet: 7½ x 11¼ in. (19.1 x 28.6 cm.)
Gift of Mrs. James A. Cline, Jr., 1954
1954.278

Rocky Mountain Chain (Plate LVI)
Color lithograph
Sheet: 7½ x 11¼ in. (19.1 x 28.6 cm.)
Gift of Mrs. James A. Cline, Jr., 1954
1954.279

Big Blackfoot Valley (Plate LXVI)
Color lithograph
Sheet: 7½ x 11¼ in. (19.1 x 28.6 cm.)
Gift of Mrs. James A. Cline, Jr., 1954
1954.285

Rocky Mountains — Looking Westward
(Plate LXVII)
Color lithograph
Sheet: 7½ x 11¼ in. (19.1 x 28.6 cm.)
Gift of Mrs. James A. Cline, Jr., 1954
1954.286

Mount Rainier from Near Steilacoom
(Plate LXIX)
Color lithograph
Sheet: 7½ x 11¼ in. (19.1 x 28.6 cm.)
Gift of Mrs. James A. Cline, Jr., 1954
1954.288

Maria's River
Color lithograph
Sheet: 7½ x 11¼ in. (19.1 x 28.6 cm.)
Gift of Mrs. James A. Cline, Jr., 1954
1954.261

ARTHUR F. TAIT
1819-1905

See N. Currier
1965.196
Also Currier & Ives
1969.220

CARL WIMAR
1828-1862

On the Prairie
Lithograph (hand-colored) by L. Grozelier after
Wimar, 1860
Printed in margin, l.l.: On Stone by L. Grozelier;
l.c.: Entered According to Act of Congress in
the Year 1860 by J. E. Tilton & Co.; l.r.: Chas
Wimar, pinxt.
Printed below image: On the Prairie/Published
by J. E. Tilton & Co. Boston/Printed at
J. H. Bufford's
Image: 17¼ x 25¾ in. (43.8 x 65.4 cm.)
Purchase, 1965
1965.7

German born Carl (Karl or Charles) Wimar settled at
St. Louis, Missouri with his parents, and at the age of
fifteen received his first instruction in art from pano-
ramist Leon Pomarede. Wimar returned to Germany
in 1852 to further his art studies at Dusseldorf under
the supervision of Emanuel Leutze. Wimar stayed in
Dusseldorf for approximately four years and returned
again to St. Louis in 1856. In 1858 he made the first of
several excursions up the Missouri River to Forts Clark
and Union and afterward devoted himself to painting
Indian and western life. He was one of the founders of
the Western Art Academy in 1859.

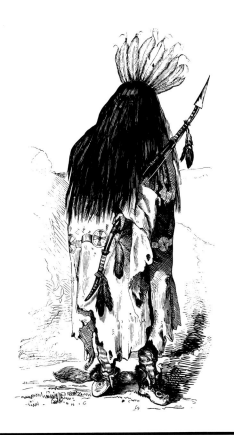

ETHNOGRAPHIC CATALOGUE ENTRIES

BY MARSHA V. GALLAGHER

From the first contacts with Europeans, American Indian clothing, utensils, and ritual objects were collected, first as souvenirs or curiosities and later as specimens documenting a different and, in many instances, a rapidly disappearing way of life. In recent decades such material has begun to be generally recognized as a wonderfully varied form of aesthetic expression, and there has been a steadily growing appreciation of American Indian artifacts as art. The Indian cultures of the West are well represented in the Joslyn's extensive ethnographic collection, and a catalogue of the Museum's Western art would not be complete without some mention of these pieces. On the following pages are illustrated a few fine examples of artifacts from the same regions portrayed in the Joslyn's Western paintings: the Plains, the Southwest, and California.

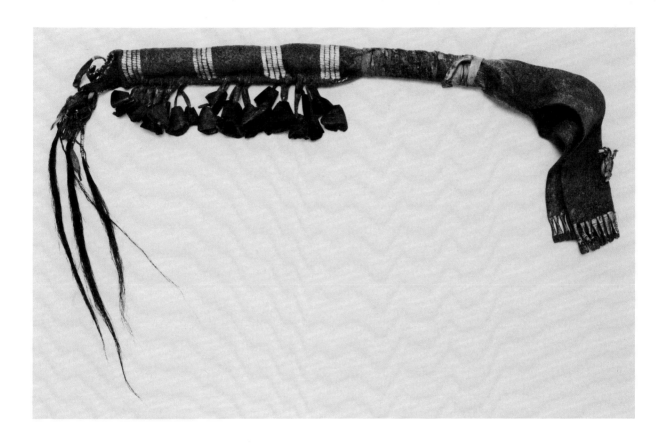

RATTLE

This type of rattle was part of the ritual paraphernalia of a warrior society among the Arapaho.

Rattle
Arapaho (Plains) ca. late 19th or early 20th century
Wood, hide, dewclaw, quill, horse hair
Length: 25 in.
P.10

Shirt and Leggings
Omaha (Plains) ca. 1870-80
Hide, beads, human and horse hair
Length: 30 in. (shirt), approximately 46 in.
(leggings)
Purchase, 1981
1981.47a-c

SHIRT AND LEGGINGS

This shirt and pair of leggings were illustrated in the comprehensive study of the Omaha tribe by Alice Fletcher and Francis La Flesche, published in 1906. The leggings, with their long flaps or tabs at the ankle and a pattern of circles representing hail, were described by the authors as being of the type worn exclusively by chiefs. The shirt is not so specifically referred to but, since ornamented shirts were among articles given as a prescribed means of political advancement, it is likely that this beautiful example once also belonged to a man of some importance.

Viewed together, the shirt and leggings appear to be one costume or suit and this may have been the case. However, leggings with long tabs are a very old style on the Plains, dating primarily to the first half of the nineteenth century but persisting somewhat later among certain tribes (Feder 1962:148). Moreover, the color of the shirt and leggings is similar but not identical, suggesting the use of a different pigment or application method, or of differential loss of coloration through longer use, or a combination of such factors. These and other small details suggest that the pieces may have been made at different times, with the leggings somewhat older than the shirt. They are in any instance very rare and handsome examples of nineteenth century Omaha garments.

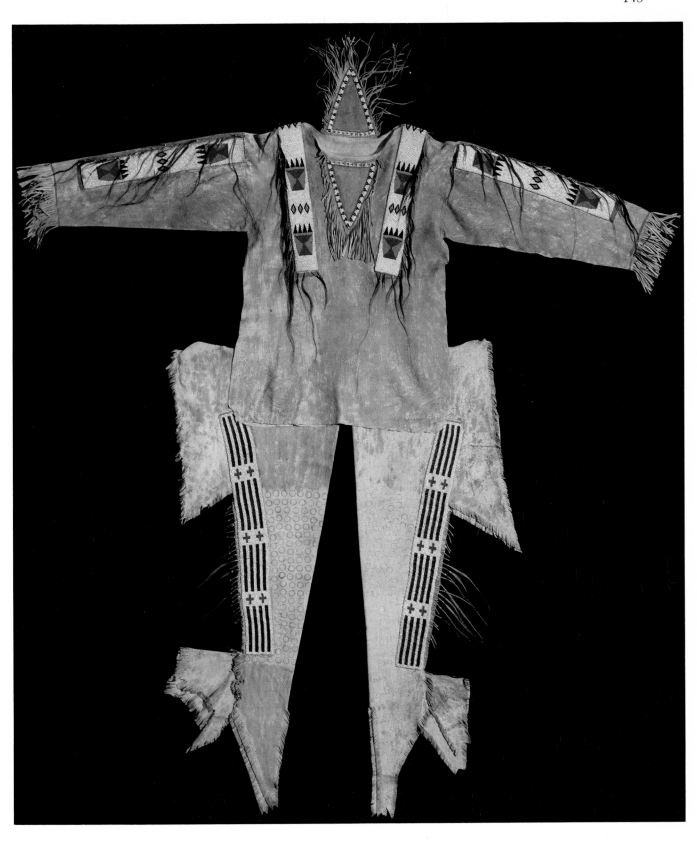

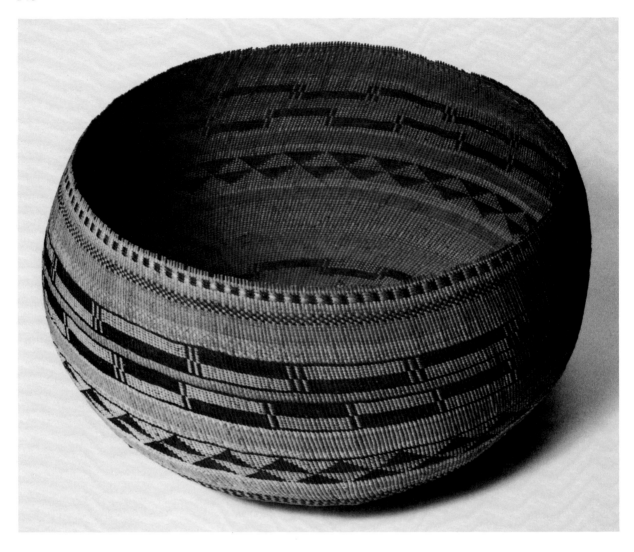

Basket
Pomo (California) Probably early 20th century
Plant shoots and roots
Height: 10 in.
Purchase, 1952
1952.185

BASKET

The native peoples of California produced an incredible variety of technically excellent and aesthetically pleasing basketry. The Pomo tribe is especially well-known for small and very finely coiled baskets, often decorated with colorful feathers or beads. Their utilitarian pieces, like the twined seed storage basket shown here, generally show a similar skill and artistry. The decorative band of rectangular motifs is called by the Pomo "deer back," the triangles "butterflies" or "arrowheads."

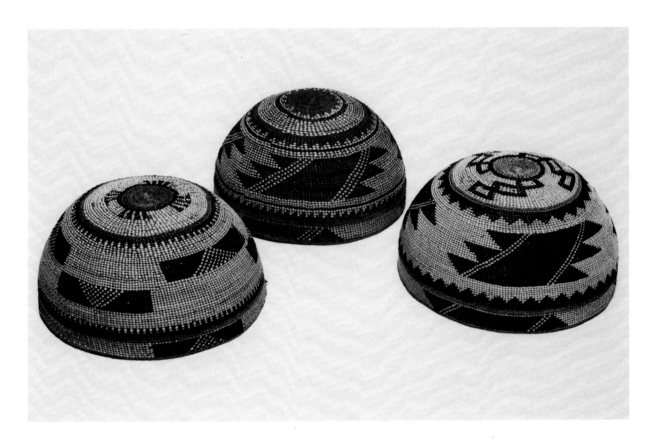

BASKETS

Baskets
Left to right: Yurok, Karok, Yurok (California)
Probably early 20th century
Plant shoots and roots
Heights: Approximately 3 in. each
Permanent Loan, Omaha Public Schools, 1950;
Gift of Mrs. A. F. Jonas, 1947; Gift of Omaha Art
Institution, 1926
285.1950; 1947.483; 1926.23

These are traditional women's dress hats, made for wear on festive or ceremonial occasions. They are worn with only the rim touching the head. The designs are woven with an overlay stitch that shows on the exterior but not the interior of the basket.

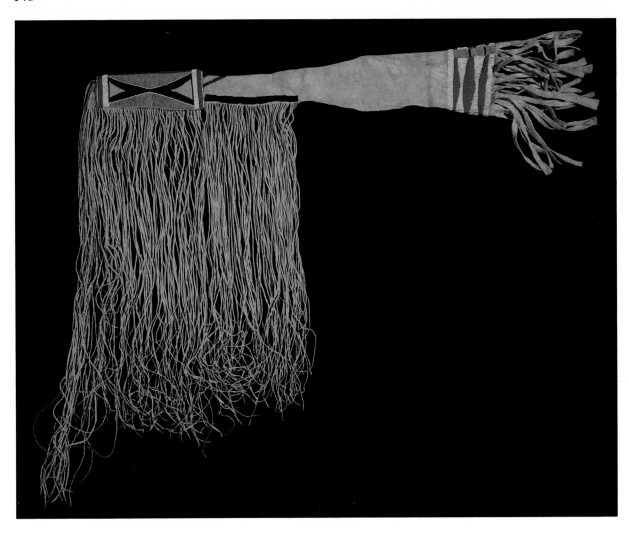

Rifle Case
Crow (Plains) ca. 1870-80
Hide, beads, cloth
Length: 48 in.
Gift of Mrs. A. H. Richardson, 1956
1956.112

RIFLE CASE

The beadwork colors and designs and the long, graceful fringe are all typically Crow. The case was collected by Captain John G. Bourke, a nineteenth century army officer and author, perhaps best known for *On the Border with Crook*. Bourke was deeply interested in the Indian cultures he encountered on his Western military campaigns and published many books and articles on them.

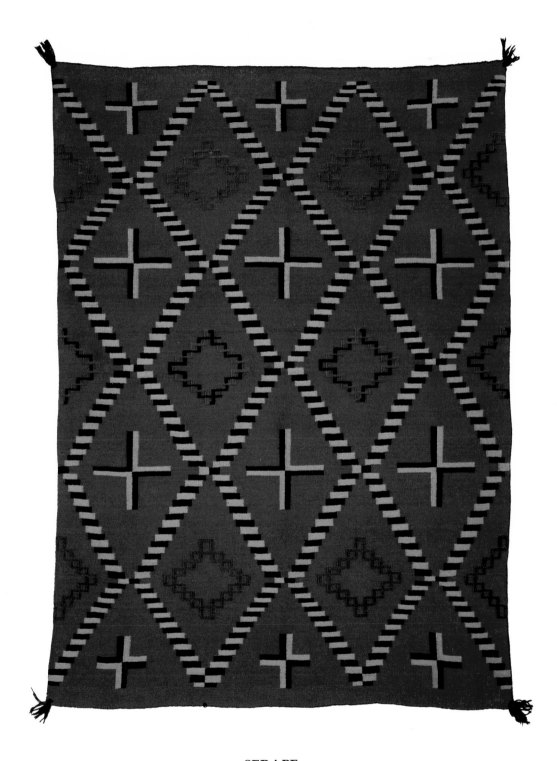

SERAPE

Serape
Navajo (Southwest) ca. 1870-75
Wool
Length: 70 in., Width: 51 in.
Gift of Mrs. A. H. Richardson, 1956
1956.90

The Navajo weaving tradition extends back at least 300 years. Serapes and other wearing blankets, like most Navajo weaving prior to 1880, were made for personal use.

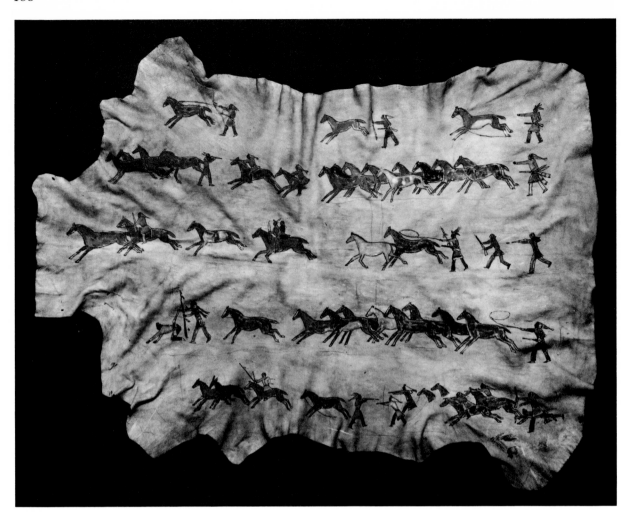

Painted Hide
Northern Plains ca. 1900
Elk hide
Length: 55 in., Width: 74 in.
Purchase, 1951
1951.545

PAINTED HIDE

The pictographic painting of robes and tepees is an old Plains art form. Only men painted in this style and the subject most often was the representation of heroic deeds, such as the horse raid depicted on this elk hide. Probably made for sale rather than personal use, the scene is a particularly lively and vividly colored one with a realism to the figures not often found on earlier pieces.

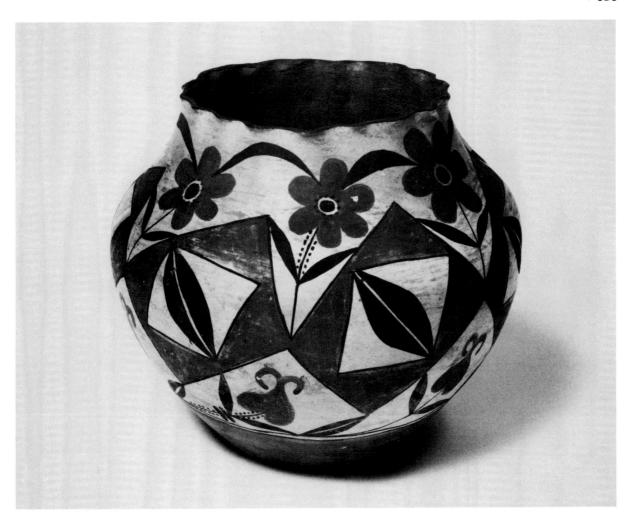

JAR

Jar
Acoma Pueblo (Southwest) ca. 1870-1900
Ceramic
Height: 7½ in.
Permanent Loan, Omaha Public Schools, 1950
201.1950

Floral and bird motifs began to appear on Acoma pottery more than a century ago. Intricate geometric patterns are also common, and in recent decades some potters have revived the use of certain prehistoric Southwestern designs, particularly the distinctive bird and animal figures of the Mimbres culture.

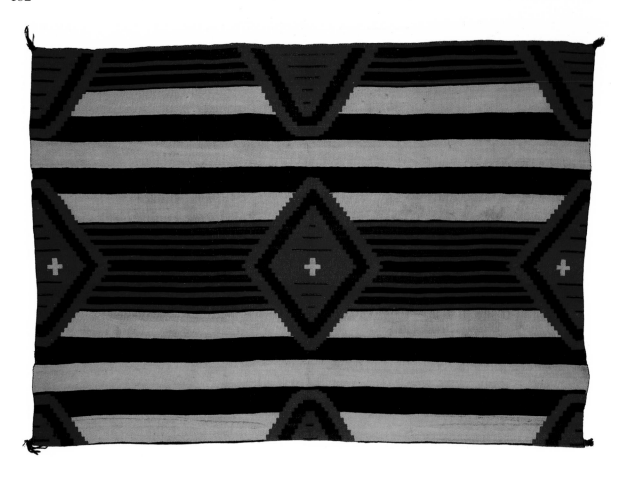

BLANKET

Blanket
Navajo (Southwest) ca. 1870-75
Wool
Length: 49 in., Width: 73½ in.
Gift of Col. Forrest E. Jones, 1980
1980.33

This type of wearing blanket, woven wider than long, is commonly called a "chief blanket." It was certainly not confined to men of rank among the Navajo, but was widely traded to other Indian tribes where it presumably would have been a comparatively costly article and perhaps therefore, an indication of prestige. The earliest chief blankets had a pattern of simple stripes (called Phase I chief blankets by students of the history of Navajo weaving). By 1850 rectangular blocks had been added to the stripes (Phase II) and by 1870 there were terraced diamonds as well (Phase III). Variations on all three patterns continued to be woven for wear throughout this time period and were later occasionally reproduced as rug designs, particularly the Phase III pattern. The blanket pictured here is a classic Phase III which has been shortened along one edge; originally the top and bottom edges would have been identical.

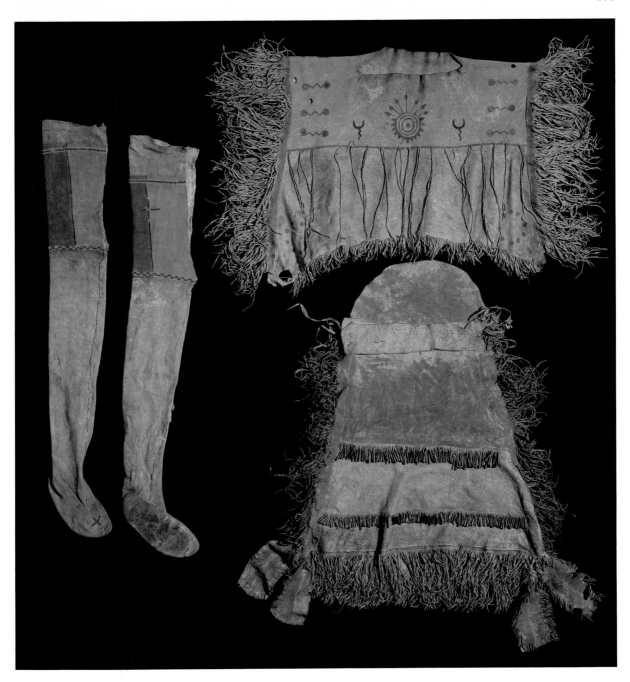

WOMAN'S CLOTHING

Clothing
Eastern Apache, probably Mescalero Apache
(Southwest)
Late 19th century
Hide, metal, beads
Length of skirt: 36 in.
Gift of Mr. and Mrs. Ralph W. Jacobus, 1958
1958.63a-c

This three-piece woman's outfit of blouse, skirt, and moccasins is of the type worn by a young girl at the special religious ceremony which marked her passage from girlhood to womanhood. Such a costume would generally be kept within a family and used in the puberty ceremony by successive generations of young women.

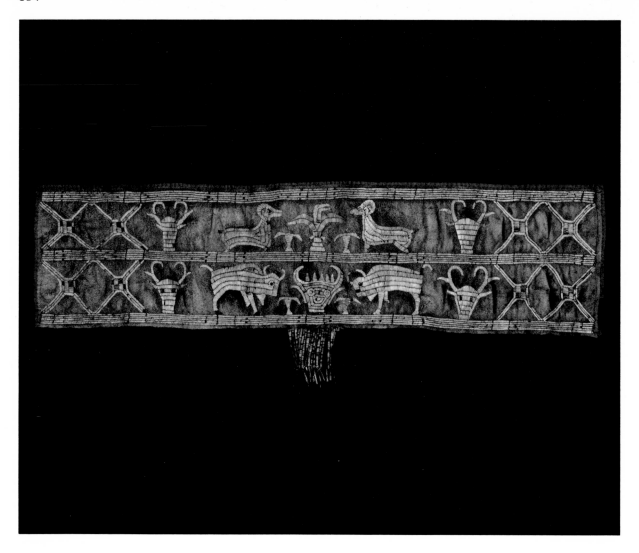

QUILLED STRIP

This finely detailed quilled hide strip, bound in cloth, was once a decorative applique on a baby's cradle-board cover. The imagery is still vivid, though the colors have faded with time.

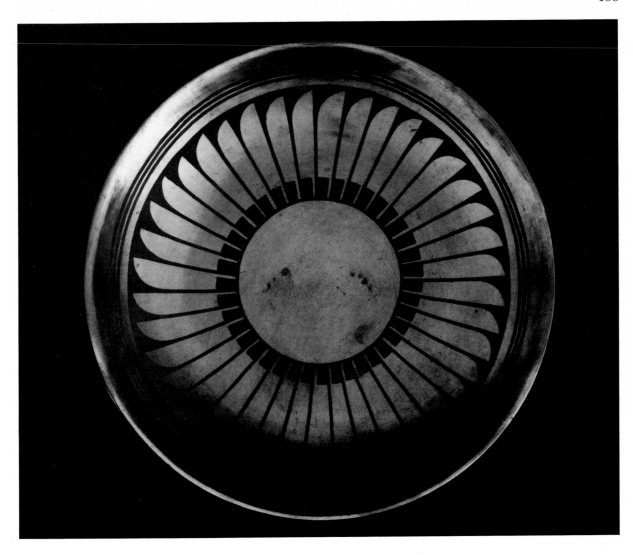

Plate
San Ildefonso Pueblo (Southwest) ca. 1950
Ceramic
Diameter: 14¾ in.
Gift of Clarke Field, 1957
1957.53

PLATE

This plate is an excellent example of the work of the late, famed potter, Maria Martinez. The stylized feather design and the almost mirror-like gloss of the polished black surface are both characteristic of Maria's pottery. She and her husband, Julian, originated this now widely-used Pueblo technique of a matte design on a polished surface. Maria was also apparently the first Pueblo potter to sign or otherwise hallmark her work. In doing so, she signed her name variously as "Marie" or "Maria." From the 1930s on, she frequently worked with various members of her family in producing her pottery, and their names were added to the signature on the vessels they made with her. The plate shown here is signed "Marie and Santana;" Santana was Maria's daughter-in-law.

BIBLIOGRAPHY

Audubon, John James. *The Birds of America.* 7 vols., Royal 8vo. New York and Philadelphia: Audubon and Chevalier, 1840-44.

_____. *The Viviparous Quadrupeds of North America.* 3 vols., Royal 8vo. Philadelphia: V. G. Audubon, 1854.

Bushnell, David I., Jr. "John Mix Stanley, Artist-Explorer." *Annual Report of the Board of Regents of the Smithsonian Institution. . .for the Year Ending June 30, 1924.* Washington, D.C.: Government Printing Office, 1925.

Feder, Norman. "Bottom Tab Leggings." *American Indian Tradition Magazine.* Vol. 8, No. 4. 1962.

Fletcher, Alice C. and La Flesche, Francis. "The Omaha Tribe." *27th Annual Report of the Bureau of American Ethnology.* Washington, D.C.: Smithsonian Institution, 1906.

Groce, George C., and Wallace, David H. *The New York Historical Society's Dictionary of Artists in America, 1564-1860.* New Haven: Yale University Press, 1957.

Haberly, Loyd. *Pursuit of the Horizon.* New York: The Macmillan Company, 1948.

Hayden, F. V. *A Survey of Yellowstone Park, and the Mountain Regions of Portions of Idaho, Nevada, Colorado and Utah.* Boston: L. Prang and Company, 1876.

James, Edwin. *An Account of an Expedition from Pittsburgh to the Rocky Mountains in 1819, 20 and 23.* 2 vols. Philadelphia: Carey and Lea, 1823.

Lewis, James Otto. *Aboriginal Port-folio.* 10 parts. Philadelphia: Lehman and Duval, 1835-36.

Maximilian, Prince of Wied. *Travels in the Interior of North America.* Translated by H. Evans Lloyd. London: Ackermann and Company, 1843. Reprint edited by Reuben Gold Thwaites, Cleveland, 1906.

McCracken, Harold. *Portrait of the Old West.* New York: McGraw-Hill Book Company, 1962.

McKenney, Thomas L., and Hall, James. *The Indian Tribes of North America, with Biographical Sketches and Anecdotes of the Principal Chiefs.* Folio: Philadelphia, E. C. Biddle, 1836-44. Octavo: Philadelphia, 1842-44. Reprint edited with an introduction by Frederick Webb Hodge, 3 vols., Edinburgh, 1933.

Miller, Alfred Jacob. "Rough Draughts to Notes on Indian Sketches." Manuscript, 288 pp., n.d. Library of the Thomas Gilcrease Institute of American History and Art, Tulsa, Oklahoma.

Miscellaneous Reports of the Smithsonian Institution. Washington, D.C.: Government Printing Office, 1900.

Moorehead, Alan. *Fatal Impact.* New York: Harper and Row, 1966.

"Portraits of American Indians with Sketches of Scenery, etc. Painted by J. M. Stanley." *Smithsonian Miscellaneous Collection.* Volume II. Washington: Government Printing Office, 1852.

Proceedings of the Board of Regents. *Annual Report of the Board of Regents of the Smithsonian Institution. . . for the year 1864.* Washington, D.C.: Government Printing Office, 1872.

Reader's Encyclopedia of the American West. Edited by Howard R. Lamar. New York: Thomas Y. Crowell Company, 1977.

Report of the Secretary. *Annual Report of the Board of Regents of the Smithsonian Institution. . .for the year 1864.* Washington, D.C.: Government Printing Office, 1865.

Reports of Explorations and Surveys to Ascertain the Most Practicable and Economical Route for a Railroad from the Mississippi River to the Pacific Ocean. Washington, D.C.: Government Printing Office, 1855-60.

Ross, Marvin C. *The West of Alfred Jacob Miller.* Norman: University of Oklahoma Press, 1951. 2nd ed., 1968.

Scranton, Robert. *Aesthetic Aspects of Ancient Art.* Chicago: University of Chicago Press, 1964.

Taft, Robert. *Artists and Illustrators of the Old West, 1850-1900.* New York: Charles Scribner's Sons, 1953.

Truettner, William H. *The Natural Man Observed: Catlin's North American Indian Gallery.* Washington, D.C.: The Smithsonian Institution, 1979.

Wilkins, Thurman. *Thomas Moran, Artist of the Mountains.* Norman: University of Oklahoma Press, 1966.

INDEX OF ARTISTS